MW01007763

ı.

lor.

EXPERIMENTS IN ART RESEARCH

Experiments in Art Research: How Do We Live Questions Through Art? is not a conventional research methods guide; it's an encounter for asking questions through art.

Originating from the work of a community of tightly connected scholars, artists, and teachers, the book unfolds through a tapestry of moments, practices, and people, embracing the celebration of works in progress and in community. Rooted in the practice of permission-giving, the narrative intertwines personal stories—laying bare the transformative power of unconventional teaching methods, risky endeavors, and the breaking of scholarly norms—and begins by understanding that "art" and "research" are not separate. After that, there are endless directions to take up. Instead of a handbook offering rules or best practices, this text offers an inspiring collection of joy, longing, and determination.

This is fascinating reading for arts-based researchers, artists, educators in the arts, education scholars, research-creators, performance theorists, art history scholars, art education scholars, inter- and anti-disciplinary scholars, qualitative and post-qualitative researchers, decolonization scholars, public humanities scholars, and writing pedagogy scholars.

Sarah Travis is Assistant Professor of Art Education in the School of Art and Design at the University of Illinois Urbana-Champaign, USA.

Azlan Guttenberg Smith is a PhD student in Writing Studies at the University of Illinois Urbana-Champaign, USA.

Catalina Hernández-Cabal is Instructor of Women's and Gender Studies in the Academy for Transdisciplinary Studies at Virginia Tech University, USA.

Jorge Lucero is Full Professor of Art Education in the School of Art and Design and Associate Dean for Research in the College of Fine and Applied Arts at the University of Illinois Urbana-Champaign, USA.

"Instead of acceding to the dominant definition of experiment as empirical proof or evidentiary test found in the sciences, *Experiments in Art Research* returns us to another, largely forgotten (or repressed) definition of experiment as a feat of magic or sorcery. Each chapter in this delightfully subversive collection of essays, letters, anarchives, vignettes, compositings, visual journals, and critical commentaries casts a spell that reanimates the trifecta "art," "research," and "education" with mystery and joy. If the editors ground the collection in the concept of permissions—as the imaginary space to test limits of reality and, in turn, experiment with what lies at the very edge of the knowable and perceivable about ourselves, our communities, and the cosmos writ large—then I can eagerly reply: 'Yes, you have my full permission!'"

Tyson E. Lewis, *Professor, University of North Texas, USA,*
and co-author with Peter Hyland Studious Drift:
Movements and Protocols for a Postdigital Education

"*Experiments in Art Research* is a delicate and daring invitation, re-kindling liveliness in research. Embracing new forms through luminous experiment, I encountered audacious and delightful discourse that respects the mystery of art research as relational event. The book—an artwork!—radiating the ethos of care by captivating detours, unlocking doors of discipline, connecting through collages, drawings, gestures, and becomings. Nearing poetry, it is perpetually in flux, breathing new life into the very heart of art research."

Merel Visse, *Associate Professor, Drew University, USA*
and University of Humanistic Studies, Netherlands

"This book felt like stepping into an underground party where I got immersed in an extraordinary circle of writers, thinkers, teachers, artists and activists. *Experiments in Art Research* is a vibrant amalgamation of contemplations and reflections, bound by two steadfast threads: every contributor is a 'person who thinks-with-art,' and they share intimate connections through personal affiliations, narratives, and bonds of friendship. Grab a snack and a beverage and join a conversation that transcends boundaries between art, education and research. Embark on a journey that takes you from academic to intuitive writing, from syllabi to lived curricula, from nature-bathing to open coding, from screendance to handwritten correspondence, from femicide, homophobia and neo-colonialism to restorative behaviors and Japanese tea gatherings, from imposter syndromes to ancestral knowledge, and from a veiled camel's secret to learning to become an 'oddist.'"

Emiel Heijnen, *Professor,*
Amsterdam University of the Arts, Netherlands

"Innovative and playful, *Experiments in Art Research: How Do We Live Questions Through Art?* gathers both new and leading voices in Arts-Based Research, representing diverse artistic media, cultures, and disciplines, from anthropology and creative writing to rhetoric and art education. This volume presents scholarship that connects the personal and the professional in meaningful and creative ways, grappling aesthetically with real life issues."

Liora Bresler, *Professor Emerita,*
University of Illinois Urbana-Champaign, USA

"The authors in *Experiments in Art Research: How Do We Live Questions Through Art?* transgress the boundaries of taken-for-granted best practices in academia by creating permissions—while extending a welcoming invitation to you, the reader—to join them in testing the pliability of research as material."

Daniel T. Barney, *Associate Professor,*
George Mason University, USA

"At their worst, universities are individualistic, hyper-competitive places where learning—amongst undergraduates, postgraduates, and faculty—is constructed as a private investment in each person's preset future. At their best, universities are collaborative, mutually-inspired places where learning arises in and through people offering permission to each other to engage with the potentiality of the unknown. At the intersection of the arts and education, this edited collection provides one account after another of the university at its best."

Tyler Denmead, *University Associate Professor,*
Faculty of Education, University of Cambridge, UK

EXPERIMENTS IN ART RESEARCH

How Do We Live Questions Through Art?

Edited by Sarah Travis, Azlan Guttenberg Smith, Catalina Hernández-Cabal, and Jorge Lucero

Routledge
Taylor & Francis Group
LONDON AND NEW YORK

Designed cover image: "Would you like to participate in an artistic experience?" by Ricardo Basbaum with participation of University of Illinois students and faculty, 2021.

First published 2024
by Routledge
4 Park Square, Milton Park, Abingdon, Oxon OX14 4RN

and by Routledge
605 Third Avenue, New York, NY 10158

Routledge is an imprint of the Taylor & Francis Group, an informa business

© 2024 selection and editorial matter, Sarah Travis, Azlan Guttenberg Smith, Catalina Hernández-Cabal, and Jorge Lucero; individual chapters, the contributors

The right of Sarah Travis, Azlan Guttenberg Smith, Catalina Hernández-Cabal and Jorge Lucero to be identified as the authors of the editorial material, and of the authors for their individual chapters, has been asserted in accordance with sections 77 and 78 of the Copyright, Designs and Patents Act 1988.

All rights reserved. No part of this book may be reprinted or reproduced or utilised in any form or by any electronic, mechanical, or other means, now known or hereafter invented, including photocopying and recording, or in any information storage or retrieval system, without permission in writing from the publishers.

Trademark notice: Product or corporate names may be trademarks or registered trademarks, and are used only for identification and explanation without intent to infringe.

British Library Cataloguing-in-Publication Data
A catalogue record for this book is available from the British Library

ISBN: 978-1-032-55490-7 (hbk)
ISBN: 978-1-032-55493-8 (pbk)
ISBN: 978-1-003-43097-1 (ebk)

DOI: 10.4324/9781003430971

Typeset in Optima
by SPi Technologies India Pvt Ltd (Straive)

LIBRARY - UNIVERSITY OF LETHBRIDGE

CONTENTS

EDITORS

Sarah Travis is Assistant Professor and Chair of the Art Education Program in the School of Art and Design at the University of Illinois Urbana-Champaign. A former public school art teacher from New Orleans, she uses narrative, phenomenological, and arts-based inquiry methods to critically examine issues around identity and experience. Through this inquiry, she explores how art education can be an active process of resistance to oppression that is a pathway for joyful, creative, and collaborative agency.

Azlan Guttenberg Smith, MFA, is a writer, teacher, PhD candidate, sibling, friend, person at play. They're uncomfortable with bios and abstracts and often writing itself, even if they love it. How might we enact a kind of meeting in a few lines, what kind of meeting would it be, and is that the kind of meeting we want? Their research moves toward queer possibilities and collective liberation. Their art facilitation celebrates lives weaving together.

Catalina Hernández-Cabal is a Colombian American feminist artist, educator, and dance and improvisation practitioner. Catalina studies the intersection of movement, critical and feminist pedagogies, and contemporary art practices, to challenge oppressive ideas about difference and to provoke generative ways to encounter others. Catalina practices thinking-with by constantly working through partnerships, collaborations, and multiple forms of dialogue.

Artist **Jorge Lucero** currently serves as Full Professor of Art Education in the School of Art and Design and Associate Dean for Research in the College of Fine and Applied Arts, both at the University of Illinois Urbana-Champaign. Formerly a Chicago Public School teacher, Lucero's lifelong testing of school's materiality

happens as visible and invisible artworks, writing, and teaching. Recently he co-edited with Catalina Hernández-Cabal the book *What Happens at the Intersection of Conceptual Art & Teaching?* (published by the Amsterdam University of the Arts) and he's currently finishing the manuscript for a 40-interview compendium called *Alongside Teacher: Conversations About What, Where, and Who Artists Learn With*. In 2023, he was named the National Art Education Association's Higher Ed Educator of the Year. Lucero is an alum of the School of the Art Institute of Chicago and Penn State University.

CONTRIBUTORS

Tim Abel is a collage: practicing visual artist, educator, co-parent, spouse, part of and in the world. In navigating this practice of conceptual collage, their artmaking, teaching, and art-sharing spans into, around, and beyond art museum spaces, higher education spaces, and elementary school outreach spaces.

Jackie Marie Abing, MEd, is a PhD student in Anthropology at the University of Illinois Urbana-Champaign. She studies diasporic, abolitionist activism between the United States and El Salvador. She is interested in the rise of Anti-Human Rights discourse in the face of mass incarceration as a dominant form of state population control. In her growing artistic practice, she explores inter-sections between art and the city landscape in order to challenge/resist state forces.

Angela Inez Baldus (she/her) teaches and studies at the University of British Columbia in the Department of Curriculum and Pedagogy. Her current work looks at correspondence as a method and material that might be used in the study of art and teaching. All her work addresses conceptual ways of making and thinking with others and the ethical and relational properties of doing.

Jennifer Bergmark is Assistant Professor in Art Education at the School of Art and Design at the University of Illinois Urbana-Champaign. Her research is concerned with culturally relevant pedagogy, arts integration, arts advocacy, community arts, Native American art and culture, public engagement, exhibition as creative practice, and visiting artists in K-12 schools.

Shivani Bhalla is an artist, scholar, and educator working as Visiting Assistant Professor of Art and Visual Culture Education at the University of Arizona. She is also a PhD candidate in Art Education at the University of Illinois Urbana-Champaign. In her research, she explores the intersection of artmaking and disability in art education. Her dissertation is an arts-based and interpretive autoethnography that explores her disability experiences.

Ana Melissa Caballero is a Colombian dancer, educator, and independent arts manager currently based in Barcelona. Ana Melissa has developed her own movement vocabulary in contemporary dance through intensive study of different techniques. Her research interests focus on self-image, embodied experiences in dance, care within movement practice, and inclusive pedagogies and methodologies in dance. She considers movement study and the kinesthetic the root of her creative and academic research.

Paulina Camacho Valencia is an interdisciplinary artist, educator, and scholar. She is Endowed Assistant Professor of Art Education at the University of Arkansas. Camacho Valencia's work invites others to engage in relational practices in order to generate collective deconstructions and analyses of power and colonialism that promote the development of strategies to creatively reimagine possibilities for other ways of configuring the world. She sustains this work by spending time learning from her human and more-than-human relations.

Alicia De León-Heller is a multidisciplinary artist and educator, attempting every year to surrender the classroom to arrive at an autonomous space run by students. She currently teaches art at a middle school in Austin, Texas, and while she usually has a lot to say, she is currently in between feedings of her 1-month-old and needs to go now.

Ishita Dharap is an artist and educator. Her work interrogates personal and communal discomfort through rigorous and playful reflection, often manifesting in drawing, text, performance, curriculum, and installation. She currently works as Education Coordinator at the Krannert Art Museum at the University of Illinois Urbana-Champaign, where she is also pursuing a doctoral degree in Art Education through the School of Art and Design.

Natalia Espinel is a Colombian artist and educator working at the intersection of visual arts, critical pedagogy, somatic practices, movement improvisation, and performance. As a Fulbright scholar, she completed an MFA in Integrated Practices at Pratt Institute in New York while pursuing a year of study in Dance/Movement Therapy and is currently a PhD student in Art Education at

the University of Illinois Urbana-Champaign. Natalia's transdisciplinary and multimedia projects explore embodied, healing, and collaborative ways of being together through the arts. Her most recent large-scale multimedia production was presented at the Teatro Mayor Julio Mario Santo Domingo and received a research grant from the Tinker Foundation.

Richard Finlay Fletcher (he/him) teaches in the Department of Arts Administration, Education, and Policy at The Ohio State University. His work asks how public learning programs at temporary large-scale contemporary art exhibitions can be used to unsettle the colonial institution of the university. A former classicist, he created the blog, platform, and persona Minus Plato (2012–2022) to transition from inherited Western canons through a decolonial arts and education centered on the transforming work of global Indigenous artists. He tries to live in a first-draft world.

Lori Fuller is a dedicated artist educator with a diverse background in teaching. She has worked with learners from age three to elders in a variety of settings. She is passionate about teaching art to underserved populations and has designed programs for learners with disabilities, elders, and people with memory loss. Lori loves to incorporate innovative ways to engage learners with the arts for self-discovery. Her passion is working with learners in social settings, inspiring students to create collaborative artworks.

Rachel Yan Gu is a ceramic artist, educator, researcher, art installer, and curator inspired by eastern and western pedagogy, philosophy, and aesthetics. She earned a BFA and MFA in Ceramics and worked as a studio manager in a community art center in New York. Currently she is a PhD student in Art Education at the University of Illinois Urbana-Champaign and her research focuses on art criticism, studio art, and psychology. Her artworks have been exhibited all around the world.

Tiffany Octavia Harris is a storyteller, filmmaker, photographer, and shapeshifter from Atlanta, Georgia. Tiffany's interests include autoethnography, Black girlhood, culturally relevant pedagogy, Indigeneity, speculative fiction, the US South, and human survival as interdependent with ecological restoration. Her creative craft draws on ethnodrama performances, DIY photography curation, gardening and hiking as traditional ecological knowledge, experimental filmmaking, and poetry. Tiffany is currently Assistant Professor of Educational and Social Foundations at the College of Charleston.

Emily Jean Hood is an artist, teacher, and researcher currently serving as Assistant Professor and Coordinator of Art Education at the University of

Arkansas at Little Rock. Her work explores frictions between materiality and sociocultural perspectives on art and education. She is an award-winning art educator and co-editor of the book *Pedagogies in the Flesh: Case Studies on the Embodiment of Sociocultural Differences in Education* (Palgrave, 2018). Her scholarship has been published in *Studies in Art Education*, *Art Education*, and *International Journal of Education through Art*, among others.

Rita L. Irwin, a lover of all the arts and experiencing new cultures, can often be found in museums and galleries around the world learning about the nuances of what it means to be human. She also lives her art through her walks along the Fraser River and the Pacific Ocean near where she lives, in Steveston, a fishing village annexed by the City of Richmond, BC. Whenever possible, she also walks the enlivening trails of Pacific Spirit Park, a second growth forest on the edge of The University of British Columbia campus. Working with colleagues living nearby and elsewhere, she encourages story-telling about how walking is a powerful method of research for artistic research and particularly a/r/tography. Through photography, painting, poetry and prose, Rita Irwin thinks deeply about life questions, pedagogy, and art itself and seeks to live a life of compassion and passion. A Professor and Distinguished University Scholar of Art Education at The University of British Columbia, her greatest joy is witnessing her students embrace their own passions as they seek to instill compassion in their own lives.

Ava Maken Ali is pursuing a PhD in Art Education at the University of Illinois Urbana-Champaign. She holds an MFA in Visual Studies from Columbia College Chicago and a BA in Art and Architecture from Azad University, Central Tehran Branch. She completed a Contemporary Architecture Certificate from Polytechnic University of Milan. An interdisciplinary creative, Ava's art research focuses on intricate human-animal connections through creative writing. She crafts secret language, exploring relationships with metaphorical animals, especially a camel. Her journey as "The Evil Ava" finds solace, facing life's challenges guided by her camel persona.

Emmanuel Francisco Navarro Pizarro is a Puerto Rican artist based in San Juan, Puerto Rico. Working with oil paint, he creates *plein-air* depictions of the regional landscape of colonial towns and dense tropical wildlife. He is interested in kindling an interest in classical traditions within the local community and documenting the enduring architecture and customs of the 18–20th century in Puerto Rico.

Niki Nolin is an artist and educator at Columbia College Chicago. Her work blends painting and poetry with motion and assemblage. Working solo or

collaboratively with students, artists, and poets, her focus is to awaken the viewer to the spaces between words and images and the associations of thought-play and choice. Her works are exhibited at Art Chicago, Museum of Contemporary Art Chicago, Womanmade Gallery, Art Prize, Chicago Cultural Center, International Calligraphy Organization, eNarrative Roundtable Boston, CAA, Fideofest Tallin Estonia, SIGGRAPH, and others.

Nancy Nowacek is an interdisciplinary artist, educator, and researcher. Her artistic practice explores new social imaginaries through embodied experiences. In addition to the ideological demolition derby in development with co-author Allison Rowe, Nowacek is pursuing intergenerational participatory performance works in Minneapolis and New York.

Kaleb Ostraff is an assistant professor of Art Education at Brigham Young University in Provo, Utah, after completing his a PhD in Art Education at the University of Illinois Urbana-Champaign. Before pursuing his PhD, he enjoyed teaching middle school art classes in Utah public schools. Kaleb has an interest in the spaces where disciplines overlap and examining the affordances of these spaces for education and art making. His current research interests include museum studies, teacher posture, reinterpreting the idea of archives and collections, cultural heritage, critical pedagogies, and curriculum development.

Cesar Peña has a PhD in Art Education from the University of Illinois Urbana-Champaign, an MA in Art History, and a BA Industrial Design from Universidad Nacional de Colombia. He is currently Professor at School of Architecture and Design at Universidad de los Andes, Bogotá. His research hinges around the cityscape, the image, and the gaze as part of the negotiation of urban space. He is currently writing on the relationship between fine arts and arts and crafts schools in the 19th century and is co-curator of the project Reverberated Bauhaus, which has been exhibited in Bogotá, Medellín, and proximately in Quito (2024). In 2023, he took part of the advisory board for the exhibition *Modern Design in Latin America*, MoMa (2024).

Everardo Reyes is a PhD candidate in ethnomusicology at the University of California, Berkeley. His research focuses on the intersections between music, social movements, and Indigenous self-determination.

Shannalia Reyes is a parent artist who loves creating collaboratively with her family and community. Sometimes an educator, most times a learner, she enjoys pre-K to adult art educational experiences.

Gail Glende Rost is currently a doctoral candidate in art education with a focus in K-12 design education at the University of Illinois Urbana-Champaign. Her background includes degrees in both landscape architecture and graphic design. Gail's special interests include social issues related to educational access and the development of problem-solving skills and self-efficacy. She also is an avid artmaker in encaustics, mixed media, and sculpture. Wherever she travels, she visits art museums, zoos, arboreta, urban gathering places, and seashores.

Allison Rowe is an interdisciplinary artist, educator, and researcher. Her artistic work attempts to re-personalize political discourses, exploring the possibilities that exist in this transitional process. She is currently planning an ideological demolition derby with her co-author Nancy Nowacek.

samantha shoppell (she/her) is a student, educator, researcher, and tea drinker. She has nearly a decade of experience teaching in intercultural and bilingual K-12 contexts in the United States and Japan. Her work focuses on the pedagogy and embodied practice of Japanese traditional arts with an emphasis on tea ceremony. Currently, she is exploring the relational aspects of the interdependent host-guest dynamic in tea and how this hospitality can be practiced in education.

Blair Ebony Smith, also known as lovenloops, is a practicing multimodal artist-scholar and lover from southside Richmond, Virginia. Her art and scholarship explore themes of memory, loops, home, coalition, everlasting love, and sound/listening. She uses her lived experience as a lover and DJ/beatmaking practice to engage Black (girlhood) study. Blair is currently Assistant Professor of Art Education and Gender & Women's Studies at the University of Illinois Urbana-Champaign.

Albert Stabler is a white cis male, middle-class, severely nearsighted, neurodivergent writer and teacher with interests in art and activism. He has written primarily about contemporary art and art education, focusing on race, disability, and punishment, and his work has appeared in major art education journals, as well as in *Third Text, Critical Arts, Law and Humanities*, and *Helvete: A Journal of Black Metal Theory*. He has over 25 years of experience in teaching and arts-related community work.

Lindsey Stirek specializes in Japanese arts and aesthetics and teaches university courses on manga, anime, and Japanese tea ceremony. She began studying *chadō* (the Way of Tea) in 2009 and has spent several years in Japan honing her skill. Her research interests are localized and contemporary

implementation of traditional arts, application of indigenous teachings to art, and making art from foraged materials.

Jody Stokes-Casey is Assistant Professor of Art Education at the University of Kentucky. Her research is in the history and historiography of art education and incorporates oral history methodologies. She is interested in how the stories we tell influence our pedagogical practices and shape place-making, cultural narratives.

Juuso Tervo is Assistant Professor of Arts-Based Research and Pedagogy at Aalto University, Finland. His research and writing combine historical and theoretical inquiries in art and education, drawing from fields such as literary theory, poetics, philosophy of education, and philosophy of history. He currently serves as the editor-in-chief of *Research in Arts and Education* journal and co-runs the Nordic Master in Visual Studies and Art Education double-degree MA program in collaboration with Aalborg University, Denmark.

Jean Carlos Valentin Velilla is a Puerto Rican PhD student and art educator. With a background in developing K-12 visual arts programs, he's worked in both public and private education across north and south Puerto Rico. He employs autoethnographic techniques, using drawing as a storytelling medium to reflect on his identity as a queer person and art educator who engages in conversations about belonging, artistic expression, academic exploration, culture, and education.

PREFACING AN INVITATION; *INVITING* A PREFACE

It is such an honour to participate in this published artwork. Accepting the invitation to share a preface, I read the book and as I was reading, I felt like I was thinking alongside, and creating with, a close group of friends. Even though I know very few of the authors personally, I felt we were dreaming together of emergent, dynamic, and playful works of art as forms of living inquiry. Experiencing the experiments in this published artwork is an invitation to be playful, to imagine hope, and to embrace our communal commitment to learning and creating together. Reading this work is at once a visual delight and an invitation to visualizing. What was once a noun embraces becoming a verb and before long, readers are reading alongside, and artists are reimagining visuals as invitations to visualizing.

Throughout this work I felt the move from nouns to verbs permeate the work. The authors and artists of this work are engaged across time and space, with their own inquiries and often in collaborative inquiries with colleagues. Their work is on the move. Each piece is inviting those lucky enough to be reading and viewing this work to be engaged, to take up the work, and to be becoming part of this extensive network of artist scholars' educators committed to reimagining art and education. This published artwork is a generous invitation to be profoundly creative, and to live this creativity in every way possible, every day.

Prefacing an invitation

Receiving an invitation to write a preface for a work that involves Jorge Lucero as a central figure is at once exciting yet daunting. Am I up to the task? Jorge

is a larger-than-life figure in the field and his students and colleagues embrace his energy, his enthusiasm for difference, and his zest for life. What I learned through this work of art is that being alongside isn't daunting, it is exhilarating! In experiencing this work, it ceased being a singular work and instead became a stream of invitations to be alongside in a vibrant community. I found myself reimagining the preface from a noun to a verb, understanding it as prefacing. My contribution here is about mobilizing the invitation I received to become one in which each of you are immediately invited to become involved with this incredible community of artist-scholars rethinking art education. In other words: prefacing an invitation.

If you do take up the act of prefacing as I found myself pursuing, then I hope you too will take up the activity of inviting a preface as you actively invite others to be part of this vibrant community of practice. The act of inviting is a generous act. It is a hopeful act. It is a radical act. Inviting others to be actively engaged in resisting the predictable, and instead, to be actively trusting the process of learning alongside, is truly exhilarating—and as such, it is a radical form of learning and creating.

Embracing learning alongside, I am inviting you to participate in this prefacing by taking up one, two, or three propositions. These propositions are invitations to be in the creative spirit of the scholarship experimented with and embodied in these chapters. May they inspire an enthusiasm for searching out that which is still to be known. They are inspired by others who posit propositions for research-creation such as Erin Manning (2016), Manning and Brian Massumi (2014), Sarah Truman and Stephanie Springgay (2016), as well as my own community of practice as explored with Nicole Lee, Ken Morimoto, Marzieh Mosavarzadeh, and Rita L. Irwin (2019). Propositions do not have predetermined end points, nor predetermined processes of engagement. They are speculative and active, and gesture toward a rich potential of something to be experienced that was at first perhaps never even imagined, yet enacted in ways that emerge as engrossing, inspiring, and enactive.

Proposition #1: To read what is unwritten.
We often read what is written, yet there is more on the page, in between the
lines, outside of the lines, in the margins, in the white spaces left for us to
breathe. Experiment with writing in-between the lines, thinking alongside the lines, creating outside the lines, with the works in this book. You
are alongside the author-artists, and by experimenting with language and
image and other multimodal ways of being alongside, you can read what
is unwritten.

Proposition #2: To be speculatively experimental.
To engage in comfortable practices allows for comfortable engagement. To
engage in unfamiliar experimental practices opens us to something that

could be uncomfortable, yet speculatively more than, even greater than, we could have foreseen. This is an invitation to be speculatively experimental as you engage with the work in this book.

Proposition #3: To move with philosophy.

To walk and think is to move with philosophy, not just for a few steps but with anticipation of many more steps. Long walks, whatever this might mean to you, is inviting thinking in profoundly embodied ways, and yet it is more than this. Walk with this work and feel the event becoming itself.

Inviting a preface

As I draw this prefacing to a close, I invite you to take up the act of inviting a preface, with your colleagues and friends. Perhaps take up one, two, or three of these propositions as an active way to begin to speculate, to create, to think again, with the works in this book. You too can be actively inviting others to become involved in this work. Inviting will mean thinking, imagining, visualizing, and being alongside this remarkable group of artist-scholars, and ultimately, it may mean inviting your own group of colleagues to take up this important work as well. May we all be so lucky!

Rita L. Irwin
Distinguished University Scholar and Professor of Art Education
The University of British Columbia, Vancouver, Canada

References

Lee, N., Morimoto, K., Mosavarzadeh, M., & Irwin, R. L. (2019). Walking propositions: Coming to know a/r/tographically. *The International Journal of Art & Design Education, 38*(3), 681–690.

Manning, E. (2016). Ten propositions for research-creation. In N. Colin & S. Sachsenmaier (Eds.), *Collaboration in performance practice: Premises, workings and failures* (pp. 133–141). Palgrave Macmillan.

Manning, E., & Massumi, B. (2014). *Thought in the act: Passages in the ecology of experience.* Minnesota University Press.

Truman, S. E., & Springgay, S. (2016). Propositions for walking research. In P. Burnard, L. Mackinley, & K. Powell (Eds.), *International handbook for intercultural arts* (pp. 259–267). Routledge.

QUESTIONS THROUGH ART, TOGETHER

An Introduction

*Sarah Travis, Azlan Guttenberg Smith,
Catalina Hernández-Cabal, and
Jorge Lucero*

What is this book? It is not an instruction manual. It's a place to meet people interested in living questions through art[1]. It's an invitation to take your own practices for a walk, as you take yourself for a walk, your eyes and nose and hands, and see who you see, who you resonate with. It's a celebration of works in progress.

How did this book happen? Through an interweaving of moments, and practices, and people.

Fifteen minutes into our Fall 2021 graduate seminar, Curriculum Development in Art, someone asked about a rubric. How were assignments to be graded? Sarah paused and answered, "I don't have an answer. So often in the classroom we're taught to pretend that we understand everything, that we're separate from everything and in control. Coming back to our in-person class, I'm tired of pretending so much." As we discussed the possibilities of not pretending so much, I (Azlan) felt something unknot a little in my heart—a pulled-tight-ness loosening toward joy. Two years later I'm part of a community grounded in moments like that.

There was a moment in that class where the graduate students showed me (Sarah) that it was okay to do something a little risky. Natalia Espinel (who appears in this book) invited us to try a kind of inquiry that was grounded in sharing weight as a form of sharing connection and insight. The exercise had one person literally laying on top of another. As an instructor, I was worried about the physical contact, about someone finding it inappropriate (especially during the COVID-19 pandemic. But Natalia invited us in with confidence and caring. Azlan accepted the invitation. Their moment of shared weight opened our class to further inquiries that included more embodiment than

DOI: 10.4324/9781003430971-1

scholarship often does. Two people's willingness invited us—not just toward Natalia's exercise, but to all sorts of new forms.

The first time I (Catalina) stepped into a doctoral class in art education, I found Jorge with a pile of books spread across tables asking students to pick the titles we wanted to read in class. The last day of that semester we had a public symposium to share our final projects, and Jorge made quesadillas for everyone. "What is happening?" I asked myself. I thought I was not allowed to do and be like that in a PhD program. That was Jorge's first permission. After that experience and meeting amazing colleagues who always think-with-art, (like Angela Baldus, also in this volume), I learned that there is always another—more liberatory—angle to engage with scholarship. In my second semester in the program, in Sarah's class, she opened the space for us to respond to readings creatively. During our study of curriculum as a complicated conversation, I responded by inviting my peers to consider the complicated and educational experience of being in proximity, without the possibility of just "letting go" and recognizing that tension in your body and the need to communicate. In that space, I offered a paper cup telephone—which I called "The Entangler"—as the medium to hold our class discussion. Jorge and Sarah later encouraged and supported a public version of having complicated conversations through "The Entangler," as a performance, at a social gathering for a major academic conference. Again, I thought we were not allowed to do, and be, _that_, as scholars. But, as this volume clearly manifests, we are allowed!! The interweaving of practices and networks of support that have flourished through permission-giving in art scholarship has opened a door for me, and all of us, to think, learn and be, exactly as we need to.

Near the end of Catalina's PhD defense, I (Jorge) asked the committee if I could say a few words. I think I was trying to say thank you and maybe even how much I enjoyed traveling alongside her on this trek, but what I ended up saying—and crying about—was how impressed I was with the path she made for herself. A path that was now ready to be retread, responded to, and invoked by a wave of creative practitioners (many of them in this book, myself included) who just needed a few permissions to rethink what it might mean to enact a scholarly and creative practice in and around art and its education. It was like we had found—or maybe fabricated—a key that let us cross thresholds many told us we couldn't traverse. And now we were on the other side. And on this side, there was an entire world to be discovered.

In moments like these we find a kind of permission to experiment in a plurality of ways of being (which are grounded in ways of knowing; or perhaps it's the other way around). These permissions seed and grow into a plurality of sensorially rich experiences and relationships. By living questions through art, we mean engaging in an aliveness that is responsive and part of larger ecologies. We _live questions through art_—visual, auditory, performed, conceptual, pedagogical—as if we are seedlings pressing up through nutritive

soil. Living questions through art is one way to engage with what is and what isn't and what might be.

Scholarship and research in the academy have taken an arts-based turn. This is still relatively new, even though the arts-based-turn—perhaps—is already in its third generation. In the brief history of research conducted adjacent to (and through) the arts, there is a trend toward clusters of scholars and artists forming around various programs and institutions. For example, one major root is the teaching and mentorship of Elliot Eisner at Stanford University with renowned arts-based scholars like Richard Siegesmund, Liora Bresler, Charles Garoian, Kimberly Powell, and others branching out from those nascent ideas. Shortly after these scholars began to establish themselves, another major root grew strong at the University of British Columbia with the advent of a/r/t/ography. Rita Irwin's leadership supports a wide community of scholars, including Stephanie Springgay, Nadine Kalin, Daniel T. Barney, Kit Grauer, Juan Carlos Castro, and many others. Each root is perhaps more clearly a root system, as Stephanie Springgay is also part of the current emergence of *research-creation* scholarship, along with other scholar-artists like Erin Manning, Sarah Truman, and Natalie Loveless. These communities—these root systems—give life to the arts as a methodological mode for research and experience.

We're not suggesting that the histories or genealogies are simple or linear. They're not. We're also not implying that they're fixed and unalterable, or that we must express any fidelity toward them. But we do find communities of like-minded scholars coming together to grow around shared concepts. One of those growth sites for the art communities of this book is Jorge Lucero's concept of *permissions*.

Permissions are nothing more than an expansion of the imagination—in some ways modeled after the premise that drives the more conventional gesture of the literature or textual review conducted by formal scholars and other creative practitioners. Thinking about permissions is a way to think about what is possible, even if the ultimate aim isn't to do anything with those permissions. It's a posture, if you will, where the works, methods, and perspectives of other practitioners open up pathways for new or reconfigured attitudes, curiosities, experiences, experiments, and pedagogies. If someone creates a sculpture that is a walk, we now know that a sculpture that is a walk *is possible*. Permissions allow us (all the contributors to this book) to test the pliability of anything that manifests a materiality, and that's every thing: physical, conceptual, and maybe even cosmic. The authors of this book take permissions from artists, scholars, teachers, activists, game designers, friends, lovers, and just about anyone who dedicates themselves to testing the pliability of their reality in order to reimagine and speculate that teachers are conceptual artists, that giving attention to things is scholarship, that the inarticulable is just as much knowledge as the things that can be spoken or written, that daily gestures of breathing and walking and dancing and touching

and speaking and writing are all sophisticated forms of scholarly practice, meaning a way of living our questions.

As we saw how these questions were alive in our community, we imagined this book project to take a snapshot of some of the projects currently underway. We also realized that *our community* is an interlocking assemblage: on a small scale, a graduate seminar doesn't involve just the people in the room, as each of us brings insights from our friends, mentors, other colleagues, and so on. Expanding outward, each of us is a living part of multiple communities, and the groups who started imagining this book are as much a part of art relationships in Colombia and Finland (to pick two) as in the United States. To reflect how the experiments in this book arose from lived relationships, we created a structure that shows "connection stories" between authors. We also created a structure whereby contributors could invite a "companion piece" into the book. These structures are an incomplete gesture toward the layered vitality of overlapping practice that this book celebrates.

The book is organized into three sections, and ordered in ways that draw out connections between the different projects. The sections important similarities (and differences). At the same time, the order and sections could have been different. You don't need to read "cover to cover." There is no one path through this. Dip into what you're drawn to.

This book takes a particular, situated approach to exploring the entanglement of art, inquiries, lives, and communities. Instead of discussing what research through art "is," we ground into practice, sharing what a community of active scholars are currently *doing* inside art research. This is a tapestry of vibrant work happening here and now. In addition to the individual projects, we hope to highlight and celebrate the way that projects unfold inside networks of living relationships. We draw from each other, cat-sit for each other, scream together on certain dark nights, and give each other rides to the airport.

This book is not an instruction manual of how to do art research. We don't believe in Best Practices, when too many of such Practices are used to shore up a hierarchy of haves and have-nots—those who Know, and the rest of us who learn from them. We believe we all know (and don't know). We see questions lived through art all around us. By moving beyond concretized definitions, we intend this as a meeting place where active art researchers share themselves and practical examples of their work. Welcome.

Note

1 We acknowledge other uses of the concept of "living questions" including the invitation by Rainer Maria Rilke (2011) in *Letters to a Young Poet* to "living our questions" and the entreaty toward "living the questions themselves" in "Apophatic Inquiry: Living the Questions Themselves" by Merel Visse, Finn Thorbjørn Hansen, and Carlo J. W. Leget (2020).

References

Rilke, R. M. (2011). *Letters to a young poet* (M. Harman, Trans.). Harvard University Press. (Original work published 1929).

Visse, M., Hansen, F. T., & Leget, C. W. (2020). Apophatic inquiry: Living the questions themselves. *International Journal of Qualitative Methods, 19*, 1–11.

PART 1

Un/Disciplined

Experiments in Disciplinarity

PART 1

UnDisciplined

Experiments in Disciplinarity

1

AN INVITATION TO COMPOST

Writing Forms for What I Can't Write

Azlan Guttenberg Smith

Not an Abstract

What's one thing you want to paint, but couldn't put in oils or acrylics, on canvas or wood? This chapter takes up writer's block, not as a problem to be avoided, but as an invitation to turn aside and write/make in other ways. In an attempt to embody some of its suggestions, this chapter's form brings together academic article, auto-ethnographic narrative inquiry, art research invitations, and conversations with friends. It draws on recent scholarship in art education and queer methodologies in writing studies to ask, "What am I making? Why make it that way? What other ways might I stumble, fall, or dance into?"

I still wonder where to start. Perhaps with a story about when I failed to write a different article, and found myself making a card game...

"Do the Thing Another Way"

Chatting at Cafe & Co in Urbana, Illinois, I showed one of my recent projects to a new friend, Ishita Dharap. Ishita was excited with the cards I'd made—as excited as I'd hoped as I sat there unsure and delighted. The cards started as an attempted "academic article" (separate from what you're reading) on the various ways writing in academia *hurt*. The central idea of this never-written article was that some of the hurts of academic writing are tied in different complex ways to identity: mine as a genderqueer person (who feels pressured to pass and promote myself as "cis" while performing research), my friend's as a Black woman (who feels pressured to "be white" in her writing), a friend's as a person with a disability, a friend's as a first-generation scholar carrying generational trauma. This never-written article didn't start as academic research: it

DOI: 10.4324/9781003430971-3

started as crying and being held by my partner; as long talks with friends, all of whom were considering leaving their PhD programs. As I tried to put my feelings together into the clear sentences and compelling paragraphs of a linear article, I ran headlong into stomachache and writer's block.

A mentor, Jenny Davis, had reminded me it's possible to respect and embrace writer's block. She lives this, and also gave me a wonderful piece about writer's block as something to be attended to (Chew and Lokosh, 2021). Instead of trying to drive forward, I tried to listen to why I was struggling to write. I heard lots of things. I'll share two. One, I didn't believe in linearity as a thought-form appropriate to what I was describing: These experiences were many things, all at once, and taking them apart made them collapse, like pulling a bit of algae from the water—in the water, it's voluminous, itself. In my hand above the water, it's a bedraggled scrap, flat, torn (Glasby, 2019; Smith, 2021). Two, I wasn't willing to write "about" my friends, but I couldn't explore my experience without grounding into interactions I have with people I love. So much of what I think—of what I am—exists in loving, embodied relationships. Instead of a researcher looking at my subjects, or even an autoethnographer learning beside them, I want to be a friend living with friends. If I was going to write about these hurts, I wanted to write more *with* them.

So I had something I wanted to paint, something that emphasized relationships, but the paints were getting in the way. I had heard friends talk about the ways they tried, compromised, or refused to ventriloquize/sanitize their voices and experiences into an academically "acceptable" voice and experience. What could I make?

Without quite meaning to, I turned toward games. I like board games. Or at least, I really like people, and games are a good way to hangout while friendships grow. Maybe it's easier to become friends while playing because games create little alternate worlds where rolling *this* dice means doing *that*, and within the arbitrary imagined (artful) world of those actions and goals, it's easier to try on surprising behaviors (Nguyen, 2020). It's easier to recompose answers to the question, "What are we to each other?"

One card I made with Jackie Abing, my friend and collaborator, went like this:

"The Fuck Is She"

My friend Jackie Abing, queer Salvadoran-Filipino American playful magic, tells me, "I try to separate myself from my writing [in anthropology]. I cannot be the same person or I would be miserable all the time. The person I am when I write, the person writing all these things, she's different and who the fuck is she. She's not me." Later we talk: Sometimes we attend to the hurt, we realize we are fighting real institutions. Sometimes we try to shove it down to *get the shit done.*

Sitting in my bed, the fragments of my intended article scattered like algae scraps in the Google doc in front of me, I opened a new window and started to make cards. Each card was an interaction I'd had with a friend: quotes about the hurt of writing in academia, lessons for how to survive, possibilities these systems told us weren't there. Some of the "friends" were scholars, the ones I'm supposed to cite in articles. When I showed these cards to Ishita Dharap in Cafe & Co, she said:

"I love these. The way you work feels so familiar to me." She paused, and added: "I think, when the thing isn't working, you have to do the thing another way."

For me, that invitation—to do the thing another way, which changes the thing we're doing, which calls into flexibility what *working* and *way* might mean— found nutritive soil in overlapping practices and communities of art research. Nutritive soil is itself an invitation to grow: to ground into how and why this writing hurts (as I try to "pass" as the kind of scholar I'm "supposed" to be; authoritative, cis, polished, hirable), and into the communities and lived experiences that give me life inside those hurts. These invitations suggest ways forward.

Following Jack Halberstam, failure becomes the chance to be something beyond the narrow confines created by how I've been taught to police myself. When my paints get in the way, what other materials might I create with? When I don't want to be *this*, what else are we? Where do our writers' blocks guide us?

Composting Methodologies

Part of me wants to be a clever clock. Clean gears and bright brass, each piece exactly where it should be, each tick careful and measured and complete. The bright/clear window of my prose would let you see the workings. (This dream is tied to productivity, capitalism, masculinist competition). But my friend Dusty Bacon and I have been composting together. We add scraps. Onion skins. Eggshells. The touches and trimmings of every day, of lives that wave through our own. In my life/research, in my reading, I'm starting to fall in love with myself as a compost heap. As a place where what is and what was decays slowly: nutrients for what will be.

Read one way, a lot of this section is me composting myself and the scholars I draw from.

I want my life/research to return to my body. It's funny to say "return," as body and I are literally inseparable. Still, Robert McRuer suggests we can "reconceive" something "paradoxically, as what it is" (McRuer, 2006). We might have to, if we've been taught conceptualizations that flow from systems of oppression.

The daily life of sweeping, cooking, walking, watching trees; of toilets, buses, phone games, libraries, post offices, pulled muscles, grocery stores; of friends and family and chattering birds, of ants and a friendly cat and bees and a neighbor's muffled music—all this is often strangely, surprisingly, enforcedly, horribly absent from what I'm doing as a PhD candidate, a teacher, an artist. Also "absent" is my body: genderqueer, uncomfortable as I sit here typing, happy when I stand up and type with my computer on the kitchen counter. In this way, my engagement with art research (and the communities in this book) follows Alberto Aguilar's suggestion, "Consider household chores as art compositions or performance" (quoted in Lucero, 2013). Bring it all back in. What if everything listed, everything I am—everything I always am, even though I'm often told (verbally or by the "quiet" workings of systemic power) to cover up, to "pass," to be respectable, to accept *this is how it is*—is involved in my art and my research?

Michael Faris theorizes the reality of a body as disproving the abstract "identity" that a certain kind of worldview assumes: rational, intentional, coherent, decisive, anointed by agency as it rises above the flesh toward a kind of godly (white, male) me-ness (Faris, 2019). ("At 21," John Updike quips, "I was elected Zeus"). bell hooks shows us education's dualism: intellect deified, body abhorrent. With these scholars as inspiration, I read Aguilar as offering one practical way to make art against (or beyond?) the restrictive systems that exclude my body from the classroom. That insist my "self" should be rational, internally consistent, and up for a raise next year. By returning to what Jorge Lucero calls the artful "materiality" of everyday dishes, sheets, street corners, and relationships, I can make art with the pigment of what (historically) is excluded from my art history textbook and my PhD. Make with everything here. Perhaps all of my recent work (including the invitations at the end of this chapter) are meant to open moments for us to do that.

If Faris, hooks, and Aguilar help me think about "my own" identity and the classroom, Nicholas Ng-A-Fook's reading of education and family (following William Pinar) helps me think about cultural narratives of connection inside the classroom (Ng-A-Fook, 2012). Ng-A-Fook sees an education system interested in emphasizing separation, individuality, shame, blame, competition, and related narratives. This abandons (or refuses to read) the real interdependence I experience when I cry, and my friend holds me; when I don't see the point and a loved one's memory comes back to me; when I feel lost and a mentor sees me. When I (not an art education grad) snuck across campus into art education seminars, I became part of a community actively engaged in being-together as a cultural narrative and a way of making art (and possibility, and lives). I think that nutritive soil led to the cards I wrote several years later. In the face of the linear competition of education, degree seeking, and academic writing, cards are social, shared, unordered. They're shuffled, dealt, recollected, passed from hand to hand. Games end and begin again. They're invitations to friends. "Same time next week?" Working

through the medium of playing cards invites a kind of education/research that is always provisional, not linear, and thumbs its nose at anointed Competition Between Individuals. Do you want to play?

My art research practice draws on my writing practice. I was overjoyed when I started reading Hillery Glasby's article, and found her giving words to what I and many of my friends had felt:

> As a queer rhetor, I often feel as though my identity is limited on the academic page [...] Similarly, my thinking is somewhat restricted when I am asked to take a firm stance; I prefer to take my time, write through thorny issues and play around in the messy stuff.
>
> *(Glasby, 2019)*

Stacey Waite (2019) opens more space for this kind of writing (and art/research) with a series of contradictory, playful, brilliant rules for writing queer, including:

> Undermine your own authority, be certain in your uncertainty, develop a voice that can be trusted even as it is subjective, unreliable...

and

> In fact, you might consider *not* making arguments and thinking of a writing context that is less like a courtroom (evidence, argument, opening statements, etc.) and more like a carnival, or a nightclub, or a swinger's convention.

I hear these voices intertwined with my friend Ishita's. What other ways could we take up when we mean to make community, make connection, make research, make questions that live through art and art that helps us live?

I'm supported by John Duffy's reminder that to write (make art/research) is to propose a relationship between two people: an Authority and a Reader, a Celebrity and a Fan, an Applicant and a Hiring Manager, and so on (Duffy, 2015). I'm supported by Paré's insistence that writing contains ideologies (in my experience of education: competition, and a self-worth that's supposed to be proven through a meritocracy that doesn't exist), and the subject positions—the kinds of being—that are (im)possible within those ideologies (Paré, 2002). I'm undercut and pained by the systems Duffy and Paré diagnose, but the awareness invites me to behave otherwise, and to engage with communities interested in building cultural power inside other forms. In 1983, Le Guin asks, "What if I talk like a woman right here in public?" Echoing Le Guin, Glasby, Waite, and so many of my friends, we can create moments that ask, "What if we interact as our embodied selves, our gendered (misgendered, and refusing gender) selves, our erotic selves, our racialized (racially othered,

and confronting racializing systems) selves, our moving selves, our sensorily entangled selves—right here in our classroom? Right here in our reading? Right here in our writing?"

These aren't new questions. Resisting or living crosswise to systems of power is as old as systems of power. Wherever I look, I see that forms of resistance are many, "exuberant," "mercurial," and building on what generations have done (Russell, 2021). Supported within art ed communities, I am finding many different ways to live into places "of uncertainty that [are] orientated by un/articulated questions" (Castro, 2007). I am learning to "dress it up, try it on, take it off," as Waite writes—where "it" might be language, but it might also be research, methodology, conceptual frame, or the expectation of being a well-maintained 'productive' brass clock. In arts-based research, I am finding ways to understand, acknowledge, refuse, reweave, and rewrite-as-beautiful-shared-silence (Rule, 2019) the narratives of competition, research, writing and art that were written into me. Art research (and community) is nutritive ground for "us"—my lived communities—to do that finding. Composting—the methodology of caring for myself, my friends, and my research as a messy, organic process, warm in its decay—invites us to help care for nutritive ground. And of course there are countless other ways. What a delight to be asking, with my friends, with my communities, with you (if you'd like), "What will we make?"

Invitations

In a research seminar with Sarah Travis and graduate friends (many of whom are in this book), I started writing invitations. Each invitation tried to make space for a way of doing, responding, sharing, celebrating, getting unstuck. These shared experiences grounded into a kind of lived reality that I do not (usually) find in words.[1] When I wanted to ground into a rich messiness—a compost pile of being—that would not exist as linear intellectual argument, an invitation and how we took up/refused it as a group held some of the "muchness" I couldn't say.

I don't share these as lesson plans someone should use. They can't be recreated. As artistic gestures—a kind of group performance art—what we did lived inside our moment, responding to our contexts and hopes. There's a deep note of sadness as I sit with never again having this community together in a room—and an even fuller joy, as I live this community in memory and ongoing relationships. In a sense, I share these as records of my experiments to do a thing another way, to create scholarly, human, interwoven inquiry-space filled with body. Space that does not manufacture the linear, that embraces failure, that paints with other paints. In another sense, I share them as descriptions of an art exhibit that you can't visit. The exhibit doesn't exist anymore. But that's okay, you and I and my friends are engaged in more kinds of making. This piece might be an invitation to compost what we have done

to make nutritive soil for what we do next. And unlike directions, invitations are something to be accepted, refused, modified.

Invitation: Whispering Into

What's one thing you need to say in this moment? Think about it, but don't write it down. When you have it, whisper the words into your hands. Carry them outside and do something that feels right with the words you're holding— throw them into the sky, or tuck them like seeds into the ground, or eat them, or anything else. Don't plan what you're going to do: go outside and notice it. Then come back inside to the group.

Those words are still here. What if instead of speaking them, we let them live where they are?

We did this soon after COVID restrictions allowed us to meet in person again. There is so much that I don't acknowledge, so many things that parts of me and my world shout that I pretend not to hear. There was something ceremonial in dipping our masks down to whisper into our hands, and then pulling our masks back up. In the walkways where my friends planted, released, and wove together the words they carried, I feel a presence, a silence that is to be cared for. A silence isn't a rock to put on my windowsill, it's harder to point to, but I might lose a rock. The cared-for silence spreads all through the walkways' dust and the grass around them.

Invitation: Playing With Weight

Begin standing, or sitting. Invitations are meant as a kind of *would you like to join me*, and the "you" and the "like to" are important. Please modify them to fit your own experience, your body, your comfort.

Let your head sway gently to the right, leading your shoulders. Perhaps your hip (or your arm) moves left to balance the weight. Perhaps it doesn't, and you step to find a new center. Keep swaying, maybe on one foot as you play with weight and balance.

My muscles spend so much of the day "holding" me "upright." Can this "holding," this "upright," become games we play together?

Writing this, I've just paused and done this invitation. Alone in my apartment. I would've rather done it with friends. That way it's often a bit embarrassing, and then funny, and then something we share. Alone it still helped me—loosen?

I often tell myself to sit and work even when that position is physically uncomfortable. Having swayed, playful and silly, I'm now typing at my standing desk. My body feels more involved in typing. Where is my body in my research?

Invitation: Boundary and Balance

I feel like I need to rebalance. Do you feel that way, too? Let's pause, acknowledge that, and then I invite you all to spend 15 minutes doing whatever might be grounding for you. Walk. Draw. Sit in a corner. Then we'll come back together.

In a trusted group, we can build on this invitation to repeat something similar. This time instead of each person doing their own separate practice, I invite you to move into small groups of about three. The group invites one person to do something that helps them ground. Without instructions, their companions follow along, respectfully mimicking their actions.

I've said (and heard people say) "I don't know what I need." What do we learn by sharing, supporting, mirroring, and embodying one anothers' habits of care? What do we share by living these balancing practices together?

This invitation arose on the fly, as we transitioned to my workshop from a powerful and tense workshop on the imagery of political hate. My workshop was supposed to involve emotional vulnerability. Honestly, when it came time to start, I just couldn't go there. So I wondered, What do I need? And I wondered, What do we need?

Someone carefully cleaned their phone. Someone went for a walk. Someone crawled under a table. As we shared space, we separately but communally lived small responses to the overwhelm of where we were.

Not a Conclusion

The invitations themselves are not what I mean to share. The invitations hope for moments of shared being—discussing, gift giving, art making, thought weaving, belly laughing, game playing, composting, embodied researching, alive, together. When I say, "Would you like to go for a walk?" the invitation is not those eight words. The invitation is a hope toward the trees we might walk beneath, the connected ground that might support each step, the conversation or silence we might mutually weave, the bits of each other's breath and tree's breath that might get into (is already inside) our lungs.

Would you like to go for a walk?

Note

1 Or any kind of symbolism smaller than life itself. As René Magritte says, "This is not a pipe." And this is not even the paint in Magritte's letters.

Bibliography

I mentioned these people.
(so here they are, in case you'd like to read them)
(though there are so many more people I could have mentioned)

(and even more I should have mentioned because of their wonderful, troubling, related work, but I haven't read them. Not yet, I hope, for some of them. But there are always more: out beyond where I've been, and submerged inside where I am)

Bakhtin, M. 1986. The problem of speech genres. In C. Emerson & M. Holquist (Eds.), *Speech genres and other late essays* (Trans. V. W. McGee) (pp. 60–102). University of Texas Press.

Castro, J. C. 2007. *Constraints that enable: Creating spaces for artistic inquiry.* Proceedings of the 2007 Complexity Science and Educational Research Conference, Vancouver, British Columbia (pp. 75–86).

Chew, K. A. B., & Lokosh (Hinson, J. D.). 2021. Chikashshaat Asilhlhat Holissochi (Chickasaws are asking and writing): Enacting indigenous protocols in academic research and writing. *Native American and Indigenous Studies, 8*(2), 1–28.

Duffy, John. 2015. Writing involves making ethical choices. In L. Adler-Kassner & E. Wardle (Eds.), *Naming what we know: Threshold concepts of writing studies* (p. 31). Utah State University Press.

Faris, M. 2019. Queering networked writing: A sensory autoethnography of desire and sensation on Grindr. Re/orienting writing studies. In Takayoshi, C. Dadas, M. B. Cox, W. P. Banks (Eds.), *Re/orienting writing studies: Queer methods, queer projects* (pp. 127–149). Utah State University Press.

Glasby, H. 2019. Making it queer (not clear): Embracing ambivalence and failure as queer methodologies. In Takayoshi, C. Dadas, M. B. Cox, W. P. Banks (Eds.), *Re/orienting writing studies: Queer methods, queer projects* (pp. 24–41). Utah State University Press.

Halberstam, J. 2011. *The queer art of failure.* Duke University Press.

hooks, b. 1994. *Teaching to transgress: Education as the practice of freedom.* Routledge.

Le Guin, U. 1983, May. *A left-handed commencement address.* Mills College. https://www.ursulakleguin.com/lefthand-mills-college

Lucero, J. 2013. Instructional resources as permission. *Art Education, 66*(1), 24–32.

McRuer, Robert. 2006. *Crip theory: Cultural signs of queerness and disability.* New York University Press.

Ng-A-Fook, N. 2012. Navigating m/other-son plots as a migrant act: Autobiography, currere, and gender. In S. Springgay and D. Freedman (Eds.), *Mothering a bodied curriculum: Emplacement, desire, affect* (pp. 160–185). University of Toronto Press.

Nguyen, C. T. 2020. *Games: Agency as art.* Oxford University Press.

Paré, A. 2002. Genre and identity: Individuals, institutions, and ideology. In R. Coe, L. Lingard, & T. Teslenko (Eds.), *The rhetoric and ideology of genre: Strategies for stability and change* (pp. 57–71). Hampton Press.

Rule, H. 2019. *Situating writing processes: Physicality, improvisation, and the teaching of writing.* University of Colorado Press.

Russell, L. R. 2021. *Women and dictionary making: Gender, genre, and English language lexicography.* Cambridge University Press.

Sipeli, P. 2019. The sleeping ancestors. *Afterall: A Journal of Art Context and Enquiry, 48,* 20–25.

Smith, L. T. 2021. *Decolonizing methodologies: Research and indigenous peoples* (3rd ed.). Zed Books.

Updike, J. 1955, February 26. Youth's progress. *The New Yorker,* 28.

Waite, S. 2019. How (and why) to write queer: A failing, impossible, contradictory instruction manual for scholars of writing studies. In Takayoshi, C. Dadas, M. B. Cox, W. P. Banks (Eds.), *Re/orienting writing studies: Queer methods, queer projects* (pp. 42–53). Utah State University Press.

2

WITNESSING THROUGH OUR *VOICES**

Jackie Marie Abing

In 2022 and 2023, I collaborated with Azlan Smith on community theater performance projects for their *Voices* series. "Voices of Memory" focused on how memory became a place where we met during the pandemic. "Voices on the Land" focused on different views of Illinois's farming practices and how they tie into wider food systems. Both projects were collaborations with specific communities, in which collaborators entrusted their stories to this effort of artistic expression. Project leader Azlan Smith crafted a script of those stories and actors performed an interwoven glimpse of those stories back to our collaborators and their communities. Through these *Voices* projects, I began thinking about coming together to share stories, to literally say each other's words, as a kind of witnessing—a witnessing that is related to and distinct from the witnessing that is important to my work as a student in anthropology. This shared space has become a kind of community witnessing I want to explore more, which leads to this reflection.

As a PhD student in anthropology, I think a lot about witnessing. What does it mean to witness each other? What happens when we bear witness and share in each other's lives? I don't consider myself someone with a background in art, having internalized messages that the arts were for someone else (not for me), and that they were certainly not something I could draw on in my anthropology scholarship.

When Azlan Smith invited me to participate in a small theater production, my gut reaction was to politely decline. My partner encouraged me to at least consider, and I met with Azlan and the other performers to read the script.

* A Companion Piece to "An Invitation to Compost: Writing Forms for What I Can't Write" by Azlan Guttenberg Smith.

DOI: 10.4324/9781003430971-4

I loved what I read. I loved the idea that art could be a tool for creating space for the sharing of stories, ideas, and knowledge. It seemed like the perfect combination of intimacy and scholarship.

As I joined the group, I was originally focused on how actors thought about authenticity and sincerity. For example, how did these performers know when they (or another) delivered an "authentic" performance? As we worked together in rehearsals, which would end with performing these stories back to many of the authors who entrusted them to us, I found myself moving other questions to the center. For example, how can we tell and share our stories? In the context of these stories, shared to be performed anonymously, how can we honor the original history of the author, and find ways to create connections through our own lived experiences?

On the day of the live performance, I remember looking out at the audience and seeing so many people express so many different emotions. Some cried. Others laughed. I felt humbled to be in a space where strangers were connecting to me, and I with them, through this retelling. In anthropology, we have a concept of *bearing witness*. We bear witness to people's experiences, to their lives, and that comes with a responsibility. In the moment of performance, I recognize theater as another form of bearing witness. This co-witnessing felt different from the witnessing I read about in my coursework. Attending a *Voices* performance is accepting an invitation to become part of a shared, momentary community. Performing in *Voices* is accepting an invitation to embody the experiences of another, and in doing so, creating a material space of empathy. Together we make witnessing an active interaction.

Now I'm thinking about art/anthropology methodologies, interwoven, as a way of coming together. How can artistic co-witnessing build spaces of empathy? How can anthropology and performance art weave their roots together? I want to keep exploring how performing each other's stories can be a kind of witnessing that comes to life in the moment of uttering each other's words.

3

EXPLORING A PEDAGOGY OF LONGING

Ishita Dharap

> *Azlan and Ishita met through a common, playful love of words, and embarked on a friendship of cooking together and board games and supporting each other's work. Azlan treasures a metal bracelet they received while meeting Ishita's family and becoming part of a wider, international family one evening in Champaign beneath a brick wall covered in ivy.*

Viraha

There is a word for the separation from a loved one in Sanskrit. *Viraha* is a painful distance from a lover or a friend and is often embodied in the act of waiting. It has been a theme in folk and classical music in South Asia for centuries. Some of the earliest descriptions of *Viraha* are about husbands leaving for the battlefield to serve kings, later for their livelihoods, or new brides migrating to their husbands' homes after getting married (Stirr, 2017). Even when used within spiritual or religious contexts, *Viraha* captures the restlessness of waiting, the pain of leaving, and the anticipation of return. The Long-Distance-Love virtual museum tour, offered as an immigration-themed program, was an attempt at briefly suspending this state of *viraha* between loved ones; someone living in Chicago, USA could attend this virtual tour with their loved one who lives in Mumbai, India. Sharing time in a digital space creates a fleeting moment of togetherness—ephemeral, yet real.

The Long-Distance-Love tour consisted of seven virtual museum tours facilitated by myself, a museum educator, at the Krannert Art Museum, and this is how they went: participants would gather on Zoom with their lover, friend, or family from another city or country, I'd introduced an artwork by sharing my screen, we'd look at it together for a while and I'd invite them to

DOI: 10.4324/9781003430971-5

share what they saw. We'd stay in the Zoom room altogether for an hour, soaking in the meanings, mysteries, and our own interpretations of the artworks with each other, all the while connecting it back to the theme of loving while far away. The structure and artworks stayed the same through the seven tours, and the conversations the artworks initiated were the real moments of learning and practicing care; participants shared stories of love, immigrating to the United States, and feeling overwhelmed in a country that makes it so difficult (for some of us) to enter, to stay, to build a life. In the hustle to stay afloat or make it big, we might forget to acknowledge the love that cracks under the weight of this distance.

Thematic museum tours, offered by museums across the world, hone in on a topic that informs the selection of objects and guides conversation. One example is tours based around themes of death or grief, facilitated for medical students and professionals. Through thematic tours—much like curatorial texts and artwork groupings—museums are able to tell new stories with their artwork, old and new. To me, thematic tours are a useful way to confront daily discomforts; as viewers, not only can we take our time to mull over intricate or complicated topics, but also return to the museum weeks, months, even years later to peel away a new layer of meaning. We can use art and artists' lived experiences as a way to move into difficult or uncomfortable conversations.

For my tours, I used three artworks from the collection and recent exhibitions—*Migrations II* (2006), *Blossom* (2004), and introductory text to *Latina Community 'Voces'* (2021) to talk about topics of longing, love, home, and migration, while centering work in the museum that comes from artists who regularly tackle these issues in their work, or address these specific experiences in the certain pieces. My continued experience with having a partner and immediate family in a far corner of the world allowed me to open this conversation with others who might be going through the same thing.

I am awake thing.			and		I feel a
You are asleep– you feel it too.					
But	I	don't	know	that.	

Loving from far away is a tiring thing; even with all the forms of contact we are able to use—audio and video calls, email, text, audio messages, watching things together, playing games—connection is difficult. There's the perpetual and frustrating issue of time. Spontaneity is hard to manage when we're also calculating where we'll be and what we'll be doing when we try to connect. This is just one more kind of loss we incur as long-distance loves. *And how do we mend these holes in time?* To lighten this strain a little, the virtual tours were offered at times that corresponded to 7 pm in the selected time zone. Visitors joining that day's tour would be joining at 7 pm "their time," while I,

the tour guide, would sometimes give the tour at 6 am, sometimes at 9 pm in Central Time—"my time." The timings of each tour were communicated to visitors through a world map with time zones that highlighted when each of the tours would take place. The time zones were chosen keeping in mind the immigrant population in the Champaign-Urbana region, home countries of the international student population at the University, and time zones that included the largest number of countries.

I imagined the art museum as being the one who looks at their watch and has to think if their lover(s) would be awake, before calling them. Could a whole museum (and its programs) be a long-distance lover?

Which Love?

bell hooks writes insistently about love as a collection of actions. She attributes our cultural 'lovelessness' to not knowing or agreeing upon—collectively— what the word means (hooks, 2000, p. 3). This tour focused on long-distance love—and worked at letting participants define long-distance love based on their experiences and asking questions about the roots of this love.

Perhaps		
we	**moved**	**closer**
to agreeing on what love is, perhaps		
	we	**didn't.**

Together, through these tours, we built our vocabulary of long-distance love— including loving someone who is no more, loving a place, or loving an old relationship that has changed with time.

Sharing Stories as Strategies of Coping

This reflexive project sought to make space for sharing experiences of sadness, longing, and love while living far away, while dismantling a singular experience of immigration. In feminist research, "reflexivity is primarily about challenging the notion of objective, neutral and value-free research, focusing instead on accounting for subjectivity" (Burns & Chantler, 2011). The tour made space for individual voices, stories, and even strategies of long-distance love to emerge from the participants, thus rendering each tour a unique gathering of longing.

Participants accompanied me on a journey of looking at artworks together, building interpretations, and reflecting on two key questions: *Does long-distance love rely on memory?* And *Does long-distance love rely on language?* These questions built towards an invitation to share strategies to answer the last question—*How do we love and care for each other from far away?*

Artworks

Does Long-Distance-Love rely on memory?

The heart wants what it wants, and the last thing it wants is memories, because it definitely wants the thing itself. Where is the thing it wants? It resides in another person, another time, another place or momentous, emotional shared dimension. Memories are like time travel—actually no, photographs are like time travel. Al-An deSouza's (2004), a photograph and delicately eked out image, plays heartbreakingly with reality and illusion, tricking the heart over and over again and bringing things close that are—or seem—far away. There is a brokenness the question tries to get at, particularly with this image being made after the artist lost his mother. This wasn't stated explicitly in the tour, and at certain other times it was; both times, the conversation ventured into the death of loved ones, a different kind of long distance. The feeling is amplified when the memories you have access to cannot be re-wrought; the elements of this missing are forever sealed in time and space.

Does Long-Distance-Love rely on language?

We looked at *Migrations II* (2006) by Wosene Kosrof; its movement draws us in to delve into its barely-catchable morsels—at first glance, strewn—across the page. Recognizing a familiar letter, *your home-tongue*, in a sea of floating letters—it happens in a trice. I led the conversation towards the theme Wosene brings up repeatedly in his work: ideas of home, movement, belonging. What does it mean to be comfortably approached by a language that belongs to you—and you belong to? How do we navigate the discomfort and unfamiliarity of being in a new place, but also in a new language? Patel and Youssef (2022) center this experience in their writing of translation: "Migrating across linguistic and cultural borders means the translated text faces the same challenges as the migrant person in a new land: lack of belonging, pressure to assimilate, threats of erasure." In acknowledgement of this moment in an immigrant's life (and language), the second artwork—rather, a piece of text that I see as an artwork—opens to joy. The text is from an exhibition titled *Latina Community 'Voces'* (2021), put together by three educators with a group of girls from a local middle school. The artists in the show—the middle school girls—write in Spanglish, addressing readers of Spanish and English, communicating their position, and inviting us into their *cultura*. The text flows seamlessly between Spanish and English, making room for questions and discomfort, but always holding the reader of any one language until the very end.

These two pieces, Wosene's painting and the Latina girls' introduction text, work to unravel the spaces between the languages we understand and the unfamiliar places we now belong to, far away from home and love.

How Do I Stay in Touch With Lake Michigan? And What We Didn't Discuss: The Love of Places

When we were leaving Chicago, my partner asked, "How do I stay in touch with Lake Michigan?" We were at home, packing, but I like to pretend we were at the edge of the lake at 31st St beach on a weekend morning, half a donut in his hand, a coffee in mine, our free hands holding each other's. How, indeed, do I fit a lake inside my consciousness, remember to remember it, to hold it and memorize it so that I can fully, deeply miss it? I wrote a letter to Lake Michigan before we left. This mushy, childish text did nothing for the lake, but it did so much for me; it made me think about all the ineffable things love is and put them messily into words—maybe like the Spanglish musings of a group of Latina girls, addressed to us, or maybe like the broken, skipping Amharic letters in *Migrations II*. Sometimes we need to say to each other how much we can't say we will miss something, to miss it properly.

Toward a Pedagogy of Longing

This pedagogy of longing is rooted in waiting; waiting to know, waiting to see, waiting to touch—smell—sense—that long distance love. This melancholy experience naturally invites introspection. We can push it a bit further to build caring futures through shared ideas of love and longing, setting the stage for critical—and at times, messy—conversations across civic, political, and emotional landscapes. It suggests a departure from grieving by ourselves and moves us towards each other—to hold, to seek, and to love.

We return at long last –	or	for the	very	first time to	each	other.

References

Burns, D., & Chantler, K. (2011). Feminist methodologies. In B. Somekh & C. Lewin (Eds.), *Theory and methods in social research* (pp. 70–77). Sage Publications.
deSouza, A.-A. (2004). *Blossom*. Krannert Art Museum, Urbana-Champaign, IL: University of Illinois. https://collection.kam.illinois.edu/objects-1/info?query=Portfolios%20%3D%20%22679%22%20and%20Disp_Maker_1%20%3D%20%22Al-An%20deSouza%22&sort=0
hooks, b. (2000). *All about love: New visions*. William Morrow.
Latina Community 'Voces' [Exhibition]. (2021). *Krannert art museum*. Urbana-Champaign: University of Illinois. https://kam.illinois.edu/exhibition/latina-community-voces
Kosrof, W. (2006). *Migrations II* [Painting]. Krannert Art Museum, Urbana-Champaign, IL: University of Illinois. https://collection.kam.illinois.edu/objects-1/info/9663?sort=0

Patel, G., & Youssef, N. (2022). All the violence it may carry on its back: A conversation about literary translation. In K. Bhanot & J. Tiang (Eds.), *Violent phenomena: 21 essays on translation*. Tilted Axis Press.

Stirr, A. (2017). Ruralising the City: Migration and Viraha in Translocal Nepal. *Journal of the Royal Asiatic Society, 27*(4), 667–680.

4

HOW IS LEARNING A COLLAGE, OR WHY AM I SEARCHING FOR A MORE SPECIFIC WAY OF TALKING ABOUT COLLABORATION?

Tim Abel

Ishita and Tim came across each other's work before they ever met. Now they're friends, and instead of asking each other "How are you?" they take turns making up a scale of feeling. So, on a scale of flaming hot cheeto <—> glacier, how are you today?

Finding Spaces

Hello. Here is an incomplete inventory of temporary interventions into space: 18 snapshots arranged in a four × five grid, each imagine containing at least one brightly colored traffic cone marking space, and all taken during daytime: cones can be seen individually, covered in stickers, upright, fallen down, in clusters, in rows (Figure 4.1). All but one of the images show the cones outside. In this inventory, most of the images have been formatted to be square-sized, but there are two images that are rectangular, taking up two spaces within the grid: one is vertical, showing a small fair-skinned child, wearing a red gingham short-sleeved shirt, jean shorts and alien-patterned Crocs shoes, in a shopping cart holding a large orange cone in front of them. Part of a large sign in the background shows the word: "world." The other rectangular image shows a gas station under construction; at least 20 cones mark a large rectangular workspace, and a couple of cones jauntily carry additional orange flags. This arrangement is trying to map a safety perimeter. This project is an ongoing incomplete inventory dating back to 2017, though most of these photographs have been taken over the past year and a half.[1] Not only is this a collection of purposeful and accidental marking of spaces, but these images also include two intentional material disruptions I made by collaging a paper cone into the space (see: second and third images in the first row).

DOI: 10.4324/9781003430971-6

FIGURE 4.1 Sixteen detours & two collage interventions.

Eighteen digital photographs by Tim Abel, 2017–2022 (from an ongoing series).

Like the cones marking a temporary perimeter, space under construction, or space of focus with the addition of the paper-made cones, how does collage simultaneously fold into and expand spaces? Starting with these cones, I am hoping to bring into focus an everyday quality to collage. In discussing what it might mean to turn social research toward what she calls "experiments in living," Noortje Marres (2013) suggests that when we dispel what is and isn't noteworthy of study and allow space for the everyday, "living experiments could be said to apply the social methods of disruption of everyday routines in order to render visible the objects and settings of everyday life" (p. 79). Applying this thinking to collage, seeing and playing with the edges is a way for us to question what edges are there and why, in the everyday. This playing makes me ask: what are the implications of collage as a pedagogical method?

Riding Together

For the longest time I have been holding onto Edith Ackermann's (2014) phrase of "being in it together" or "BIIT" as a formative philosophy for pedagogy and artmaking. I loved this phrase and the way it quickly changed DIY (the concept that Ackermann riffs on to get to BIIT) from a singular to a collective activity, but it might actually be the black and white photograph, "Family on Four Position Bicycle" that most holds my attention: four people, all fair-skinned, maybe a family, all riding a large hybrid sewing table/bicycle through an urban landscape (Bettmann, 1939).[2] A determined young man pedals from the back, a middle-aged smiling older male sits above and adds extra power by pedaling from an extended gear shaft and steering with an exaggerated steering wheel; a young girl maybe near tears sits wearily in the front, white knuckling what could be braking mechanisms, and a middle-aged woman serenely works the sewing machine nestled into this contraption. They are all wearing their Sunday best clothing. They look like they are supposed to be there and that their strange cobbled together vehicle is not at all out of place.

Upon critical reflection I find that, beyond the clear call toward collaboration embedded in BIIT, I'm entranced by the pedagogical anchor of this fabricated bike that functions through collage. This bike is a collaged space, regardless of the goal or endpoint, that works only through the interaction of these four people and only has a function in that moment. That intentional ordering and juxtaposition of people/bicycle/vehicle/sewing machine becomes a moving foundation. I am realizing that collaboration for me is nested in the idea of goal-oriented problem solving—that there is something more people, together, can figure out, by being in it together. Collage is needed before we can even get to collaboration. Collage points to this more-ness: it is about how we ask questions, who we are asking questions with and bringing more people together to ask even more questions. Or as Katherine Hoffman

(1989) suggests, through James McFarlane's (1976) discussion of collage as a practice emerging within Modernism: "the [center] is seen exerting not a centrifugal but a centripetal force; and the consequence is not disintegration but (as it were) superintegration" (McFarlane, 1976, p. 92, as cited in Hoffman, 1989, p. 3). Or as they also aptly put it: things fall together, not apart.

Between and Because

"Art is something else, perhaps an area where possibility of meaning is framed and collaboratively, collectively, determined" (Hiller, 2015, p. 55). By thinking with and through collage, art education, like the traffic cones or the bike/people/sewing machine, is something else, something more. It becomes a space to reveal connections not just to ideas and making but also between people and because of people.

Collaged Selves

I am a collage. As a reader you are also a collage and are part of this unfolding collage, among many other collages. This sense of recentering the lived experience of the individual within a network of experiences also highlights the importance of the act of forming and critically reforming personal/counter-narratives/multi-narratives and being present with each other, with all our collaged selves. It takes practice to be open to this type of detour. Allowing for a detour as a generative space, it allows space for our collaged selves in this continual and communal practice. By thinking with John Dewey (1934/1980) and invoking his call to an ongoing practice of finding resonances in edges and in the everyday, we, as thinking and being with each other, can then connect to our "full presence."

Pointing to the Edges

Collage makes the invisible visible. In contributing to this volume, a constraint was to only use two images. This was an edge. This image (Figure 4.2) is the second image for this chapter, and is of an 18 × 24-inch drawing of a photograph I took while walking up the stairs to the offices of the Krannert Art Museum at the end of November. The light and shadows from the railing formed arrows that happened to align with and point to the bottom edge of the open door leading off the landing. Drawn over or with this are three of this book editors' hands (clockwise from bottom left: Sarah Travis, Jorge Lucero, and Catalina Hernández-Cabal) as well as my hand in the bottom right. We are each pointing to an edge. When you have more hands (or voices) pointing to the edges you see more; more people working within the constraints help to generate an exponentially larger understanding of both the limits and paths

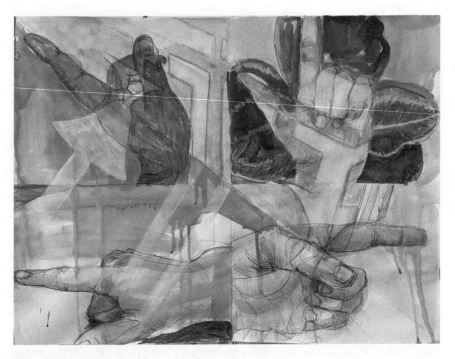

FIGURE 4.2 This is an edge.

Watercolor, color pencil, and graphite drawing by Tim Abel, 2023.

of related disruptions. I want to bring in Antonia Darder (2009), who thinks through this intentionality of interaction by invoking Paulo Freire (1993):

> We learn things about the world by acting and changing the world around us. It is [in] this process of change, of transforming the world from which we emerged, [where] creation of the cultural and historical world takes place. The transformation of the world [is] done by us while it makes and remakes us.
>
> *(Freire, 1993, p. 108, as cited in Darder, 2009, p. 219)*

My relationship, our relationship, relationships in general are situational and meanings move in multiple directions. When thinking about people learning together and as parts of an emergent collage, permission is given for one object or person to intervene by being present (in whatever way they need to be), transformed by the space, transformed by interaction and in turn transforming the space and transforming through passive and active interactions.

Considerations

Please read these as invitations:

Collage looks easy.

Collage is surprising.

Collage is an intentional way of searching, working with, responding to, combining, reframing materials.

Collage is built on resonance, careful listening to materials, international combinations, and welcoming unexpected connections.

Collage happens before, inside, during, after an artmaking/learning moment.

Collage is really about being open to detours.

Collage is more than just about how to make and respond to materials, it is a way of thinking through the sense of framing a space or a process of working together.

Collage is a way of asking how people come into the space or how they feel welcome or even trust their sense of belonging in a space.

Collage recognizes that materials bring stories, and that people carry stories with them. These embedded narratives remain hidden and connective at the same time.

Collage is a parking lot, a place of holding, in transit. A parking lot is a temporary space that is neither the beginning nor the exact end, but lets you get to where you need to be.

Collage is an intentional and conceptual framework for permission to invite fragments, parts of the self, parts of the space, parts of another person to be in dialogue.

Collage is a method of care.

Collaging is confronting and holding your own assumptions about the materials/people using the materials.

Collage is about the hands making.

Collage is a way to point at the edges.

Notes

1 From left to right: (row one) 1. St. Louis, MO, 2017; 2. [paper intervention #1] Champaign, IL, 2022; 3. [paper intervention #2] Champaign, IL, 2022; 4. [Eamonn in Lowes] Champaign, IL 2022; (row two) 5. Savoy, IL, 2022; 6. Urbana, IL, 2022; 7. Champaign, IL, 2022; (row three) 8. [gas station perimeter] Champaign, IL 2022; 9. Champaign, IL 2022; 10. Champaign, IL 2022; (row four) 11. Champaign, IL 2022; 12. Champaign, IL 2022; 13. Tulsa, OK, 2018; 14. Champaign, IL 2022; (row 5) 15. Champaign, IL, 2022; 16. On I-57 near Matteson, IL, 2022; 17. Waukegan, IL, 2022; 18. Champaign, IL 2022.

2 In the process of writing this chapter, I have finally verified that it is indeed a family since it was originally uncredited in the referenced Ackermann article. Getty

Images describes the family as Mr. and Mrs. Charles Steinlauf with their children, Fred and Ruth. Continued research let me also know that the photo of what the Steinlaufs called the "Goofybike" was taken in Chicago, 1939.

References

Ackermann, E. (2014). Cultures of creativity and modes of appropriation: From DIY (do it yourself) to BIIT (be in it together), In D. Gauntlett & Bo Sterne Thomsen (Eds). *Cultures of creativity: Nurturing creative mindsets across cultures* (pp. 1–5). The Lego Foundation.

Bettmann. (1939). *Family on four position bicycle* [Photograph]. Getty Images. Retrieved from https://www.gettyimages.no/detail/news-photo/charles-steinlauf-and-his-family-take-a-ride-on-his-news-photo/515177138

Darder, A. (2009). Decolonizing the flesh: The body, pedagogy, and inequality. *Counterpoints: Postcolonial Challenges in Education, 369,* 217–232.

Dewey, J. (1980). *Art as experience.* Perigee Books. (Original work published 1934)

Hiller, S. (2015). Truth' and 'truth to material. In P. Lange-Berndt (Ed.), *Materiality* (pp. 53–56). Whitechapel Gallery. (Original work published 2003).

Hoffman, K. (ed.) (1989). *Collage: Critical views.* UMI Research Press.

Marres, N. (2013). Experiment: Experiment in living. In C. Lury & N. Wakeford (Eds.), *Inventive methods: The happening of the social* (pp. 76–95). Routledge.

McFarlane, J. (1976). The mind of modernism. In M. Bradbury & J. McFarlane (Eds.), *Modernism: 1890-1930* (pp. 71–94). Penguin.

5

SYLLABUS READING LIST AS ARTISTIC MATERIAL

Kaleb Ostraff

As friends who also share office space, Tim and Kaleb's conversations are filled with tangents, what ifs and "oh! I see you're reading that book" moments. This is a nice way of sharing space. Their conversations lead equally to scheming big schemes, back and forths about traffic cones, and checking in about their families.

The syllabus is commonplace in education, and almost anyone who has spent time in the institutions of education in the United States will likely be quite familiar with it in some form or another. While there is a significant amount of literature and university resources dedicated to the subject of the syllabus, it mainly focuses on how to create one, how to use it, and what should go into a syllabus, but there is relatively little literature theorizing about it as a unique form and a stand-alone genre of scholarship (Parkes & Harris, 2002; Baecker, 1998; Snyder, 2009). The lack of scholarship on the syllabus may be surprising considering the level of production and place of importance the syllabus has in education, which Snyder (2009) argues has led to "informed guesswork rather than a simple application of experimentally derived principles" (para. 4). Diann Baecker (1998) further contends that it is common for teachers to inherit old syllabi. As a result, the history of where the syllabus came from and how the form of the syllabus has evolved to its current state is relatively understudied and unknown.

Beyond the fact that the syllabus, as a unique form, has gone relatively unstudied, there also seems to be a concerning lack of ownership and accountability for the creation of the syllabus. Maybe part of this lack of ownership or responsibility is a result of not feeling like any one person oversees the syllabus in all its capacities. For example, administrators do not make

DOI: 10.4324/9781003430971-7

the syllabus. They may feel a lack of responsibility despite their role in deter-mining what must go into it and dictating expectations of what is included and other policies or procedures. On the other hand, teachers also feel a lack of accountability because although they may be the maker, they do not have complete autonomy and are compelled to follow a set of conventions. Richard Sennett (2008) explains that when creation is done in a factory style where people make one part of a whole, it is common for people not to feel the same accountability for the end product. In people's minds, if their job is to make one small part of a thing, they are not supposed to be concerned with what the final product is used for; that is someone else's job. As a student and teacher, I have been guilty of overlooking the syllabus and inadequately tak-ing responsibility due to its mundane, restrictive, and dry formal qualities. Even more concerning, I never considered the origins of the practice and felt it to be something innocuous that did not merit my attention. In essence, I have inherited and used a tool/practice without considering where it came from, what it is designed to do, and whom it might benefit or hurt.

While the syllabus has taken a variety of definitions and forms over time, Snyder (2009) argues that the syllabus "as with all genres of written texts, has developed a set of conventions in terms of content and format" (para. 3). The hardening phenomenon that Snyder notes happening to the syllabus is similar to the process that happened to the pedagogical turn in the art world, which Jorge Lucero (2013) described as experiencing a "concretizing" effect of a form or movement into "a visible definition of working methods, critical lan-guage(s), forms, and—maybe most problematic—a clean-enough 'story of art'" (p. 173). As a result, I have heard people, when confronted with ideas about changing the form, resist and say things like, "Yeah, that is great, but that is not a syllabus," "The syllabus will never change," or "You are better off spending your energies somewhere else." While anecdotal, these comments point to the resistant nature of the syllabus and the resistant institutions of education in general.

The danger here is that without a closer inspection and greater accountabil-ity for the creation of the syllabus, we may be lulled into a state of unquestion-ing belief that the current conception of the syllabus is good and inherent to education without adequately considering the power embedded within to shape the education experience. Joan Schwartz and Terry Cook (2002) warn that "when power is denied, overlooked, or unchallenged, it is misleading at best and dangerous at worst. Power recognized becomes a power that can be questioned, made accountable, and opened to transparent dialogue and enriched understanding" (p. 2). Similarly, Dianne Harris (2007) cautions not to overlook mundane things like the built environment because, as she claims, the built environment is "an active agent in the formation of ideas about race, identity, belonging, exclusion, and minoritization" (p. 2). While they are not directly addressing education or the syllabus, I would argue these scholars' points have merit. The syllabus should be considered an active agent in

education. With these thoughts in mind, I feel a sense of urgency to take up the syllabus as a subject to study. This means studying the emergence of the syllabus in education and attempting to unpack its history, as well as the forces that have led to the current concretized and hardened form, while simultaneously searching for ways to make the form of the syllabus more flexible and generous as a way to be a more responsible and conscientious creator of syllabi.

Theoretical Framework

The theoretical framework I am using to examine the syllabus is a hybrid model composed of ideas from systems theory and conceptual art practices. Donella Meadows (2009) describes systems as being "a set of things—people, cells, molecules, or whatever" (p. 2) that are interconnected in some way to fulfill a specific purpose. Meadows further explains that "the behavior of a system cannot be known just by knowing the elements of which the system is made" (p. 4). However, it is more complicated because one needs to understand how all the parts are interconnected to fulfill a specific purpose. Meadows argues that using different perspectives or lenses can be helpful to see how all the elements are connected and how those relationships work together to produce a behavior or fulfill a purpose. For example, Meadows (2009) says the human eye is one of the most incredible lenses out there, but despite its greatness, it has limitations. The human eye cannot see the vast expanse of outer space like a telescope or see the microscopic particles of life like a microscope. Each lens type allows a different part of the world to be seen and more fully understood. Often, systems' interconnections and inherent structures can be hard to see, resulting in a lack of understanding and hidden behaviors going unnoticed. Meadows used the example of a slinky to illustrate this fact. When it is held in the palm, one may think they know the nature of the slinky, but not until it is released and the slinky begins to spring and recoil in its spring-like manner does one truly understand the inherent behavior of the slinky. Maybe the syllabus is similar to the slinky; without some catalyst to reveal the hidden nature of the thing, it may be easy to overlook it, feel like we know what it does, and believe it cannot be anything different.

The playful and questioning practices of artists could bring forward the hidden nature of the syllabus. Claire Bishop (2007) suggests this very thing: "the straitjacket of efficiency and conformity that accompanies authoritarian models of education seems to beg for playful, interrogative, and autonomous opposition. Art is just one way to release this grip" (as cited in Kalin, 2012, p. 43). One such example of this type of work is Allan Kaprow. Kaprow (1997) employed an artistic practice centered on questioning and play to generate alternative ways of thinking about space and power. I am further reminded of the work of my dissertation advisor, Jorge Lucero. Lucero claims that many conceptual art practices are centered on testing the materiality and pliability

of materials. He further suggests that education and its institutions should be considered artistic material that can be tested like any other material (see Lucero, 2011, 2014). Sometimes the syllabus feels like an "impossible material" (Lucero, 2021) because it feels like the form is so ingrained and accepted that it resists change in a way that can make one give up hope. However, Richard Serra, who works with giant steel slabs, which are in their own right impossible materials, has found ways to fold, bend, and shape them according to his desire. Serra is well known for his large-scale steel sculptures that tower over viewers and create organic spaces which viewers can occupy. Serra's success stems from two parts of his practice: his knowledge of the material and his willingness to try new things.

Serra has a deep understanding of the properties of steel that stems from his experience working in and around steel mills. He said it was his ability to see and understand the "properties and possibilities of the material" (Hänsel, 2018), which in the case of steel was counterbalance, mass, weight load, stasis, and gravity that enabled him to accomplish what he did. But equally important was Serra's commitment to learning and trying new things through making. In an interview with R. Eric Davis (2000), Serra explained his artistic practice:

I think perception is one way that we know the world, and if you can extend your thought and vision through making something and have a dialogue with your vision as you work, it can act as a catalyst for thought. It may turn your head in a new direction and may change how you see what is in front of you.

(p. 102)

Through the act of making, Serra was able to redefine sculpture, art, and steel by "extending the vocabulary" (Davis & Serra, 2000, p. 65) beyond the language and paradigms that existed before.

Similarly, Peter Goldie and Elisabeth Schellekens (2010) address the distinctive way art functions as a tool that "helps us appreciate our own humanity in a special way" (p. 132). Further elaborating on this idea, and referencing Anthony Savile (2006), Goldie and Schellekens (2010) state:

What is special about art, Savile says, is that: 'second nature is presented as if it were actual nature. Thus, the spectator is presented with a view of some topic or theme as if already imbued with significance, one which, in the case of beautiful art, moves him to adjust his ways of thinking about and responding in feeling to that theme as it potentially occurs in real life itself'.

(p. 132–133)

There are several points to unpack in this statement: To begin, I turn to John Ruskin (1885), who once claimed, "the greatest thing a human soul ever does

in this world is to see something and tell what it saw in a plain way" (p. 286). What Ruskin describes, but is not explicitly mentioned in Savile's quote, is that an artist had first to see something (this can be understood to mean more than physical sight) that they deemed to be significant in some way or like Goldie and Schellekens suggest, helps us to ponder the experience of being human. The second part of what Ruskin said is the part where a person tells others about it, and this "telling" part is what Savile explains well. The piece of art, in whatever form, becomes the catalyst for others to reflect on the theme or topic that the artist deemed significant. The viewer may be moved to adjust their ways of thinking or feeling toward that thing when experienced in real life. In other words, "the work of art can have a deep sense for us only if it exercises its force when we are no longer in its presence, if it *modifies our dispositions to think, to feel, and ultimately to act*" (Savile, 2006, p. 253, as cited in Goldie & Schellekens, 2010, p. 133) [italics added for emphasis].

As an artist and educator, I see the work of Kaprow, Lucero, and Serra as an invitation or permission to examine and play with the notion of the syllabus to look for new perspectives and a deeper understanding of its "properties and possibilities of the material" (Hänsel, 2018, n.p.). I hope to be able to find things that may modify the way I think, act, and feel about the syllabus. As a result, I hope I will no longer wield an inherited tool/practice naively but become more aware of what I am employing and to what ends.

The Reading List

One component of a typical syllabus is a list of reading or assigned texts. Figure 5.1 represents how these reading lists are typically presented in syllabi. Each reading is listed in a vertical sequence or may be grouped into themes or weeks, but it is a list of names, titles, page numbers, and so on. I took up this material/form for a doctoral seminar in arts-based research and poked at it to see what would emerge. Inspired by Richard Serra's *Verb List* (1967), I wanted to question the form of the reading list and through making, hopefully, extend the vocabulary (Davis & Serra, 2000, p. 65). Throughout the course, I made a series of creative gestures to play with the concept of the reading list. Two of these gestures will be discussed further in this chapter.

Gesture 1

The first gesture was an attempt to make visible the way that the authors of the assigned reading are real people and not just a name on a list. A while ago, I read *Syllabus as Curriculum: A Reconceptualist Approach* by Samuel Rocha (2020) and found it difficult to understand. At the time, I thought the language of the text utilized a lot of jargon, was too academic, and—I must admit, was elitist. However, then I had the chance to meet the author, Sam, in person,

FIGURE 5.1 Example of Reading List in Typical Syllabus.

Artwork by Kaleb Ostraff, 2022.

and my position changed. When I met Sam and listened to him talk about the ideas in his book, I did not feel like he was an elitist scholar trying to write things that others could not understand and intentionally making them feel dumb. Instead, I felt like he was sincere, and his scholarship is that way because he grapples with specific ideas that necessitate a particular type of language. In other words, my relationship and perspective of the text changed when I imagined sitting down and talking in person with Sam instead of in the disembodied way that I read it at first.

Building on this concept, I wanted to know if there was a way to bring these authors to life or put a face to a name. I imagined what it would be like to read a text with the actual author sitting with me and conversing with them. As a result, I made an augmented reality experience that took each of the assigned authors' portraits and placed them in a semicircle around the reader (Figure 5.2). This way, I could read any text with these authors hovering there, reminding me that real people wrote those words. In other words, it was a way to bring to life the words of the texts allowing me to realize the idea of sitting in conversation with these authors.

Figure 5.2 documents the experience that a user could have.

Gesture 2

In my experience as a graduate student during the digital age, most of the assigned reading I do is digital. For example, in one semester, I had two graduate courses in which all the assigned reading was provided digitally in PDF

FIGURE 5.2 Semicircle of Authors.

Artwork by Kaleb Ostraff, 2022.

form. While on the one hand, I appreciated my professors providing digital PDFs for the way they cut costs, were easy to annotate, and were easily accessed; I wondered how the form the reading was assigned might influence the educational experience for both the students and the teacher. For example, a file of ten PDFs is experienced very differently than a stack of ten physical books. For this gesture, I wondered what would happen if I took my digitally assigned readings and pushed them into the physical world by printing them. To answer this question, I took the assigned reading for my two courses, shrunk them down, and printed them out double-sided. Afterward, I cut them into three-inch strips and glued them into one long continuous scroll wound onto an old wire spool. The long strand of readings, when stretched out to full length, measures about 1500 feet (Figure 5.3).

When I printed out my readings and made them into that large scroll, I was shocked by the sheer quantity of readings I was asked to do. In addition, the embodied experience I had while scrolling through the reading and having to squint to read the small type was completely different from what I experienced when I read PDFs on a digital device. The reading was like a journey,

FIGURE 5.3 Graduate Reading Scroll.

Artwork by Kaleb Ostraff, 2022.

stitching those authors' words into a path I had to walk. I could measure it, feel it, and experience the reading in my body in a way that is impossible when digital. The form changed how I experienced the reading and might suggest that when something exists in a digital form, it significantly changes readers' embodied experience.

Reflections and Considerations

At one point during this time, I talked with my brother about some of these gestures, and he commented, "what is the point?" On one level, these gestures may seem to others to be useless, merely play, or even take them as me being unserious as a scholar. My intention was not to be a jokester but to examine a material that seems so mired in the concretized form it has developed over time by imagining it as an artistic material. I often thought about what could be learned about the materiality of the syllabus by making things that exist digitally physical or physical things exist digitally. My intent was to extend my vocabulary (Davis & Serra, 2000), consequently changing how I think, act, and feel about it in the future.

One of the most important things these gestures revealed is the human/ relational aspect of learning. In many ways, the traditional form of a syllabus, that document that is shared and nowadays usually exists only digitally, hides the relational aspect of learning. It is easy to forget that those names on the reading list are real people that are or were living, breathing, people that had lives, families, cultures, wants, biases, faults, and so on. It may be easy to forget the work and physical demands that reading takes when we assign a PDF instead of a physical copy of the readings. It also may be easy to think that the assigned reading or texts are the content or what will be learned, but it neglects the way that each student brings a whole set of texts that reside in their being and were built from their life's experience.

When I created the augmented reality gesture, I liked being reminded that someone real wrote those words. Subsequently, I think about reading differently when I think about an actual person speaking to me, and I can see them. Throughout, I was reminded that a reading list is not a one-way conversation in which the author or teacher through the author speaks, but that those reading are consciously or unconsciously speaking back. We [teachers, students, classmates] are in conversation with each other and the authors of the reading list when we read texts.

So, what does all of this do or result in? As a result of these exercises, I have found that my disposition toward the syllabus has been modified. I am more aware of what the traditional form and practices of creating a reading list might communicate, and I am more aware of ways that we might disrupt that narrative. More than anything, I have been moved toward a more profound realization and commitment to embrace education as a relational and human activity. The student/teacher relationship is dynamic and is better described as a conversation where we speak to each other. It prompts me to alter my teaching practices to embody this reality. I am not really proposing that everyone prints out their reading list for a semester and make a giant roll, although that might be a good thing; I am not really proposing that every time we read a text, we should have an augmented reality version of the author present with us, but maybe that would be amazing if we did. I am proposing that the syllabus and the traditional form in which we make a list of texts for students to read ought to be questioned and played with. In addition, I hope that when people see my gestures they feel, act, and think differently about education in general and move toward embracing learning and teaching as a relational act.

References

Baecker, D. L. (1998). Uncovering the rhetoric of the syllabus. *College Teaching, 46*(2), 58–62.

Bishop, C. (2007). The new masters of liberal arts: Artists rewrite the rules of pedagogy. *Modern Painters, 19*(7), 86–89.

42 Kaleb Ostraff

Davis, R. E., & Serra, R. (2000). Richard Serra talks about drawing on paper. *Extended Vision, 14*(5), 60–102.
Goldie, P., & Schellekens, E. (2010). *Who's afraid of conceptual art?* Routledge.
Hänsel, S. (2018). Material and expression – reflections on sculptures by Richard Serra and Eduardo Chillida. *Sculpture Journal, 27*(3), 321–331.
Harris, D. (2007). Race, space, and the destabilization of practice. *Landscape Journal, 26*(1), 1–9.
Kalin, N. (2012). (De)fending art education through the pedagogical turn. *Journal of Social Theory in Art Education, 32*, 42–55.
Kaprow, A. (1997). Just doing. *TDR (1988-), 41*(3), 101–106.
Lucero, J. (2011). *Ways of being: Conceptual art modes-of-operation for pedagogy as contemporary art practice.* Ph.D. thesis, Pennsylvania State University.
Lucero, J. (2013). Long live the pedagogical turn: Brazen claims made for the overflowing art/life intersection and the longevity of its eternal pedagogy and study. In J. Burdick, J. A. Sandlin & M. P. O'Malley (Eds.), *Problematizing Public Pedagogy* (pp. 173–182).
Lucero, J. (2014). Marginalia and pliability. *Visual Arts Research, 40*(1), vii–x.
Lucero, J. (2021). *A conceptual artist in every school.* Jorge Lucero. https://www.jorgelucero.com/work#/a-conceptual-artist-in-every-school/
Meadows, D. H. (2009). *Thinking in systems: A primer.* Earthscan.
Parkes, J., & Harris, M. B. (2002). The purposes of a syllabus. *College Teaching, 50*(2), 55–61.
Rocha, S. D. (2020). *The syllabus as curriculum: A reconceptualist approach.* Routledge.
Ruskin, J. (1885). *Modern painters.* (Vol. 3, Part 4). John W. Lovell.
Savile, A. (2006). Imagination and aesthetic value. *British Journal of Aesthetics, 46*(3), 248–258.
Schwartz, J. M., & Cook, T. (2002). Archives records, and power the making of modern memory. *Archival Science, 2*, 1–19.
Sennett, R. (2008). *The craftsman.* Yale University Press.
Serra, R. (1967). Verb List. Museum of Modern Art, New York, NY, United States. https://www.moma.org/collection/works/152793
Snyder, J. A. (2009). *Brief history of the syllabus with examples.* Derek Bok Center for Teaching and Learning, Harvard University.

6

WHAT HAPPENS WHEN YOU ARE NO LONGER THE TEACHER?

Alicia De León-Heller

Kaleb and Alicia met at the University of Illinois Urbana-Champaign; due to the pandemic, they didn't see each other much in person, save for a few moments at an unconventional open-air art education gathering. They recently saw each other again at a conference, where Kaleb told stories about supporting his wife in the labor & delivery room, offering comic relief to Alicia, then 7.5 months pregnant with her first child.

January 2023

A collective gasp and then a loud *stomp*. I turned around to meet the commotion. Bewildered, I stared up at one of my students, up on a table, taking selfies in the middle of class. I was in my fourth month of my first year of teaching, trying to get through a lecture on texture, and now desperately searching for solutions to a problem I'd never anticipated. I attempted to maintain a blank expression on my face, and watched as this young man took power, presence, and control away from me and commandeered himself into the new class leader. I must have asked myself a hundred questions in a matter of split seconds, but I was the most surprised when I asked myself, *Is this ok?* I realized then that I was actually quite impressed with this bold display of defiance, although equally terrified, and I was curious about how this situation would pan out. I knew I could not scare him into compliance, as I normally might attempt—nor did I want to. Perplexed, I wondered what my teacher mentors might do; then I wondered what my artist mentors would do. You see, on any given workday, my brain negotiates between at least two different modes: the artist and the teacher. Sometimes my role is even more fragmented, like when I'm also the accountant, the nurse, the therapist, and,

DOI: 10.4324/9781003430971-8

at times, the bootcamp sergeant. But on this day, watching Jimmy* parade his noncompliance up and down our flimsy tables, I quieted the voice that I associate with "the teacher" (classroom manager, employee handbook follower, parent caller, lawsuit-fearer, etc.) and paused in awe at the artistic moment unfolding before us all. Perhaps this disruption could teach us all something new.

While studying art in college, my favorite pieces were the ones that centered around the themes of disruption, mischief, protest, and audacity. Artists like Tania Bruguera, Adrian Piper, Guerilla Girls, Yves Klein, and Marcel Duchamp captured my attention and inspired some of the work I did while in school. I was most moved by performance artists and marveled at how they dared to do what they considered important, even if it caused a disturbance or some discomfort among their audiences. It is no surprise then, that when I was confronted with this audacious behavior by one of my students, clearly a demand for power, that I was reminded of these art scholars. I thought of Bruguera's *Tatlin's Whisper #6 (Havana Version)*, and how Jimmy's defiance, which brought my class to a halt, was like the audience members that took to the stage in Havana and brazenly spoke their minds. They, including Bruguera, were aware of the risk they were taking by expressing themselves so openly while living under a conservative regime, and yet they courageously proceeded. For Jimmy to parade his self-expression loudly was not unlike that moment; nor was it unlike Adrian Piper staring at bus riders with a sock in her mouth, uncomfortable for everybody. I watched his performance play out for a few more minutes, and when the class seemed to lose interest in the display, I looked up at him and asked if he'd please get down. He did, without a fuss, and became my biggest fan after that day—a feat, considering his ongoing problematic behavior in other classes. Meanwhile, I'd started to ponder how this moment could empower us all. How could I open my classroom up so that students felt more in control? How could I teach them about switching up power dynamics while still maintaining a respectful environment? Do the students need more outlets of self-expression or situations in which to push boundaries? What systems or policies could I implement so students would feel empowered to lead one another and need less of me to monitor them?

First, I had long noticed that students in Jimmy's class and a few others were really poorly accustomed to talking excessively to each other at inappropriate times, so I started to offer students the opportunity to teach the class in my stead. I did so with sincerity, and not a sarcastic undertone, because I figured if what they wanted was to talk to each other, we could try making that happen in a productive way. This led to so many students wanting to teach that I had to create a sign-up sheet. Students braved it alone or went up in pairs and wove together an impromptu lecture with only a few bullet points I provided at the beginning of class. The rest of the class often watched for my reactions when students went off course but time after time, I applauded their

efforts and courage. Sometimes I'd mimic typical (annoying) middle school behavior while the student teachers were presenting, in an effort to give students a small comedic taste of what their disruptions looked like. The role reversal proved to be effective, because soon students started to correct themselves and each other when they were misbehaving, no longer waiting on me to be the authority. Soon, my classroom was running with very little need for me. One student would take attendance, while also controlling the playlist and answering the phone throughout class time. Another would lead the class through the warm-up at the beginning of the hour and explain the expected tasks for the day. Other students passed out materials and returned them at the end of class, while the rest of the class just sort of settled into this new normalcy.

Trying this new approach to our dynamic was such a great experience and I only regret not trying it sooner. Empowering the students to lead the class opened up so much time for me to be present with my students, continue building relationships, and to help them with their artwork. Sitting at their desks, just like them, the playing field was leveled if only for an instant, and students felt more comfortable talking with me. It is not surprising to me to see these now-former students of mine march into my class on their way to their new classes, reminding my new students of the classroom's expectations, reminding me they're always available to teach for me, and leaving to greet their new teachers with confidence. I cannot fathom a greater outcome from a moment when I was mortified, watching Jimmy take selfies on top of tables, to now seeing my students embody leadership beyond our time together.

I am a different educator today as a result of having learned from my most uncomfortable moments, starting with Jimmy's performance and continuing still today. Those moments have taught me about myself and my students and have helped me recalibrate myself and recenter what I do around student well-being and growth, as opposed to curriculum or my own ego. I'm not sure if Jimmy was as impacted by his shaking my class up as I was; but I know that he was certainly proud of himself, disrupting his "bad boy" narrative at least for a moment, each time he got done teaching. At the very least, I hope my students are leaving my class with more confidence and social skills that will serve them in life. Today, my students have leadership roles to set the expectation of leadership from the start of the school year. I believe this helps them understand the terrain and build up their confidence while they make new friends in class. Now that the second semester has started, we'll be transitioning into student teaching soon. I hope that this practice sends off an exemplary group of empowered students into their next levels of education and growth, and that they intuit that they can always tip the balance of power should they need to—with or without some discomfort.

7

A CALL FOR SOCIAL ENGAGEMENT

The Arts Proposal as Creative Research

Allison Rowe and Nancy Nowacek

> *Allison, Alicia, and other University of Illinois Urbana-Champaign community members gathered online to play collaborative games during the first difficult weeks of the pandemic. It was a lovely way to meet new friends and collaborators.*

"We still need 12 work samples."
"I need a one-page CV from you."
"We have the work samples from the park proposal."
"Where are those files?"
"I started a folder in our project folder."
"Where is that? Sorry. Can you resend me the link?"

Triangulating between an office in midtown Manhattan, a basement art studio in Brooklyn, and an apartment in Toronto, we worked via conference call at lunchtimes and early evenings around work schedules. Together we—with collaborating curator Mariel Villeré—were compiling materials for another Request for Proposals: merging our varying research practices around waterways, climate change, human agency, and forms of bureaucracy for a participatory artwork in a rural Canadian town. We titled our proposal *The Department of Human and Natural Resources*.

Beginnings

Our collaborative work first began in 2009, when we were enrolled in a small cohort of students pursuing a Master of Fine Arts in Social Practice at California College of Art. Though we may not have asserted it at the time, we were both

DOI: 10.4324/9781003430971-9

there because of and for our late mentor Ted Purves. In the mid-2000s there were three graduate programs in socially engaged art: two helmed by internationally acclaimed artists and one run by Ted, a brilliant writer, artist, and educator whose steadfast political convictions grounded his practice in distributed authorship and localized ethics of care. Whereas the other two programs seemed to offer atelier models of working with a well-known artist as a springboard for one's own practice, Ted asked: *What might we build together?* This question continues to orient our collaborations.

Our shared work most often takes the form of research and planning as we develop proposals in response to requests for artwork or commissions that fund exhibitions or public projects. We generate concepts and forms with abandon, energized by ideating together. Ice bridge! Feelings sign! Obstacle course! Office! Our shared values and energy carry us through the administrative burdens of responding to calls, and our love for one another guides us in our oscillating labor efforts. Though our ambitious projects do not come to fruition as much as we would like, we maintain relentless optimism in our collaborative pursuits, immersing ourselves again and again in the joy of ideas.

The Department of Human and Natural Services

In 2015, Allison began a PhD in Art Education at the University of Illinois Urbana-Champaign to study the ways that galleries and artists collaborate on socially engaged art. She undertook ethnographic research following the production processes of two works—from selection through execution, and post-project debriefing. At one site, a small but exceptionally active gallery in the sub-Arctic, she observed that many of the visiting artists who came to execute work generated extractive projects that required input or labor from the community (Rowe, 2021).

The year after Allison's research trip that same gallery issued a call for proposals inviting artists to undertake work in their town the following summer. We got on the phone—Allison on a dog walk, and Nancy making lunch—and talked through how we might generate a project that could flip the script on the extractive model of social practice so often experienced by this community. Knowing of the remoteness of the place and the limited resources available within the region, we developed, with curator Mariel Villeré, the concept of a Department of Natural & Human Services: a month-long performance through which we would turn their gallery into an office that aimed to respond to needs shared by local residents.

Request for Proposals as Creative Research Form

There are two kinds of public art: guerilla works that are undertaken in the public realm without permission or support, and commissions that are

supported by institutions that follow safety protocols, obtain permits, and generally ensure a risk-free environment for the various publics who will encounter the project.

It is the latter that often begins with a Request for Proposals. As socially engaged artists whose works invite public participation, our creative practice is part theatre, part education, and part free-form play (Nowacek, 2011, 2019; Rowe, 2019). A major distinction of our collaborative practice is the importance of what performance studies scholar Shannon Jackson (2011) refers to as "support structures" (p. 33): the resources, people, systems, and ideologies that undergird a work. We see our projects as both enabled by and entangled within the budgets, staff, spaces, and policies of the institutions with whom we collaborate. As such, when responding to a call we do not simply think of how we will leverage a particular opportunity to generate art, we also dive into the ways that the site and its politics become a part of the work.

Our research process is instigated by framing a Request for Proposals question through a lens of space and place so that we can responsively engage with people in a particular town or city, as well as the art institution. We must become quick students of the environment we seek to work in so that we can brainstorm ways that our individual practices, ideas, and obsessions might come together in forms that are meaningful to our intended audiences. Local geographies, cultures, and histories form the touchpoints that bring specific context to our respective ongoing research practices.

With a handful of inspiring concepts, our artistic research investigates form, materials, and process as a function of the project site. Sketches, collages, models, and storyboards unpack possibilities as well as more questions: how, exactly, could we realize each idea in each place? What publics would this idea engage? This cycle of sketching and seeking repeats itself up until the deadline, interspersed with writing, the component of our creative research process that forces us to concretize our concepts. We have generated enormous amounts of creative research this way.

By existing in the state of perpetual possibility, the Request for Proposals is simultaneously high and low stakes: the odds are *nearly* impossible. Though our work at this stage is merely hypothetical, we research as though every project will, and must, achieve full realization. We participate in open calls for a single commission to which hundreds of other proposals are entered. If not selected, we find new contexts for our ideas and transform them accordingly.

Our proposal for the small town in the Canadian sub-Arctic did not come to be, which allowed our ideas to oscillate toward another Request for Proposals for an exhibition at NURTUREart, a long-venerated Brooklyn non-profit gallery. However, this new context inspired another wave of creative research. We asked ourselves what opportunities this exhibition would open

and which it would foreclose. Because this new Request for Proposals was written for a more traditional exhibition context in Brooklyn, New York, and not a six-week residency in a rural Canadian town, we transposed our original ideas from a labor-intensive community-engaged project toward a group exhibition from artists working in the intersection of environmental issues and bureaucracy. The resulting exhibition *The Department of Human and Natural Resources* featured works by the Environmental Performance Agency (Catherine Grau, andrea haenggi, Ellie Irons, and Christopher Kennedy), Li Sumpter, and the authors: interactive artifacts and mediated performances that deployed bureaucratic cues to grapple with environmental issues. The final exhibition, collaboratively conceived and researched, was curated by Mariel Villeré. The overview of the exhibition reads:

> Transforming the gallery into a site for performance and as a departure point for collaborative production, *The Department of Human and Natural Services* aims to foster trust, experimentation, and open dialogue. The exhibition puts forward the role of artists in activism and proposes creative strategies in response to the current course of global warming and its myriad effects on environmental, political, and emotional levels *The Department's* office is therefore a repository, a stopover, and a meeting place.
>
> *(Villeré, 2019)*

And Again

This is but one instance of our process. We have researched countless sites, interlacing our environmental and participatory practices for Requests for Proposals across the United States and Canada. For example, our research for an arts venue in Queens, New York, lead to a proposal of a durational multimedia work about different forms of time concerning the climate crisis, featuring a local glacial erratic—a boulder carried by an ice sheet from one location and deposited in another—a wall clock, and a hand-knit sock. This concept unfolded into research on different kinds of wool and patterns for knitting socks, a deep dive into clock design, and the necessary technologies needed to film the glacial erratic over a 24-hour cycle. Even though that proposal (and many others) have not been accepted, we do not consider the time spent on them wasted. Working together to imagine new works, and the pleasure of the research generated through them is equitably important. Each time we collaborate on a submission we get to spend time together, immersed in research, solving problems through art, and learning with one another. In turn, this labor and knowledge have tangible and intangible impacts on our

practices. It begins with every new Request for Proposal and continues in manifold and untraceable ways for years to come.

"Are you done with your section?"
"What do you think of this title?"
"Can you send the Zoom link again?
"Drop the articles at the end and I'll polish up our citations"
"I finished the images"
"It's done! I got it in! Thanks so much for those last edits."
"Hey, check out this call, I think it might be a great fit for us ..."

References

Jackson, S. (2011). *Social works: Performing art supporting publics*. Routledge.

Nowacek, N. (2011). *Public postures* [Socially engaged artwork].

Nowacek, N. (2019). *Log Book, Public Agreement*, and *Typical Conference Call* [Documentation image of Nowacek's notes, a form for members of the public to sign to take on the work of climate change, and video documentation of Nowacek on a conference call, all ancillary works to Nowacek's *The Bridge* in the exhibition *The Department of Human and Natural Services*.]

Rowe, A. (2019). *Emotional labor specialist: Climate change hotline*, [Documentation images of Rowe's interactive installation in the exhibition *The Department of Human and Natural Services*.]

Rowe, A. (2021). *The social throughout: A multi-sited ethnographic case study of socially engaged art at the gallery* (Doctoral dissertation, University of Illinois at Urbana-Champaign).

Villeré, M. (2019). *The Department of Human and Natural Services*. Mariel Villeré Website. Retrieved December 10, 2022, from https://marielvillere.com/The-Department-of-Human-and-Natural-Services

8

REFLECTING COMMUNITY THROUGH COLLABORATIVE PUBLIC ART PROJECTS

Blair Ebony Smith and Jennifer Bergmark

The last time Allison and Jennifer got to see each other in person they were in San Antonio for a conference. Allison was on her way to a restaurant with good taco reviews when she ran into Jennifer and some other friends. Everyone decided to go to the restaurant, which turned out to be a comedically far and less-than-scenic walk. They still had a great time.

Reflecting Community Through Collaborative Public Art Projects

Walking into a public elementary school has a familiarity to teachers, students, and families through the sights, sounds, and the energy coming from the students. There are observable exchanges between students, excitement to be together, as well as the disagreements and conflicts that are inevitable when bringing large groups of people together. While there are many commonalities among public schools in the United States, there are also stark differences in how schools are funded, services offered, and standardized test scores, all of which impact the reputation of the school and the wider community (US Commission on Civil Rights, 2018). Words have power and the reputation of "bad schools" can filter down to how the students feel about themselves, their school, and their community. We believe that art can create a positive disruption through visiting artists bringing artistic interventions and resources (including preservice teachers and professional art materials) to the school community (Ginwright & Cammarota, 2007). Working alongside one another creates opportunities for researchers and preservice teachers to learn from and with the community through dialogue and to shift negative

DOI: 10.4324/9781003430971-10

assumptions about the school and community through the creation and distribution of positive messaging that comes from within the school community.

In this chapter we describe the purpose and goals of this project, the artistic interventions that took place with visiting artists at a local elementary school, and how the experiences of preservice teachers were guided through the position of working alongside and critical listening. This project focused on collaborative social practice art experiences that were facilitated through visiting artists sharing their work with a local elementary school, William Estrada and two artists from *Art Build Workers* (n.d.), Kim Cosier and Josie Osbourne. The school we collaborated with was an underperforming school with low enrollment, with a high teacher turnover rate, serving a low-income community. Through the local newspaper and discussions with the art teacher, we learned there was negative press about the school and the neighborhood which contributed to low morale within the school and a lack of pride in their school from students. Our goal as researchers was to facilitate art experiences with artists and school collaborators to shift perceptions about this school and this community and invited our own students, preservice art teachers, to learn through working alongside the artists and students. Our scope was broad, asking, "What happens when you create a space for collective art-making practices that are facilitated by visiting artists and preservice art teachers at an elementary school?" What we found was taking time to create artistic interventions outside of the normal school day and disrupting schedules, routines, and expectations invited shifts in elementary students' perceptions through collaborative creating and working alongside artists and preservice teachers. We also found that our preservice teachers learned through working alongside artists and students, but that critical listening was a key component to openness and learning.

The artists were chosen for their work with communities to align with our focus on creating artistic interventions and opportunities to be present with elementary students. As defined by Jack Richardson (2010), "Interventionist art precipitates a pedagogical event that positions the artist as a significant producer of the conditions for knowledge rather than as the central authority of its meaning" (p. 31). These artistic interventions disrupted the usual limitations of one art teacher in a classroom, the schedule and routine of the school day, and disrupted the negative perceptions of school and community through creating new messaging. To facilitate a disruption of negative perceptions, these artists brought their creative practices as a social intervention, countering the negative messaging with affirmative messaging from within the school community. Even within the school day art is seen as a "special" or enrichment, and its importance is downplayed as it is sidelined rather than being a part of the core curriculum. While one teacher expressed that this activity should only be for students "who deserve it," her thoughts illustrated this view that a visiting artist was a reward and undervaluing the potential for art to

connect students to their school community. This project was not art as enrichment, this was art as empowering. This art focused on the collective rather than the individual through a social exchange of ideas and images (Cosier, 2013).

We worked with three guiding principles as we designed this experience and coordinated this visiting artist program with the elementary school: 1) art and creative practice have value (Hickman, 2010; Freedman, 2003; Stankiewicz, 2001, 2) social practice (also referred to as socially engaged art or public practice) is a relational artistic practice that focuses on engagement (Bishop, 2023; Helguera, 2011; Jacob, 2006), and 3) art can help break down school-community barriers (Lawton, 2019; Ulbricht, 2005). Moreover, Judith Burton (2009) solidified these guiding principles stating, [Victor] "Lowenfeld is consistently preoccupied with a more hospitable claim: that artistry, both creating and responding, is about making the world personally meaningful and endowing the outcomes with social and aesthetic significance" (p. 325). It was our intention to create a series of artistic experiences, delivered through the hospitality of the visiting artists and preservice teachers, for students to recognize the value in their school, their community, and themselves while creating work together that affirmed a sense of pride.

Responsive Pedagogy and Relational Creating

Working with the art teacher and visiting artist, William Estrada, we transformed the gymnasium into an art workshop with workstations for screen printing and button making, disrupting the norms of the space and activities. This allowed for an entire grade level of students, approximately 70 students, to come into the gymnasium and work together at the same time. Estrada's work incorporates celebration and representation by making art with communities through his art cart. Speaking about his work, Estrada (2019) states that his intentions as an artist are

> To reimagine art, not as a luxury, but as a tool for organizing, mobilizing, building, and amplifying the stories and needs present in the community. To reclaim art as it has been used for decades within marginalized communities, as a form of celebration, representation, and resistance.
>
> *(p. 364)*

The workstations that Estrada created in this school space provided enough structure to allow for multiple activities for students to flow through but softened the structured edges of the school experience into a relational art space.

In planning conversations with Estrada and the art teacher, we learned that the principal had created an affirmative "we choose" this school as a statement to create pride in the school. Estrada created a screen print design taking

"we choose this school," adding "because," and leaving a blank space that invited students to express why their school is important. Estrada inserted this text into a banner that zigzagged down the page. This design was burned onto three silkscreens for printmaking and students were invited to screen print the design and then modify the design by adding their response to the prompt and adding color in and around the design to make it their own. Estrada's work was part of the continuum of dialogue initiated by the principal, but also created a space to invite students to process and respond to their feelings about and relationship to their school. This conversation was continued through a second visit by Estrada. He invited students to send him drawings about how they felt about their school and community and Estrada combined all the submissions into a single drawing of a heart with a banner at the top that included the name of the school. This collaborative design was for a second screen printing event because the students really wanted to make t-shirts. This second visit exemplifies the idea of art as a social exchange of ideas. The students couldn't wait to put on their newly printed t-shirts and many of the students slipped them on over their clothes as they walked out of the gym.

For the next project, we invited two Art Build Workers artists, Kim Cosier and Josie Osbourne, to work with us to continue these conversations and to create messaging for the school community that reflected student perspectives and positive identity. The work of Art Build Workers is focused on collaboratively creating imagery that amplifies the voice and messaging of organizations and movements through banners, screen printing posters, and designing large parachutes to represent a vision for advocacy and change. Through a dialogue with students, the art teacher took their ideas about why school was important and developed designs for two parachutes that we would paint with Cosier and Osbourne. The parachute project required more preparation, so the transformation of the gymnasium began the afternoon before the event. Cosier and Osbourne traced the design onto the parachutes and provided directions to set up the space to facilitate the art making while saving the floors, tables, and brushes from damage.

The parachutes were a collective design that required careful painting, but students also had an opportunity to create their own posters and banners at different stations. The banners were less structured and were overflowing with individual thoughts and designs unified through the borders of the banners. Students were called over to work on the parachutes in small groups and preservice teachers helped guide the elementary students to fill in areas, using one color at a time. The stations were essential to allowing for a flow and multiple opportunities for student engagement. Of course, having over 70 students at one time resulted in a few spills and footprints across the banners, but with the many hands from the preservice teachers, these were minor incidents. This project also included a family day to extend this project into the

community. This expanded the collective work and provided an opportunity for students to work alongside parents, and an opportunity for parents to converse with the artists and preservice teachers. At the end of two days of painting, looking at the parachutes was satisfying to see the culmination of collaborative art making and hard work. That was not the end of the social and relational aspects of this project. Students activated the parachutes through play as part of the end of the school year celebration (Figure 8.1).

Sound and Listening as a Reflexive, Artistic, Research Practice

To take up sound and listening as a reflexive, artistic intervention and research practice with preservice art teachers, participation in the art projects described earlier was a requirement for undergraduate early field experience within a course entitled *Teachers as Researchers*. In this course, students are expected to work with a cooperating local K-12 teacher to complete 20 hours of observation for the semester. Typically, students are tasked to observe cooperating teachers in the classroom and/or create and teach lesson plans in these classrooms. Within this project, the preservice art teachers were asked to work collaboratively, assisting the students and visiting artists to build a relationship with the art teacher and classroom, as well as the school-wide community. The focus was less on curriculum development and lesson planning and more on being and making with and alongside students, visiting artists, and teachers.

Knowing that we would work with a school with a large population of Black and marginalized young people, the themes of the course were critical arts-based research, sound, listening, and Black youth celebratory pedagogies. This meant studying the intersections of arts-based research, sound art, and teaching art that drew from interdisciplinary fields such as Black girlhood studies, hip-hop education, sound studies, and art education. I wanted us to think about ourselves as DJs that listen deeply to what's in and around us. The following questions guided our creative research in class as artists, teachers and researchers/DJs: 1) How do we hear and how do we listen? 2) How do listening and the ways we listen contribute to our teaching of art and art-based research practices? 3) How do we compose and mix sounds? 4) How can we do sound art that engages many senses, to understand what we learn when listening to our surroundings, students, and people?

The goal was for students to be a part of the art projects and to listen closely to the school, students' stories, narratives, and interactions to learn more about them, their school, and community. Each week that the preservice art teachers participated in the project, they were tasked with completing creative observations of their time at the school as a major part of their teacher research. These weekly assignments asked students to create artworks with a description in response to their observations in the art classroom and during

FIGURE 8.1 Students activating the parachute they helped create during a field day activity.

Photograph by Jennifer Bergmark, 2023.

public art sessions with visiting artists in the gym. Along with creative responses, the preservice art teachers gathered and shared collections of images, field notes, recordings, and artworks to begin to think about and across each other's themes emerging in their creative research and observations at the school. The preservice art teachers' creative responses and collections were utilized for the final project asking students to create a sound artwork (i.e., mixtape/EP/soundscape/musical or visual essay) that built on knowledge and research practices of listening and sound in class and the local elementary school. To think and create with each other, they were also asked to incorporate data collected by classmates within their final work.

The preservice art teachers' final projects ranged from ten-minute soundscapes, stop-motion animation, ceramic pieces, graphic designs, and glitch art. For example, one student leaned into their stop-motion practice to create a short film incorporating student voices, play, art, and curiosities about art (Figure 8.2). They used color, shapes, text, paint, collage, on-site field recordings, sound scoring, and stop-motion to listen deeply to young people's joy and curiosity when learning and making art together. Play, curiosity, and experimentation were key themes. In this artwork, children's laughter,

FIGURE 8.2 A preservice educator's stop-motion animation for final project.
Still of stop-motion animation by Blair Ebony Smith, 2023.

explorations, and play amongst each other were central to observations, listening, and sound art research. Themes emerging from their artistic research and participation in the public arts project enabled preservice art teachers to think more deeply about what schools can do/be for students when making space for them to be artists, see artists, and engage in dialogue and creation.

Conclusion

While the elementary school students were able to participate and create as individuals, the focus of the artistic interventions was building collective creative practice, learning to think, create, and be together as a community. Students created work with artists and saw their ideas reflected in what they made together. The role of the preservice teachers was to help elementary school students create their work through facilitating the processes of screen printing and button making. This collective art-making experience allowed for dialogue and a focus on the social aspect of pedagogy. In facilitating these art experiences, preservice art teachers were provided with an opportunity to be with elementary students, to work alongside, to listen, and create artworks in reflection rather than being responsible for facilitating the whole group

experience. The benefits of these artistic interventions served both the elementary students and the preservice art education students. Interventionist art focuses on knowledge acquired as part of community production (Richardson, 2010) and these experiences shifted the focus from planning and instruction to allow space for the development of social knowledge through dialogue and conversation. This allowed preservice teachers to live inquiry through art with professors, visiting artists, and elementary students by giving them space to ask and live with important questions creatively. Showing up in artistic research productions, students asked challenging questions about their experiences at the elementary school.

Art is inquiry and social practice and interventionist art prioritize a position of "unknowingness" and/or "outsiderness" (Jacob, 2006, p. 140) that requires listening and creating alongside rather than being the voice at the front of the room. Observing the interactions and relationships through these creative practices clarified a need to provide more of these spaces and opportunities for preservice art teachers. We acknowledge that this was a temporary intervention, but listening and working collectively sets a foundation for a sustainable relationship with schools, art teachers, and communities. As participant observers, we worked alongside our preservice teachers and the elementary students. We heard and saw the excitement in the elementary students and the love they expressed for their classes and their school as they created work and put on their freshly printed t-shirts before they were even dry. As faculty, we want to prioritize finding spaces that allow us to provide opportunities for our preservice teachers to focus on listening and working alongside students while learning collaboratively through making art together.

References

Art Build Workers. (n.d.). https://artbuildworkers.com

Bishop, C. (2023). *Artificial hells: Participatory art and the politics of spectatorship.* Verso Books.

Burton, J. M. (2009). Creative intelligence, creative practice: Lowenfeld redux. *Studies in Art Education, 50*(4), 323–337.

Cosier, K. (2013). This is what democracy looks like: Art and the Wisconsin Uprising. *Journal of Social Theory in Art Education, 33*, 1–20.

Estrada, W. (2019). Resilience and power: Learning with communities through art. *American Quarterly, 71*(2), 363–370.

Freedman, K. J. (2003). *Teaching visual culture: Curriculum, aesthetics, and the social life of art.* Teachers College Press.

Ginwright, S., & Cammarota, J. (2007). Youth activism in the urban community: Learning critical civic praxis within community organizations. *International Journal of Qualitative Studies in Education, 20*, 693–710.

Helguera, P. (2011). *Education for socially engaged art.* Jorge Pinto Books.

Hickman, R. (2010). *Why we make art and why it is taught.* Intellect Books.

Jacob, M. J. (2006). Making space for art. In P. Marincola (Ed.), *What makes a great exhibition?: Questions of practice* (pp. 134–141) University of the Arts, Philadelphia Exhibitions Initiative.

Lawton, P. H. (2019) At the crossroads of intersecting ideologies: Community-based art education, community engagement, and social practice art, *Studies in Art Education, 60*(3), 203–218.

Richardson, J. (2010). Interventionist art education: Contingent communities, social dialogue, and public collaboration. *Studies in Art Education, 52*(1), 18–33.

Stankiewicz, M. A. (2001). *Roots of art education practice*. Davis Publications.

Ulbricht, J. (2005). What is community-based art education? *Art education, 58*(2), 6–12.

US Commission on Civil Rights. (2018). *Public education funding inequity in an era of increasing concentration of poverty and resegregation*. Briefing Report.

Layton, R. H. (2003) Art and agency: A reassessment. *Journal of the Royal Anthropological Institute, 9*, 447–464.

Charman, H. (2016). How constructivist education ... contemporary art ... education and public engagement ... doi:10.1111/j... 1–12.

...

PART 2

I/Us

Experiments in (Shared) Identities

9

DIALOGIC HISTORYING THROUGH RESEARCH-CREATION

Jody Stokes-Casey

This conversation is an attempt to locate and situate my academic (Dr. J) and personal (Jo) selves toward a research practice in the history of art education. Highly influenced by oral history theories and methods (Portelli, 1991) and polyptych methodology (Garnet, 2015a, 2015b, 2017), this dialogue is a real-imagined unfolding of the two as a performative and conceptual gesture by an early-career academic.[1] Through this form, I attempt to think with research-creation methodology (Loveless, 2019) toward a research agenda in history. Underlying the conversation are questions about history as a past-facing practice through research-creation which is often a future-facing and speculative practice: How/can the methodology of research-creation build and/or uncover histories?

--fold--
FOLD. Folds within the document are interrelated notes and narratives that enact the polyptych structure. They provide extensions to (un)fold layers within the dialog. Folds, footnotes, and framing devices are additional layers within the piece to support the reader as well as further experiment with research-creation in a "neutral" voice [within this text, meaning, not one of the dialogic voices].
--fold--

Set: Dr. J (an academic voice) and Jo (a public—personal voice) situated within the space of this chapter enter into dialogue. Rather than a bifurcation, the dichotomy is a performative convenience toward unfolding a conversation. As historical documents and artifacts are often parts of a story that

DOI: 10.4324/9781003430971-12

become constructed toward a whole, the representatives of academic-public self within this dialogue are neither individual nor together a full representation, but metaphor.

Dr. J: In a video interview posted to YouTube by Canada's History Society channel, oral historian Alessandro Portelli (2016) surmised that both interviewer and narrator are co-creators in an oral history; he said, "implicit in the stories that people told was what they thought of me, because they tell the story to the kind of person they think you are." This point asks us to continually situate (Haraway, 1988; Harding, 1992) ourselves, the researchers, within the histories we collect, research we undertake, and interpretation we perform. The fact that we are two aspects of the same person in dialogue experiments with Portelli's theory, each telling the other the story presented for the self we perceive in one another.

Jo: You academize to me and I present a personal response to you. Because I know your goal is a public representation through research, mine is a public-personal framing; I'm telling you who I think you are through the response. Both shape the narrative we construct.

Dr. J: That means you trust me as many narrators do trust interviewers of oral history—to an extent. Afterall, the promise of [public]ation means I am not as trustworthy of a discussant with potentially private matters.

Jo: Not only that, but it doesn't allow for a change of heart or mind unless that change, too, becomes public. I don't want to derail the conversation too much, so I'll just say briefly to think about the personal things found in archives, like letters and diaries. They are so exciting for historians to find and provide a glimpse into a person's life. These may become used as a device for a historian towards multiple purposes. Though the research may be deeply intriguing, the ethics get a bit gray.

Dr. J: That's where the situating of the self within research questions and methodologies becomes key. Honestly, it is more important that I am completely transparent with you than that you are with me because you need to know what I plan to do with your story before you decide how much of it to share. This particular conversation is not to get too deep within the personal rationale of [our] research, but to conceptualize how we do it. This conversation is one of the ways to consider methodologies of historical research within a field like art education which lends itself to creative possibilities.

Jo: I will share—a bit, but you know I'm more private, usually opting for an inner reflection than sorting out my thoughts with a public audience. I am particularly interested in the culture and history of the real-imagined (US) South. I may be so bold as to claim a *love* of place that drives the research and am also continually critical and problematize

the South and therefore the "relationship" I have to it—you know we're in an "it's complicated" relationship status and my ideas change. I suppose I want control over my own narrative, so I hesitate to explore the personal within this academic realm.

Dr. J: At the same time, we as artists, researchers, and teachers can't help but to be present in *all* of the work that we do. It's an interesting intersection between us as researcher and personal selves that Natalie Loveless (2019), through Donna Haraway (2003) and Thomas King (2003), explores by stating, "it is in allowing ourselves to be drawn by our loves, our intensive and extensive curiosities, attentive to what and whom we are *driven* to explore, and examining the complex web of relations that we inherit thereby, that we might inhabit research questions ethically" (p. 27, emphasis in original).

Jo: Basically, my input is critical. Because if your academic self is working towards research that, according to Loveless, is *ethical*, then you cannot sever me, the representative of the personal self, from your research. Without including my voice, your work is missing an honesty about ourselves. Without me, pulling again from your Loveless quote, our *loves* and what *drives* us towards research would be unjustly ignored.

---fold--

DRIVEN. The emphasis Loveless (2019) places on the word *driven* in the quote above invites an opportunity to share how we [Dr. J & Jo] use *driving* [a car] as a method of data collection in the research of place and cultural-historical geography of the South. Similar to walking methodologies as arts-based research (Springgay & Truman, 2018), driving builds a connection to place through familiarity through navigation, traversal, and repetition.

Riding and driving created a deep connection between myself in childhood, adolescence, and young adulthood and *home*, familiar places in rural West Tennessee where I grew up. After moving to a new state, Illinois, for graduate school, I experienced a feeling of loss—of being cut off from my history and connection to my sense of place in moving away from the South.

I began documenting my long commute in Illinois, first through field notes like seeing a coyote hunting in the median of the interstate or noticing a patch of blue chicory flowers along a specific stretch of the road. Next, I began recording small parts of the drives as seconds-long videos compiled to represent a year-long commute of road, weather, traffic, and bits of audio from internal or external car sounds like the radio and windshield wipers. Together, the notes and videos (in)form a research-creation process and multimedia archive of the *desire* for dialogue with place.

Embracing and resisting [too much] academizing through [driving as] research-creation became a fold in my dissertation project in the Mississippi Delta (Stokes-Casey, 2021). When I was able to travel to my research site,

driving the back roads around the small town and in the county became an essential part of connecting with, experiencing, and understanding the cultural-historical geography. I used mixed media to collect data such as photos, video, and occasionally natural materials that would not have been possible to access without *driving* [curiosity and love].

---fold---

Jo: That fold shows how the personal ties into research. I could even see some of that "data" as comparable to traditional archival materials like photographs and journals. It's documenting moments in time and connections with place.

Dr. J: *Historying* which Greg Dening (2006) describes as "a verb-noun … a process, never done, dialectical, and dialogic" (p. 6) illustrates the historian's process in grappling with the past as a process of creative decisions of inclusions, eliminations, and framing towards a [partial] product that is a history. Dening's description emphasizes dialogue as a method of *historying*, which is one of the reasons we chose to present this process through this form of a conversation. That fold does describe how personal experiences may be gathered and used as data. The fold also experiments with form within this dialogue through methods of the polyptych (Garnet, 2015a, 2015b, 2017) and research-creation (Loveless, 2019).

Jo: So, what you're getting at is that stuff like the driving data experiment where we are creating stories, essentially, could relate to historical research?

Dr. J: Maybe. It's certainly worth exploring through methodologies, especially in a field like art education which is more open to creative experimentation.

--fold---

EXPERIMENTS. In our [Dr. J & Jo] recent dissertation research (Stokes-Casey, 2021), we experimented with *historying* through polyptych methodology as data collection and form through multiple modes of (re)presentation including columns and captions, assemblage, invitations, and hyperlinks.

Columns and Captions: In the dissertation's introduction and conclusion, a personal narrative column runs vertically alongside the academic main text of the dissertation. In this narrative column, I speak from [Jo's] first-person experiences about traversing landscapes to and from the research site. This situates the researcher within the project illuminating interactions with place. It provides an alternative method for the reader to engage with the text. Extended captioning of images in the column become vignettes and additional folds within the narratives.

Assemblage: From gathered materials, such as photographs, videos, rocks, and seeds, taken from the drives around the research site, I constructed an assemblage with multiple wooden panels to represent aspects of the cultural-historical geography as they unfolded through the research. The materials, images, and arrangement within the polyptych assemblage are a form of inquiry through which connections between symbols, objects, and historical findings are made. None of the materials or panels are permanently affixed with the intention to resist a finished product, as *historying* resists products of history.

Invitations: Within the dissertation are a few prompts that invite the reader to contribute to the narrative. These interactions create the potential for the reader to correct, redirect, and insert into the narratives presented, thus creating more folds.

Hyperlinks: Using the digital publication format as inspiration, images throughout the dissertation are interconnected in a web of relationality through hyperlinks. The hyperlinks are designed to disrupt the linear format of the document and create folds throughout the text, complicating the narrative and producing many more narratives dependent on the reader's interaction.

--fold--

Jo: That seems very different from what I imagine most people think of when they think of history.

Dr. J: Maybe so …. That is part of the experimental nature of this dialogue and the question it is asking. One of the things Loveless (2019) notes is that research-creation recognizes that "the methods, tools, and approaches used, […] are determined as back-formation *from the question or problem itself*" (p. 40, italics in original). There are some examples that may help to better understand how historical research may overlap with research-creation. One is Sadyia Hartman's (2007, 2008) work where she pulled from a historic ledger a singular mention of an enslaved girl murdered aboard a transport ship and, through a process similar to research-creation, constructed multiple narratives of what potentially happened to the girl.

Jo: I definitely remember reading that one. I think what we've been talking about is a different approach, but I can see the connections in that example. I suppose with this work that you're doing, I recognize and appreciate the importance of recognizing my part in all of this. But, I think, for me, I don't want to overshare the personal stuff. Like your oral history narrators, I want the research to respect my boundaries.

Dr. J: I can respect that. I also understand that the ongoing practices within the research-creation of histories of art education for me/us mean our

perceptions of the situations will change. Who knows, maybe you'll become more comfortable integrating our voices over time. The questions and problems, as Loveless (2019) says, guide our path forward.

Note

1 The polyptych means many (poly) folds (tych). The polyptych methodology embraces mixed methods of data collection such as oral history, archival research, and visual/material culture. It also offers a structural form through which to conceptualize and present data, making it an apt method for undertaking research on the history of art education (Garnet, 2015a, 2015b, 2017).

References

Canada's History. (2016, April 27). *Alessandro Portelli: Speaking of oral history*. YouTube. https://www.youtube.com/watch?v=vEToq3T_LZQ

Dening, G. (2006). Performing cross-culturally. *Australasian Journal of American Studies, 25*(2), 1–11.

Garnet, D. (2015a). *A storied history of art education: The art department at Central Technical School, 1892–2014* [Dissertation]. Concordia University.

Garnet, D. (2015b). Polyptych construction as historical methodology: An intertextual approach to the stories of Central Technical School's past. *International Journal of Qualitative Studies in Education, 28*(8), 955–969.

Garnet, D. (2017). The polyptych methodology and new histories in art education: Charting a Legacy of stories from Central Technical School, 1896–2014. *Visual Arts Research, 43*(2), 58–73.

Haraway, D. (1988). Situated knowledges: The science question in feminism and the privilege of partial perspective. *Feminist Studies, 14*(3), 575–599.

Haraway, D. (2003). *The companion species manifesto: Dogs, people, and significant others*. Prickly Paradigm Press.

Harding, S. (1992). Rethinking standpoint epistemology: What is "strong objectivity?" *The Centennial Review, 36*(3), 437–470.

Hartman, S. (2007). *Lose your mother: A journey along the Atlantic slave trade*. Farrar, Strauss, Giroux.

Hartman, S. (2008). Venus in two acts. *Small Axe, 26*, 1–14.

King, T. (2003). *The truth about stories: A native narrative*. House of Anansi Press.

Loveless, N. (2019). *How to make art at the end of the world: A manifesto for research-creation*. Duke University Press.

Portelli, A. (1991). *The death of Luigi Trastulli and other stories: Form and meaning in oral history*. State University of New York Press.

Springgay, S., & Truman, S. E. (2018). *Walking methodologies in a more-than-human world: WalkingLab*. Routledge.

Stokes-Casey, J. (2021). *Art education shaping historical narratives in the Mississippi Delta: A polyptych study of CARE* [Dissertation], University of Illinois Urbana-Champaign]. http://hdl.handle.net/2142/112965

10

RESISTING RESEARCH*

Juuso Tervo

Thank you, Dr. J and Jo, for inviting me (another J!) to your conversation. As someone who is interested in alternative epistemologies in historical research—more precisely, epistemologies that linger in the uncertainty that research (historical or not) so often aims to administer or undo—I found your text to be an important and exciting contribution to the current discussions of means and aims of historical research in art education. To draw from your vocabulary, what *drives me* to your thought and practice is *multiplicity*: multiplicity of past and present voices, subject positions, materials, and media that historical research (as you discuss and practice it) may arrange, rearrange, or disarrange depending on what kind of "web of relationality" one's research is tangled with.

When engaging with your dialogue, my attention was drawn to the relation between the personal self, historical research, and resistance—a relation I would like to think with you in this short piece. Why these three in particular? If, as you write, we must "continually situate ourselves within the histories we collect," and if historying as a practice of research-creation "resists products of history" by locating us in an ever-multiplying "web of relationality," I wonder how to understand this resistance vis-à-vis the personal self; that is, when it is not only "traditional methods" that historying resists, but also—or, first and foremost—the role and function of the self in academic research.

Your strategy of setting up a dialogue between two aspects of yourself certainly offers a compelling example of what this can mean in practice. In particular, I see that we should take Jo's hesitancy to "explore the personal within the academic realm" seriously, and not to reduce it to a mere obstacle to be overcome. Indeed, as it has become somewhat customary in the present-day

* A Companion Piece to "Dialogic Historying Through Research-Creation" by Jody Stokes-Casey.

DOI: 10.4324/9781003430971-13

academia to summon the self to verify the obvious fact that the world is much more complex than research (historical or not) can ever handle in toto, it is worth asking, what do we expect the personal self to do in historiographical experimentation—for example, when disrupting "the linear format" of studying, analyzing, and (re)presenting the past? Instead of diving into ourselves to look for an answer, I suggest we take a critical look at historical research itself. This is because rather than trying to *restore our faith* in historical research, I think we should *resist it*.

Here, I use the word *faith* deliberately. I consider experiments with historical research as possibilities to render operative the disquieting sense of losing faith in established knowledges and practices. This means that it is *loss*, rather than inspiration, that encourages me to study and write history otherwise. While I am using the first-person pronoun here, there is nothing particularly personal about this. Quite the opposite, to make withering faith a personal matter (one can think of heretics in religious communities) means to reduce the resistance this loss entails to a singular deviation from the norm. This, in turn, means that both inclusions and exclusions of the personal self in historical research can be seen to leave the function of the norm undisputed: either the self becomes part of a legitimized methodological framework and is thus seen to produce valuable historical knowledge (a reason for inclusion), or it is deemed *too* personal and thus useless for academic knowledge production (a reason for exclusion). Whether excluded or included, the personal self ends up saving academia from itself: it stands as a proof that academic research (like any object of faith) has the capacity to endure every imaginable disruption or deviation that might question its legitimacy and function. In other words, if we have lost our faith in historical research, we can always restore it by making research personal to us—within, of course, the parameters that our academic imagination allows.

My aim is certainly not to paint a gloomy picture of the potentials of the personal self in historical research. Far from it. I see that resisting the unwavering faith in academia's ability to make sense of everything everywhere (including ourselves) opens the past and the present to the very multiplicity that Research (with capital R) can never handle. Drawing from Ariella Aïsha Azoulay (2019), what is at stake here is "not a counterhistory, but counter to history" (p. 567) that questions practices of legitimization meant to guide our historical imagination. From this perspective, Jo's hesitancy to "explore the personal within the academic realm" can be understood as a *personal, epistemological*, and *ethical* act of resistance that shifts the question "what *can I do* for historical research?" to "what historical research *cannot do*?"—a shift that, at least for me, offers an intriguing point of departure to experiment with the histories we read, write, and study; or, in a word, *make*.

Reference

Azoulay, A. A. (2019). *Potential history: Unlearning imperialism*. Verso.

11

VISUAL JOURNALING AS A FIELD GUIDE FOR THINKING THROUGH MAKING

Shivani Bhalla

One day Jody and Shivani were walking to the bus stop after a presentation at the University of Illinois Urbana-Champaign. Jody asked, "How are you doing?" and Shivani told the truth. She was overwhelmed, and unsure of her place in academia. It's powerful to let yourself cry in front of someone. Remembering it, Shivani says, "I'm grateful I had a caring soul with me, offering me space to be vulnerable without pretending to be in control."

While working on my dissertation, I realized that art making and writing played an important role in expressing the complexity of my disability experiences. Though I have been engaging in art-making practices for a long time, working on my dissertation over the past few years helped me explore the relationship between art-making practices and my disability experiences through various formats like paintings, artist books, and visual journals. In this paper, I will specifically discuss the formats of visual journaling that started almost two years ago to discuss how it allowed me to record my everyday experiences around caretaking, the intersectionality of disability identity, and the connection of disability with my spiritual and cultural practices.

The format of visual journaling became especially handy in expressing some of the aspects of my disability experience that I struggled to articulate in other visual and written formats. Unlike the bigger writing projects or art-works that took days to finish, working in the journals became a way to capture my fleeting emotions and unstructured thoughts. Working in the journal felt like memoing to capture my spontaneous thoughts and emotions in a

DOI: 10.4324/9781003430971-14

fluid and less rigid manner. Also, in this journal, I identified an overarching connection between various aspects of my everyday experiences, between abstract and complex phenomena related to disability. It became a place to think through ideas and concepts as if conversing with myself; recording and articulating these thoughts became a way to know myself better.

In this chapter, I will discuss the connection between disability and intergenerational trauma by analyzing my connection with my ancestors and the importance of grieving. The journal became the foundation for forging connections between my disability and cultural nuances around disability and illness. The connections that I felt existed deep down within me, but I could not articulate them through my writings yet. It became a place to sit with hunches and intuitions and meditate upon them through art making and free writing in the journals.

Thinking Through the Absences

Donna Haraway (2016), in "Staying With the Trouble," discusses how a humble inquirer must approach the research from curiosity. Referring to the work of Hannah Arendt (1982), Haraway introduces the concept of "to go visiting" (p. 127), which requires one to train and involve one's whole being and not just one's imagination to make others (research subjects) interesting. Since in my autoethnographic research, this other is me, I try to approach my experiences by being true to my innermost self.

The process encouraged me to think about various aspects of my existence and whole being through my connection with people, places, and ways of being, both present and absent from my life. Since, in my current phase of life, the feeling of absence predominates over presence, the overwhelming feeling of loss often saturates my visual journals. Working on the journal became a way of mourning for my family members no longer in my life, my sense of self and ways of being before being diagnosed with a chronic illness, and my struggles with disability and illness. Referring to Vinciane Despret's (2015) work, Haraway (2016) referred to mourning practices in human beings as part of philosophical ethology. Looking at research practices as a form of response-ability, Haraway refers to the importance of storytelling to coexist with the living and dead, "many kinds of absence or threatened absence must be brought into ongoing response-ability, not in abstract but in homely storied cultivated practices" (p. 132). Approaching my research as a form of response-ability, visual journaling becomes a place to tell stories of loss experienced by my grandparents as they witnessed the post-independent massacre caused by the partition between India and Pakistan and how it appears in our lives through intergenerational trauma.

Working in this journal, I also thought about how this intergenerational trauma manifested in our lives through the presence of mental illness and other illnesses in the family. After multiple iterations of working in the journal and writing about these seemingly unrelated ideas and experiences that started making sense, I could see a pattern emerging. It wasn't a linear process but writing and working in a journal through drawing often went hand in hand and helped me develop these connections further. The images existed independently; they did not illustrate the written text, but the written texts and images often complemented each other.

A Place to Join the Dots

In *Interpretive Autoethnography*, Norman Denzin (2013) refers to autoethnography as the methodological framework for joining the dots between various aspects of an individual's life. Working in a visual journal felt very personal and allowed me to approach the topic of disability subjectively and acknowledge my past experiences and the cultural environment in which I grew up, hence helping me join the various aspects of my existence. It became especially important after relocating to the United States and losing my past ways of being, which led to feeling *dis-ease*. This further encouraged me to a connection between the state of *dis-ease* with the disease. I could see how being in this state of dis-ease for an extended period was responsible for the prevalence of mental illness and other diseases in my family. This process of making connections, joining dots through multiple iterations, and acknowledging my experiences bestowed a strange calmness that is only experienced when you can express yourself and feel seen and heard. For me, art making was my way of doing that.

Also, this space encouraged me to connect disability with spiritual and cultural practices and a feeling of wellness. I was encouraged to analyze the experiences of my other family members and develop a connection with my ancestors. Dwelling on the concept of illness and disease from the non-Western perspective by exploring the relationship between the living and the dead helped me forge the connection between intergenerational trauma and disability (Figure 11.1).

My exploration became more than what I had initially planned. My relationship with my ancestors stood out to me in this visual journal that I have referred to over and over again in many different ways. Making connections—finding similarities between their struggles and mine, trying to identify their presence in my life which I also explore through narrative writing in my dissertation. It also became a place to connect my personal and spiritual life with my scholarly interests. And I was exploring the relationship between my ancestors and their gratification of my well-being.

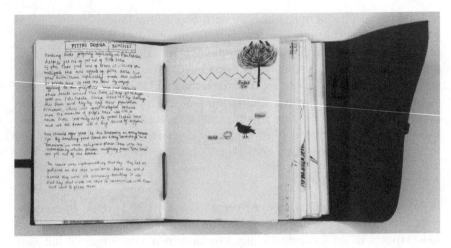

FIGURE 11.1 The Act of Gratifying the Ancestors.

Page from visual journal by Shivani Bhalla, 2021.

A Place to Make Kin

While working on this journal and making connections, I am "making kin" (Haraway, 2016, p. 99) with the scholars whose work resonates with me, and this book becomes a witness to my fascination and love for scholars such as Gloria Anzaldúa (1987, 2015). Anzaldúa's work greatly influenced my research approach and theoretical and philosophical positioning. I see her as one of my academic ancestors. Reading the work of Anzaldúa, I could feel deep love and respect for her that instantly made me recognize her as one of my *kin*. After reading about her experiences with her illness and her struggles living in the *borderlands*, I could feel a deep spiritual connection with her which I could only justify as claiming her as my ancestor. The visual journal became a place to witness and record my connection with her as one of my *pitrs* (ancestors) (Figure 11.2).

As Hindus, we often show our gratitude towards our ancestors, who we believe visit us in the form of birds and animals, through small acts like feeding them. Feeding the sparrows is an important part of my daily practice, which I look forward to. In one of my drawings, I show Gloria Anzaldúa as a (*pitr*) ancestor visiting me in the form of a sparrow. Just like Haraway's (2016) "Camille stories," which explores the symbiotic joint between a human child and monarch butterflies migrating between Mexico and the United States, in my drawing, Anzaldúa appears as a hybrid creature, a symbiotic joint between a sparrow and human. And like Haraway's (2016) symbiotic human child, *Camille*, who is a connection between past and future generations, my representation of Anzaldúa as my ancestor is also reminiscent of the connection between the living and the dead.

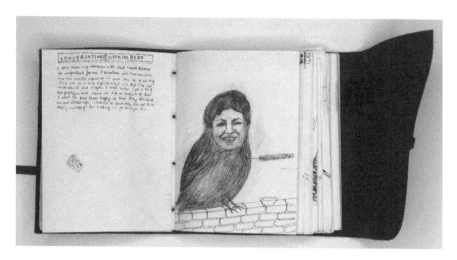

FIGURE 11.2 Gloria Anzaldúa's Visit as a Bird.

Page from visual journal by Shivani Bhalla, 2021.

A Place to Grieve

Sometimes when I was feeling too overwhelmed, I would let my experiences overflow and be absorbed in the pages of the book. Sometimes the handmade paper of the book acted as a blotting paper to absorb that excess of emotions. It became a place to delve into the experiences of death and loss and make peace with the unknown. They condensed at the places where emotions were running high.

My fascination with death and the relationship between the dead and the living is also evident in my artworks. I don't know if my preoccupation with death was my way of preparing for my mother's death, who was a hospice patient. My fascination with death becomes very visceral in these journals. I am even exploring the cultural nuances of death in Hindu culture and how to care for the dead after death. It is considered important to gratify our dead family members and ancestors. It allowed me to capture the materiality of death. How do we want to capture the intangibility of death? I am exploring the cultural nuances around illness, death, and disease in a very personal yet objective way.

References

Anzaldúa, G. E. (1987). *Borderlands/La frontera: The new mestiza*. Aunt Lute Books.
Anzaldúa, G. E. (2015). *Light in the dark/Luz en lo oscuro: Rewriting identity, spirituality, reality* (A. Keating, Ed.). Duke University Press.

Arendt, H. (1982). *Lectures on Kant's political philosophy*. Harvester Press.

Denzin, N. (2013). *Interpretive autoethnography*. Sage.

Despret, V. (2015). *Au bonheur des morts: Récits de ceux qui restent*. La Découverte.

Haraway, D. (2016). *Staying with the trouble: Making kin in the Chthulucene*. Duke University Press.

12

IN THE SPACE BETWEEN THE LINES

Lori Fuller

> *Shivani and Lori met while working on this book. They are connected through their relationship to art, which they take up as a record of the past, a means of engaging with themselves through time, and a site for creating new understandings of themselves and their worlds.*

John Dewey once said that we live in a world of situations. What Dewey (1939) referred to as the concept of "situations" is our interactions with people, objects, and our environments. Our life is a collection of situations stored in our memory—some are joyous happy memories that are brought to the surface when we hear a familiar song or see a familiar face, and other memories might be repressed and brought to life when we experience familiar feelings of anger or pain. While not all situations are equal, according to Dewey, our experiences of them provide a key element to human learning. Awareness of one's lived experiences provides powerful insights into human behavior and is central to understanding our identity. For me, the process of understanding starts with doodling, a simple yet chaotic line recalling *situations* of the past to bring insight to the present.

I spent most of my life living in small farm towns throughout the Midwest. In every town I lived, everyone was your neighbor. Everyone (well, mostly everyone) was friendly, hardworking, barefoot during the summer, and white middle class. I was raised in this small-town culture with Catholic values. Attending a Catholic school was important to my parents, who saved money for the four of us to attend from grades 1–8. We went to church every Wednesday during the school day and our family of six attended every Saturday evening for 5:30 pm mass. We routinely left our two-story farmhouse at 4:30 pm so we had time to pray and go to the confessional for our

DOI: 10.4324/9781003430971-15

sins committed during the week. I was the middle child with three brothers and sisters, so sins piled up quickly.

We moved several times during my early school years. By the time I was in the fourth grade, I was in my fourth school. I quickly became scared to make friends because deep down, I knew there was another moving announcement lurking. I became withdrawn and spent most of my time alone, feeling weird and out of place. I was a shy, quiet, reserved, and awkward young girl when my mother surprised me with a drawing book. As I began to draw the animals in the book, I quickly realized the power of line. Drawing opened my world to imaginative creatures, confidence, positive energies, and a new version of me. My pencil magically transformed a shy, quiet, awkward girl into a happy, self-confident, courageous, twirling dancer who reached for the moon and stars. My mother somehow knew that a simple drawing book of animals was just what her awkward girl needed.

I have always enjoyed *careful* doodling, that is, doodling at the right moment in time. In my younger years, getting caught doodling during class meant a trip to the principal's office in which there was a paddle hung on the wall. You could not miss it. In the small rural Catholic school, there wasn't room for students doodling and not paying attention in class. The school lessons strictly focused on memorizing math formulas, spelling words, state capitals, and Catholic songs. School art was limited to holiday crafts which included decorating Easter eggs and constructing cotton ball Santa beards. My soul craved a spontaneous form of drawing; I still doodled, but under a watchful eye. In school, while no one was looking, I doodled a zoo of animals from my book. Most of the time, the type of art my doodling, dancing, creative soul craved was restricted to my time outside brick school walls.

I still doodle, but this time it isn't careful.

Doodling, for me now, is freedom. It is a performance, a collaboration where identities converge and conflict. It is sometimes *war*. It is a method of inquiry. It is everything wrapped into this nice bundle. It is scholarship.

The process of doodling awakens the spontaneous and unintentional memories that generate stories that begin to create a larger narrative. My pencil guides this inquiry. If the goal of research is to discover something previously unknown or to bring a new awareness or new knowledge to a topic, then for me, doodling is an integral component to my research process. Doodling invites the forgotten stories that become a visual record of interactions with my inner self. It is my personal encounter with art, a record of my lived experience and insight into the why. It is discovery.

The Performance Is the Process

The stage is ready. I feel like dancing. My pencil hits the stage, and the scene begins. The line is a chorus, releasing energy from my body. I am connected

to the pencil, and it is connected to my life. I value this connectedness. I draw upon my energies; my heart is pounding. I feel my sadness. I feel my anger. My pencil never leaves the stage, it is one continuous breath of invented black line gliding across the empty white page. I am engaged with my senses. Suddenly, scene one is complete when the line ends where it began.

Take a breath
Each doodle starts with a blank white page. My pencil starts in a random location, like a thrown dart. I take a deep breath, close my eyes, and let the pencil run free to wander aimlessly on the page.

Breathe
I proceed without thought; I am immersed wholly into this process. I am engaged in the spatial, temporal, and emotional process. I let everything go. The line has control. The line carries my voices, it breathes life into the secret, the hidden, and the known. The line recalls flashbacks of conflict and reconciliation. This is truth in the face of selfishness and greed. This is my response to egotistical people and their lazy ways. This is an explosion of power, an eruption that has been brewing like an eternal flame. This is me raging war. This is my silence, my regrets, and my second thoughts. This is doodling.

This is me in the flesh
I open my eyes and see my life on the stage. My eyes start to see familiar characters, faces from the past in the doodle shapes. My past comes to life, the forgotten events and happenings that had been stored away. This is an organic process. I am immersed in the complexity of odd shapes. A surge of memories slowly makes its way to the center stage. I start unlocking doors, doodling in the familiar shapes of characters I feel and know. The story starts to unfold, and the characters begin to speak.

Doodling as a Collaboration Between Characters

Doodles are a journey into the conscious and subconscious. Black lines record an unfiltered stash of experiences where memories are unfolded and refolded. Doodles are a record of hidden memories and regrets. The characters of my now vivid past materialize into the white spaces.

There is absence of color
The curtain opens and an unfolding of characters show up for the opening acts. Characters from the past begin to dominate the white spaces. I am hidden in the dark, black, whispering shadows. There are black and white

spaces; it is me reacting to them. I am in the dark spaces—yelling, laughing, reaching, and dancing (Figure 12.1).

In the fragmented spaces, identities converge. They tell a story of a journey of memorable triumphs and failures, my silent battles—some won, some never fought. I look for answers and they are still out there, waiting and lingering in the shadows of the doodles. This is a journey of discovery, an internal investigation where my voice is heard.

I begin to fill in the details of the doodles. The characters mysteriously appear to provide clarity into the unknown and investigate the why. I am in the shadows as the voice of truth, an unheard voice living inside my soul. I am interacting with the characters on the stage (Figure 12.2). The dialogue is my story. My inner and suppressed voice, written here in italics, is represented in the dark places of the doodle, lingering between spaces.

Look, a familiar face! It's Mr. Old-fashioned Undergraduate History Professor, who stopped in the middle of his Civil War lecture to make a public announcement...

FIGURE 12.1 Dance like no one is watching.

Drawing by Lori Fuller, 2022.

FIGURE 12.2 The collective.

Drawing by Lori Fuller, 2023.

"Look Miss, If YOU are that tired, you should leave this class. Sleeping is not acceptable!!!"

Ugh, if you only knew I was working as a full-time fast food overnight shift manager so I could afford to get my degree. It's not easy going to school during the day and dealing with drunks in the drive-thru at night. You have no idea how hard it is to smile at people who crack awful sexist jokes at the drive thru. You have no idea what it is like when I must find time in my schedule to sleep. You should walk in my worn-out greasy shoes and worry if the person next to me thinks I smell like french fries. But I am just going to drop my head and shrink in my seat. This is a battle I am too tired to fight.

That doodle shape looks like the Pretty Blonde Girl in fourth grade.

I remember you and I remember you telling everyone that the only reason you let me come over to your house for a sleepover is 'cause your mom made you invite me. I liked your mom; she made excellent Kool-Aid, and she had a soft voice. Why am I so weird, so different from anyone else??? I hate myself.

Ahh. There's Mrs. High School French Teacher who sneaks a peek at me in church every Saturday night. She looks suspicious.

> *She caught me writing notes in her French class. I cannot pronounce these words without her correcting me. How embarrassing! I cannot get anything right in this class. I literally cannot hear what you are saying!! I can't hear certain sounds at all. I CAN'T HEAR YOU!!!* **Why didn't you bother to check my hearing? I went through most of my life reading lips and not knowing I had severe hearing loss. Why didn't you care?**

This is me, dancing in the shadows. I am graceful and pretty. You just don't know it yet …

There I am standing in the second row next to the red-haired boy, ready to sing in the school choir. I love music and I am ready to sing for the program. We are waiting for Sister Nun to get us started. The record starts and we start singing.

"Miss Lori, Miss Lori? Could you try not to sing so loud?"

All eyes look at me, even the red-haired boy with fake-looking freckles teacher's son. Does no one want to hear my voice? (Ugh.)

I love dodgeball. The girls in my class are easy targets … and the first to go.

Aww, there is sweet grandma Lucy. We lived so far away and could only see her about four times a year.

> *I loved her secret recipe of chicken dumplings and her coconut pies. I loved watching her make homemade noodles on the counter. She would dump handfuls of flour right on the counter and make a hole right in the middle for the raw eggs. She would mix it with her bare hands—her bare hands!!*
>
> *I wish I could tell her I loved her. I don't think I ever told her. I am a terrible and awful person. … What was I thinking?*

I was always embarrassed about my appearance. I felt clumsy and long and I had big feet. In high school PE class, we had the option of aerobics or weight-lifting. I firmly chose to lift weights. Now, I'm dancing …

Doodling as an Investigation of Identity

What is so special about a spontaneous activity that is traditionally associated with boredom? The uniqueness lies in its process, the folding and unfolding of experiences and the surreal randomness of personal yet forgotten stories. It is found in the performance without a script, a live improvisation that develops as the space allows. It is found in the gesture that opens the doors to

explore themes of identity, conformity, and acceptance. Doodling allows me to create unexpected understandings of myself, my interactions, and my practice. What began as an embodied performance transformed into unique insights that otherwise might have been forgotten. I am no longer silent. I am informed. Doodling breathes life into my memories and through the characters of the past, I develop new ways of understanding.

Doodling as a Way of Knowing

Doodling has long been considered a mindless activity used to cure boredom. Yet, for me, doodling is a holistic experience that has become a way of knowing. The key to unlocking this process is not found in the mechanism itself but through a performative process of making connections with the past and present to gain understanding for an informed future. The key is to step outside comfortable boundaries and engage in self-dialogue to reveal deep unfiltered pathways to understanding. There is splendor in randomness and there is beauty in chaos.

Reference

Dewey, J. (1939). *Experience and education*. The Macmillan Company.

13

PARALLAX OF GRIEF AND RESTORATION

Gail Glende Rost

Lori and Gail overlapped in their time at the University of Illinois Urbana-Champaign but know each other primarily through their resonant work and motivations. When they started an email chain to write this connection, they realized they both came back to graduate school to "find a way" through caring and structures of care-taking—for ourselves, our students, our loved ones, our lost beloveds.

Introduction

In this past year, I experienced the emotional trauma of losing my partner of 44 years. Instantly, my foundation, the framework built through a shared life, disappeared. Routines, points of reference, feedback on my thoughts, shared jokes, gone. Needs previously met went unmet. At this moment, at this depth, it was a total upheaval. As time passed, I intuited the need to create new norms, or to *see* the new arrangement of my life. I established new habits; I inspected and then left old routines behind.

Over the last century, scholars have described grief as a series of "states" (Prigerson et al., 2021, p. 7) with an acknowledgment that passing through such states does not preclude "reexperiencing each proposed psychological state" (Prigerson et al., 2021, p. 7) as a cyclical process. I have found this concept of *states* helpful as it recognizes a possible framework, a structure. When I visualize change, I look for the underlying structures. In this moment, I reached to my practice of design thinking with which I can determine contributing variables to a problem through an abductive methodology. Contrary to negotiating an unknown using scientific *thinking*, the design process, or design *thinking* lets us accept a hunch and to discover insights through

DOI: 10.4324/9781003430971-16

relational research (Kolko, 2010, Yeoman & Carvalho, 2019). For this writing, I share interdisciplinary insights relating to social psychology and grief-processing principles in addition to identifiable benefits within an ecological restoration study. Using constructs of arts-based research such as "the complex transformative phenomena that occur at the nexus of arts-based expression, reflection, and relationships in the arts therapies" (Gerber, Bryl, Potvin, & Blank, 2018, p. 3), I proffer a messy companion device of an internal verbal feedback loop which initially in my grief was never silent. *Yes, I am the one— the other parallactic point. I just couldn't stay silent (at least at first) and was at times, taunting, at others, supportive.* Using bearings based on a restoration and resilience grieving framework (Prigerson et al., 2021, p. 7), I explored my internal healing abilities through art making and nature experiences to negotiate the instability of grief and encourage my repair and restoration.

Definitions

Parallax. a. The difference or change in the apparent position or direction of an object as seen from two different points. b. *figurative* and in figurative contexts. Distortion; the fact of seeing wrongly or in a distorted way.[1]

Companion device. Glossary term: a companion device requires a parent device, such as a smartphone [or a body, or a lead concept], to fully operate. The opposite would be a standalone device that can do everything on its own.[2]

Restoration. c. The action of bringing back into existence; re-establishment, reinstitution; renewal. 4. The action of restoring a person to health, consciousness, or vigor; recovery of physical strength.[3]

The Misalignment

Parallactic[4] Identities, My Companion

Ever-present but stealthy as *it* seeps into every moment is my grief. *Oh, give me a break. The drama of it. Just stop already. We have been through this.* As much as I try to ignore it, the physical and psychological pains are there. The gut, the incessant self-talk, the reminders everywhere; the *first-lasts*. It is hard to distract, to make go away. *I know, I know. Everything you've read tells you that you gotta go through it. There aren't any short cuts. It's yours, you can't give it away and you can't ignore it.* Am I moving through it? I can feel a difference at times. The lows don't go as low. The weeping is less frequent; I know the triggers. I have been laughing. And then, I worry, "Is this okay? Is it okay for a widow to laugh, to forget for this moment?" *Oh, for pity's sake, let up. You need these reactions. You're still alive. You know it is part of a process and you're not giving up what you have been. You are discovering who you are now,*

I am so distracted. Forgetful, even. Focusing is super hard. I am not getting done what I need to get done. I feel paralyzed sometimes. **Wait. Wait. Wait.** *Have you thought about how maybe this is what you need to get done right now? You ARE rebuilding, reinventing, becoming. The past measurements don't even exist! Did they ever? Those were yours, too, right? You gotta let go.* So, seriously, what's next? I am not sure what *step* to take next. *While you're fretting about some construct of your own making which, quite frankly, is arbitrary because you're the only one who actually cares, other worlds are moving around you! Other opportunities! **Just take one next step.** I have mostly* moved past the fear that I am dying next. But what if I die without being done? What decision is actually in front of me? *Done with what? That's just it, isn't it? You have a distorted view right now. The old framework broke. What are you going to do about it? Maybe that dissonance you feel is because you're looking in the wrong places; you're misaligned. You are applying the old rules to a new set of actions.* Change. This goes right back to change, to managing change. Managing this loss requires recognizing my actions. *Yeah. Think about that. You had a system in place that's gone now. It supported you for such a long time; it isn't coming back, not in the same way.* Ah, yes. *So, when do you feel the most connected? When do you feel your best-self on this new journey?*

Loss to Restoration to Alignment, an Explanation

The transformation of *both* to *only* happened *to* and *with* me. I worked with a single reality, but I oscillated between two alignments, or two frameworks: *then* and *now, both* and *only*. Described as "dual process coping" (Lundorff, Thomsen, Damkier, & O'Connor, 2019, p. 22), this phenomenon concerns the vacillations between reflecting through a restoration-orientation (RO) and a loss-orientation (LO) when living through the grief process (Lundorff et al., 2019). Loss-oriented appraisals focus on making meaning of the death, cognitively processing or reframing the related emotions, and accepting the loss. Restoration-oriented appraisals promote adaptation by identifying skills that must be learned in one's new life, rebuilding shattered assumptions about the world, and redefining one's identity, similar to the meaning-making perspective (Papa, Rummel, Garrison-Diehn, & Sewell, 2013, p. 915). Failure to oscillate or to move back and forth from loss-orientation to restoration-orientation in the grieving process can result in pathology with higher rates of pathological responses such as depression, self-harm, and suicide. Research shows that bereaved spouses who exhibit adaptive coping through RO show increases of the RO positive affect over time. Conversely, those with initial challenges of loss-orientation may continue with higher LO over time (Lundorff et al., 2019; Papa et al., 2013). My personal experience in resolving the parallax or limiting my oscillation has been critical in my developing life without my partner.

Guiding Restoration Processes

This chapter describes my employing design thinking as a problem-solving approach that permits solution making without clinging to initial assumptions. My intentional integration of design thinking processes supported my realignment toward a non-oscillating paradigm by facilitating the use of the creative arts and social psychology strategies. Employing design thinking made my self-knowledge visible. It was synthesized through the constraints of the bereavement. My objectives for restoration became clear and "grief resolution" (Papa et al., 2013, p. 915) could begin to afford restorative changes. As a visual and sensory thinker who learns and processes new information through seeing and feeling, I drew upon my already-established arts-based set of practices for my restoration activities. Such activities made available "sources of identity continuity, mastery and purpose" so that my self-evaluations could include a feeling "of being capable, strong or in control in descriptions focused on concrete behaviors" (Papa et al., 2013, p. 919 as cited in Bauer & Bonanno, 2001a, 2001b). According to Papa et al. (2013), "preservation or continuity in one's sense of self post-loss may be contingent on a sense of self-efficacy and the ability to attain concrete goals" (p. 919). My journey led me to create new art pieces and productive writing and spend much time in nature.

Sample Restoration Activities for Me

The most positive restoration-orientation activities with which I engaged during this past year included *seeing, making,* and *doing* through my art. This included anticipating the making of my art, creating a new space, exploring art, collecting materials, and increased awareness. Prior to my loss, I was engaged in this work as my own; it was a strong part of my agency. It now has significantly contributed to my increased sense of well-being as I continue.

Each of these activities aided me in explicitly expressing something inside me which needed expression. Figure 13.1 and Figure 13.2 are examples of my photographic work. In addition, studies in how art production changes the brain show that "visual art production has an impact on psychological resilience" (Bolwerk et al., 2014, p. 7) which I ascertain contributes to my restoration.

A second restorative activity within the profound healing experiences for me has been my engagement in the *art of the natural world*. Berman, Jonides, and Kaplan show that simple and brief interactions with nature can produce marked increases in cognitive control. "To consider the availability of nature as merely an amenity fails to recognize the vital importance of nature in effective cognitive functioning" (2008, p. 1211). The benefits of my being in nature included the reduction in my "directed attention" (Berman et al., 2008, p. 1207). This reduction allows a recovery of neurological processes and provides cognitive relief. Being in nature may thus add to the restorative process

FIGURE 13.1 Letting go.

Photograph by Gail Rost, 2022.

FIGURE 13.2 Shadow-bed.

Photograph by Gail Rost, 2022.

of cognitive relief. These types of activities, art making and being in nature, worked to mitigate the cognitive dissonances of the *voice* or the oscillation within my grieving process.

Through making my art and my being in nature as well as other activities I have yet to discover, I will continue to purposely influence my restorative-orientation toward a healing consonance. My own works of my doctoral studies in art education, my senses of process and identity through previous solo experiences, allowed me to retain self-efficacy (Papa et al., 2013). As I reflect on my restoration-orientation, I cognize my agency and acknowledge that although my next steps may be unknown, I can take positive actions to heal. *So, your answers lie in the opportunities you are identifying and will continue to identify. You fill your days with activities that build and restore. Don't stop making and being in and with your art. Use your hands, use your brain, try new techniques, have new conversations. Get lost in nature. But I know it's going to be rough. It will be. You are making it one step at a time.*

Notes

1 Dictionary, O. E. *"parallax, n.".* Oxford University Press. https://www.oed.com/view/Entry/137461?

2 Internet of Things Guide. *"companion device".* IoTGuide. http://internetofthings guide.com/c/cti.htm.

3 Dictionary, O. E. *"restoration, n.".* Oxford University Press. https://www.oed.com/view/Entry/137461?

4 I define parallactic in this chapter as a descriptor that has the qualities or characteristics of a parallax. Defined as "the apparent displacement or the difference in apparent direction of an object as seen from two different points not on a straight line with the object; *especially*: the angular difference in direction of a celestial body as measured from two points on the earth's orbit. With an etymology coming from Middle French *parallaxe*, from Greek *parallaxis*, from *parallassein* to change, om *para-* + *allassein*, to change, from *allos*, other" Merriam Webster, 2023. https://www.merriam-webster.com/dictionary/parallax. Used commonly as parallactic orbit, libration, or motion in astronomic studies.

References

Bauer, J., & Bonanno, G. A. (2001a). Doing and being well: Adaptive patterns of narrative self-evaluation during bereavement. *Journal of Personality, 69,* 451–482.

Bauer, J., & Bonanno, G. A. (2001b). I can, I do, I am: The narrative differentiation of self-efficacy and other self-evaluations while adapting to bereavement. *Journal of Research in Personality, 35,* 424–448.

Berman, M. G., Jonides, J., & Kaplan, S. (2008). The cognitive benefits of interacting with nature. *Psychological Science, 19*(12), 1207–1212.

Bolwerk, A., Mack-Andrick, J., Lang, F. R., Dörfler, A., & Maihöfner, C. (2014). How art changes your brain: Differential effects of visual art production and cognitive art evaluation on functional brain connectivity. *PloS One, 9*(7), 1–8.

Gerber, N., Bryl, K., Potvin, N., & Blank, C. A. (2018). Arts-based research approaches to studying mechanisms of change in the creative arts therapies. *Frontiers in Psychology, 9,* 1–18.

Kolko, J. (2010). Abductive thinking and sensemaking: The drivers of design synthesis. *Design Issues*, 26(1), 15–28.

Lundorff, M., Thomsen, D. K., Damkier, A., & O'Connor, M. (2019). How do loss- and restoration-oriented coping change across time? A prospective study on adjustment following spousal bereavement. *Anxiety, Stress, & Coping, 32*(3), 270–285.

Papa, A., Rummel, C., Garrison-Diehn, C., & Sewell, M. T. (2013). Behavioral activation for pathological grief. *Death Studies, 37*(10), 913–936.

Prigerson, H. G., Kakarala, S., Gang, J., & Maciejewski, P. K. (2021). History and status of prolonged grief disorder as a psychiatric diagnosis. *Annual Review of Clinical Psychology, 17*(1), 109–126.

Yeoman, P., & Carvalho, L. (2019). Moving between material and conceptual structure: Developing a card-based method to support design for learning. *Design Studies, 64*, 64–89.

14

THE VEILED CAMEL'S SECRETS

Ava Maken Ali

Gail and Ava met by working on this volume. As they read each other's work, it felt like Gail's quest for restoration in sorrow and Ava's camel creativity made up a secret handshake between different scholarly, imaginative ways to make lived possibilities in art.

[Who Am I in General?]

Months of contemplating how to ask important questions through my art research, and I forgot I live inside a creature (human) that is still a mystery…

I am an interdisciplinary creative practitioner. And if you haven't guessed it yet, I also happen to be a camel. That's right, a camel with artistic talent. My research revolves around portraying animals and human–animal relationships, which I explore through various media, including drawing, soft sculpture, and design in photo and video editing—I like to think of these mediums as my weapons, which you'll soon understand why. However, what truly excites me in this art research is delving into the exploration of identity, self-expression, and those intriguing interpersonal relationships (yes, including my exes) within the realm of creative writing and literature.

Animal Army? A survival mechanism, aiding in coping and avoidance.

To be completely honest, my art practice can, in a sense, be viewed as a nonviolent portrayal of animal sacrifice where animals represent sin, as suggested by one of my favorite feedback items from my friend Josh. Why? Well, as I mentioned earlier, my research focuses on the complexities of human–animal connections in the realm of creative writing and literature.

DOI: 10.4324/9781003430971-17

In this endeavor, I aim to create a secret language, a collection of curses hidden within the world of creative writing and literature. It's like creating a hidden treasure map but with more drama and fewer pirates.

By utilizing this unique artistic language, I aspire to convey deeper meanings and evoke powerful emotions in my audience. It's a way for me to express my ideas and feelings captivatingly and mysteriously. So, in a nutshell, my art becomes a means of communicating hidden messages and exploring the complexities of human–animal connections through the power of creative expression.

I, the talking camel, see you as a foolish cow!

Now, let's talk about my charming camel persona. In my art practice research, I do something quite unusual—I actually become a camel. You can call me "The Talking Camel," the one and only. Through this camel alter ego (although I dislike the term "alter ego" for unknown reasons), I transition into the entity known as "The Evil Ava," delving deep into the murky waters of my emotions and life experiences; especially the difficult and negative ones. The alter ego that emerges from my art practice is like having a darker and naughtier version of myself to play with. The camel persona allows me to be a bit of a troublemaker and metaphorically take a stand against those I wish to (although it's all in metaphorical terms). This gives me a way to openly express emotions that may not be entirely acceptable in a society that often demands me to be polite and respectful.

But how do I symbolically express my feelings toward them? I tell stories, my friend (well, maybe not really my friend, as I don't like everyone. Just kidding, or maybe not). I write tales that represent my experiences and then turn them into art, sharing lessons for myself and others to learn from. This is why I like to think of various art media as my weapons, empowering me to express and reflect upon my journey.

Let me explain it in my own words: I take on "The Evil Ava" character, portrayed as a camel, and use metaphorical animals in my creative writing to explore my past relationships and to mortify people who have hurt me. As an Iranian female, I have found freedom of self-expression in conditions of oppression through my evil persona, a camel. In my artistic journey as the one and only "The Evil Ava," my camel persona helps me to find solace, cope with life's challenges, and survive the wild ride of existence.

[Why Camel?]

Be careful! She can be a camel …

Someone once described a camel as a mix between a snake and a folding bedstead.

(Irwin, 2010, p. 14)

In his book, *Camel*, Australian wildlife photographer, conservationist, and television personality Robert Irwin (2010) sheds light on intriguing camel behaviors. When a camel is mistreated by someone, it may wait for the right moment to seek revenge by biting and kicking (p. 15). Although camels are generally gentle, they can hold grudges, expressing their displeasure through pissing and shifting. Additionally, they have the ability to spit cud from their first stomach (p. 15).

No further explanations are necessary. The readings that were meant to be read have happened; you have already gone through them!

[Art/Revenge Steps]

Now, let's break down my art practice, my process of metaphorical revenge, into two steps: step one is storytelling, where I unleash my creativity. I give human qualities or behaviors to nonhuman things like animals or objects, a technique called anthropomorphizing. Then there's dehumanizing, where I portray someone in a way that takes away their human qualities or dignity. I also dive into symbolism, using objects, actions, or images, to explore layers of meaning in the images of my work that may not be apparent at first sight. And let's use all those tools of creation, poetry, and composition; my work is a playground.

Step two is the art making itself, where I let my artistic prowess shine. I carefully implement the art weapons of my predilection (drawing, soft sculpture, and digital editing) to bring my artistic visions to life. In Figure 14.1, you can see an example of how I used my playground of the creative process and the "art weapons" of my predilection: back in 2019, I created this drawing (a chosen weapon) titled "Dwindling Tigers," inspired by one of my past's "so-called mistakes," who later proved to be just a big loser. The drawing's name was based on a T-shirt I had given him, which had dwindling tigers on it. It was all in good fun, symbolizing how his importance faded away over time (Figure 14.1).

[Camel Robot]

I want to create a robot that looks like a camel with movable joints. This camel robot will be installed next to a detailed drawing that I will draw, and it will include my voice in it. Together, the robot and the drawing will represent a camel sculptural poem, combining the realms of physical art and technological innovation. Through this camel robot, I aim to delve even deeper into the exploration of connections between humans, animals, and technology. It will serve as a unique medium to showcase the potential of art forms that involve games and robotics, pushing the boundaries of creative expression.

FIGURE 14.1 Dwindling Tigers.

Drawing by Ava Maken Ali, 2019. Photograph by Ava Aubry, 2023.

To express my troublemaker persona and confront those who have impacted me, I chose the camel identity based on religion, politics, and popular visual culture. I started this research by drawing sketches and carving basic wooden models. Now, I'm focusing on creating a large-scale wooden camel leg with movable joints. This leg will serve as a foundation for further development, adding sensors and motions to make it interactive and responsive to the audience (Figure 14.2).

For my creative project, I drew inspiration from Jane Desmond's (2016) book *Displaying Death and Animating Life*, which explores human–animal relationships in art and science and everyday life. The book's insights into the interconnectedness between humans and animals led me to create a camel robot with my human identity, blending profound symbolism with modern technology. Through this project, I aim to delve deeper into the complexities of human–animal connections, using my art as a medium for reflection and exploration while bridging the gap between our species.

The project holds particular significance for me because it allows me to express my "The Evil Ava" persona within the context of human–animal relationships. The camel robot becomes a tangible representation of the emotions and experiences I've encountered on my journey, symbolically expressing the complexities of these connections. By collaborating with engineering and

FIGURE 14.2 Initial Ideation.

Artwork by Ava Maken Ali, 2022. Photograph by Ava Aubry, 2023.

computer science students, I aim to bring this creative vision to life and enhance the interactive aspects of the camel robot. It becomes a platform to challenge conventional boundaries and provoke deeper thought about our relationship with the animal world.

This project is an extension of my overarching interest in human–animal relationships but takes it further by incorporating my artistic expression and "The Evil Ava" persona. It offers an opportunity to explore uncharted territory, using art, symbolism, and technology to convey a powerful message about the connections we share with animals and our own identities. My hope is to surprise and captivate the audience, leaving them with a deeper understanding of the mysteries and complexities of human–animal relationships.

By the way, is it really such a terrible thing that you now know about my secret experiments with art research ("The Veiled Camel's Secrets")? I always prefer to surprise and suddenly latch onto my target … whatever it may be.

References

Desmond, J. C. (2016). *Displaying death and animating life: Human-animal relations in art, science, and everyday life*. University of Chicago Press.
Irwin, R. (2010). *Camel*. Reaktion Books.

15

EXPERIMENT WITH ART RESEARCH*

Becoming the "oddist"

Niki Nolin

After graduating from a small midwestern college, my roommate and I flew to Rhode Island to visit with a former classmate. When we arrived at the airport, one of her friends with a strong East Coast accent asked us, "which one is the oddest?" We looked at each other with puzzled expressions and both replied: "Well, we're both kind of odd." She then laughed and said: "No, the painter, the painter!" I replied: "Oh, that's me. I'm the artist … the 'oddest,' the painter."

Over the years, as an artist, I have realized that being the "oddest" wasn't that far off the mark!

When I began teaching art, I became a performance artist in addition to the media that I use in my practice.

Hopefully, now, as both a teacher and a practicing artist, my students all join me in the act of becoming an "oddist" by using spontaneity and play to inform their work.

Art can feel so serious, and it is. The struggles of art students are real. The image of the artist starving in a garret runs deep in our society. Art students struggle with security, including the anxiety of family approval and their own fears for the future. Learning to become an artist is a personal challenge which requires trusting one's inner voice and learning skills to develop ideas that make art practice a viable reality. We all live in a visual world and the pursuit of art is a valuable activity. The ability to create and contribute in creative ways to one's community and develop the necessary collaborative skills are tools artists need to succeed.

* A Companion Piece to "The Veiled Camel Camel's Secrets" by Ava Maken Ali.

DOI: 10.4324/9781003430971-18

Using play as a learning tool that encourages discovery, promotes risk taking, and encourages laughter is necessary for becoming a collaborative artist within a community. To laugh opens new ideas, the ability to see more than one side of any project/goal, and most important, develops the ability to listen. Collaboration in art creates new ideas that are more powerful than what an individual could accomplish alone. Community allows us to share our common goals. Art can promote with more impact than what we can say in words alone and collaborative creation's dynamics of interaction often create laughter that lightens the mood and accelerates the work.

Placing students in a group, not of their own choosing, begins the process of creation with a note of newness and uncertainty. Providing project guidelines as needed introduces the framework necessary for group bonding to begin. Choosing photography destinations provides uniform context and resources for students to begin their work together. Subsequently, reviewing their generated photographs and analyzing their process to obtain them create a valuable camaraderie and shared sense of achievement. Sketching projection of their final images, choosing a color pallet, and beginning to realize their final project further develops a feeling of success from the entire experience.

Much laughter happens.

Collaborative Drawing Practice: Large Group Project

Artistic collaboration, a socially engaged practice, involves students in debate/ conversation and social interaction to learn their environment and create a large drawing. This collaborative drawing assignment process is organized to introduce a participatory element to artists that usually draw alone. The social interaction becomes part of the art. And it is fun.

Getting to know the city through drawing: Chicago collection and projection project.

Designate groups for large collaborative drawings: Count off "1, 2, 3" around the room to create three or four groups of students with approximately five students per group.

Organization:

1. Designate a Photoshop expert in each group (should have laptop).
2. Share text/email for contact information.
3. Determine meeting times (online or in real space) with your group:

 • To discuss and plan collaboration project.
 • To determine area(s) in the city you would like to explore.
 • To work in Photoshop.

4. Photograph the city:

 • Each group meets to decide if they are going photograph Chicago using 1 point, 2 point, or 3-point perspective.
 • Decide if they are going to work together or separately to collect images.

5. Each person should submit five photos of five different spaces.
6. During class, each group will spend time selecting and compositing the images (Photoshop) into a cohesive whole. Each group member should submit at least one image.
7. Photoshop collaboration:

 • Determine image orientation: landscape or portrait.
 • Discuss ideas and placement of the images.
 • Align the images using perspective skills.

8. Connect image to projector.
9. Final drawing must be the width of the provided paper, approximately 44 × 60 inches.
10. Choose color strategy: at least three colors.
11. Draw the projected image on the paper.
12. Share drawing space and move around the image.
13. Identify group member strengths and color the image.
14. Document and share the work.

16

AFTER CAMPECHE

An Arts-Based Research Approach to Exploring Masculinity

Jean Carlos Valentin Velilla

Ava and Jean Carlos got to know each other while playing a board game on Ishita Dharap's apartment floor. Two long scrolls of Ishita's loose charcoal drawings, maybe six feet each, stretched along the walls, and new friendships were another loose drawing in the making. One of the scrolls showed a river with mythical creatures. And, weirdly, the board game was about camels?

From Where Can We Extract Affects When Words Alone Are Not Enough?

As an arts-based researcher, I take part in the organization and creation of images that attend to self-referencing male subjectivity and move beyond what words can do through qualitative study. I work with Puerto Rican genealogical processes and the autoethnography in ways that benefit from sociological methods like semi-structured interviews and open coding. I am drawn to Arts-Based Research (ABR) because it is characterized by a resistance to reducible, replicable, and results-attached research. ABR is a methodology that centers art as the source and object of emergent research (Rolling, 2013, p. 103). In contrast to arts-informed research, which sees art as an additive process to augment the data collection process, ABR understands art as centrally important. To put it differently, ABR is not only extractive but productive. In the case of my project, this production happens through visualization and drawing around the idealized male subject from the perspective of Puerto Rican men. To arrive at such drawings, I rely on a series of other artistic processes that work as the raw material from which the content is drawn.

DOI: 10.4324/9781003430971-19

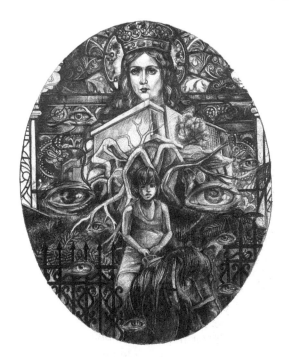

FIGURE 16.1 Autoretrato Numero Uno.

Artwork by Jean Carlos Valentin Velilla, 2022.

This work includes four procedural stages: A) the elaboration of a genea-
logical map; B) the creation of letters around the participant's male relatives
in literal and figurative communication; C) the exploration of imagery in an
archive curated through mutual participation between the participants and
the researcher; and D) the synthesizing of ideas through co-construction of
two artworks per participant (Figure 16.1).

Part A), the genealogical map, is straightforward albeit time consuming in
that it requires the participant to rummage through familial documents and
find as many images as possible to construct an assemblage that is akin to an
extensive family portrait. This includes a pre- and post-process interview
about what the experience was like and what sorts of insights, trouble, and
findings arose as the participant looked for said images.

From here, in part B) the participant drafts a series of three letters to male
relatives of their choosing. These letters will be split into three separate stages:
a formal written letter, a letter using both collage and written elements, and
an abstract letter exploring the nonverbal qualities of the relationship.

In part C), the researcher and participant explore two separate archives.
The first is constructed through the investigation of the participant's home of
origin and it will include floor plans, models, and notes about the space.
The second archive includes historical and pop cultural images brought by

the researcher, as well as images contributed by the participant. The participant engages in a process in which they are asked to identify, counter-identify, or dis(identify) with every image in the second archive.

In part D), the researcher explores the collected data to co-construct two artworks with the participants. One of the artworks centers on the participant's childhood memories around the home. The second artwork is a portrait that considers and synthesizes all the participant's experiences in the arts-based research project. The arts-based researcher co-constructs this piece with the participant although the major elaboration falls on the researcher's responsibility. This is similar to the process of artistic commissions.

Purpose, Justification, and Elaboration

As Fernando Estrada, Araceli Mejia, and Alyssa Mae Hufana (2017) have noted, there is an "undersupply of knowledge on the social experiences of Latino men—part of one of the fastest growing populations in the country with one of the lowest levels of postsecondary education achievement" (p. 315). Scholars like Derrick Brooms, Jelisa Clark, and Matthew Smith (2018) have suggested that Latino males are considered invisible, vanishing, or missing from campuses of higher education. I agree with Estrada et al. (2017) that, as with other underrepresented groups, reducing the education gap facing men from families with origins in the Caribbean "involves not only addressing scholastic outcomes like grade point average (GPA) but also the quality of their interactions with peers" (p. 315). I would take this one step further and suggest that the affective quality of male-to-male relationships and socialization in Puerto Rico could not be extracted through quantitative or qualitative explorations alone, as these would address only the context of their university environments. I believe that ABR offers valuable tools to explore relationships among Puerto Rican men, filling in those gaps through unraveling the domestic world that Puerto Rican men inhabit. The work that I am currently producing emphasizes the experience of Caribbean men in Puerto Rico. I begin this research through narrativizing the experiences and attitudes of the men who are in my immediate surroundings. Namely, my brothers, their sons, uncles, nephews, neighbors, and partners.

To this effect, genealogical charts are the first and most important step in my research process as they act as a platform for core ideas. As Alice Bee Kasakoff (2019) writes, genealogical maps have a usefulness in "visualizing and understanding changing patterns of kin dispersion over time," and seeing changes and trends of "health and social mobility" of growing families (p. 1). I believe these maps are also a way to activate conversations that could be useful in the production of qualitative data about the type of relationships held between members of a family unit; this could perhaps provide insight into the origins of behavior and conduct.

Part B introduces letter writing as a means of directing participants' attention while considering the genealogical map, and addressing individuals who appear frequently in shared histories. As Patricia Trzeszczyńska (2018) suggests, letters have been historically used for the analysis of social change, interpreting processes of adaptation, and conditions of life through circumstances of immigration. Yet today, "they are rarely used by sociologist and anthropologist" for "too many reasons such as researcher's suspiciousness, the difficulty in finding a set of letters, or the fact that letter writing is a dying art" (Trzeszczyńska, 2018, p. 48). Arts-based research could revitalize the use of the letter by designating an immediate intention to archive and preserve its content as a cultural artifact.

Before moving on to the final stage of producing illustrations, the participant engages in co-creating an archive. This moving through research via objects is formally known as elicitations: "ways to create a context where the participant speaks about her experiences elicited by some sort of external trigger" (Bhattacharya, 2017, p. 52). As Kakali Bhattacharya (2017) explains, "This trigger could be pictures, objects, tasks, videos, lyrics, websites, etc. Either the participant identifies objects or pictures or triggers that are meaningful to her, or the researcher provides such triggers to the participant to generate conversations" (p. 52). This might look like the convergence between historical items and pop cultural references.

The last portion of this project synthesizes all the above. Through the researcher, the participant and researcher co-create illustrations that come to stand in as idealized manifestations of their experiences of male subjectivity. The first illustration focuses on the domestic sphere and childhood because I am searching for the early formative memories. The second illustration is based on memories related to adolescence and adulthood to offer a perspective on the participants' lived experiences.

Melisa Cahnmann-Taylor (2008) poses the central question, what do the arts add to research projects and our general understanding of a topic under study? (p. 3). She suggests that ABR methods need not define themselves against traditional approaches to inquiry (p. 4). Instead, ABR should stretch a "researcher's capacities for creativity and knowing by producing a hybrid that supports creating a healthy synthesis" that accounts for how every way of seeing is a way not seeing (Cahnmann-Taylor, 2008, p. 4). Through this methodological approach, the following avenues are opened:

the creation of a virtual reality and a degree of textual ambiguity; the presence of expressive, contextualized, and vernacular forms of language; the promotion of empathetic participation in the lives of a study's participants; and the presence of an aesthetic form through unique, personal signature of the researcher.

(p. 8)

Building on Cahnmann-Taylor's insights, my research employs a hybrid that aims to: A) make new and insightful sense of data, B) resist the dualism in research that draws strict boundaries between researcher and participant, and C) speak to diverse audiences with an accessible vernacular. Finally, ABR allows us to move beyond words, into imagery and experience, as we discover and create lived affects.

References

Bhattacharya, K. (2017). *Fundamentals of qualitative research*. Routledge.

Brooms, D. R., Clark, J., & Smith, M. (2018). Being and becoming men of character: Exploring Latino and Black Males' brotherhood and masculinity through leadership in college. *Journal of Hispanic Higher Education*, *17*(4), 317–331.

Cahnmann-Taylor, M. (2008). Arts-based research in education: Histories and new directions. In M. Cahnmann-Taylor & R. Siegesmund (Eds.), *Arts-based research in education: Foundations for practice* (pp. 3–15). Routledge.

Estrada, F., Mejia, A., & Hufana, A. M. (2017). Brotherhood and college Latinos: A phenomenological study. *Journal of Hispanic Higher Education*, *16*(4), 314–337.

Kasakoff, A. B. (2019). The changing space of families: A genealogical approach. *Social Science History*, *43*(1), 1–29.

Rolling, J. H. (2013). *Arts-based research primer*. Peter Lang.

Trzeszczyńska, P. (2018). Bridges to the past: A Lemko family history explored through letters. An ethnographic case study. *Canadian Slavonic Papers=Revue Canadienne Des Slavistes*, *60*(1), 44–69.

17

EL CALLEJÓN DEL HOSPITAL*

Emmanuel Francisco Navarro Pizarro

The cultural work that I carry out is engaged with the material practices of drawing and painting as tools of memory (Figure 17.1). Through drawing, cultural workers in the visual arts document and intervene with settings that might otherwise be missed with new technologies of record and representation like video and the camera. Historically, painting was used to commemorate events and as a form of advertisement and propaganda in Puerto Rico that situated happenings in conversation with each other in complex ways. This history continues now. In painting a beach scene, the emphasis in materials like fences and waste become important references and storytelling tools that tell us about neo-coloniality and the current struggle for the use of public space.

My practices are currently carried out *en plein air* inspired by the work of Joaquín Sorolla. Painting makes me feel connected to a history that has evaded Puerto Rican scholarship. Some of those things include folk painting of the countryside here in Puerto Rico, the racialized history of the Puerto Rican academy, the class-based structure of education that has made transportation and funding for many precarious, and a general lack of intellectual resources that reflect the placement of art education as always elsewhere for Puerto Ricans through historical practices of Spanish colonialism and US imperialism. Drawing and painting attend to these histories through re-documenting the current moment through everyday citizenship and connecting to a broad spectrum of audiences both educated and uneducated in fine art practices.

* A Companion Piece to "After Campeche: An Arts Based Research Approach to Exploring Masculinity" by Jean Carlos Valentin Velilla.

DOI: 10.4324/9781003430971-20

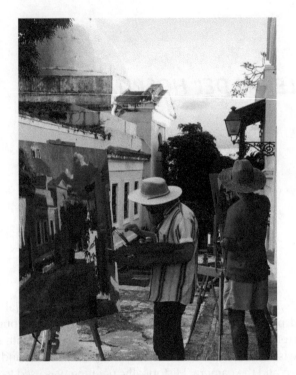

FIGURE 17.1 *El Callejón del Hospital.*

Artwork by Emmanuel Francisco Navarro Pizarro, 2022.

18
OUR CHAPTER, YOUR CHAPTER

Shannalia Reyes and Everardo Reyes

While working on this volume, Jean Carlos, Shannalia, and Ever met formally through a phone call one Saturday afternoon. They talked about histories of arrival: what it might be like to arrive at a doctoral program as a parent, how they arrived at their particular methodologies, how we arrive at the possibility of changing the language and mode of scholarship. Now they're art pen pals.

Our Chapter

We met 11 years and three weeks ago. We secretly got married at the DMV—today is our 11-year anniversary. Celebrating as a family, we are at the kitchen table, eating dinner and talking about what we are doing *inside* arts-based research. Surrounded by sounds of utensils clashing against plates, the room is filled with chatter of our kids and cartoon noises. We talk about the chapter we have been imagining and trying to write for months. This is arts-based research.[1]

Academic Real[ism]

Everardo: "We've got to sell it to them! Okay, before you read our chapter, you have to know a few things."

Shannalia: "Oh yeah, it would be great if it was our chapter, your chapter."

DOI: 10.4324/9781003430971-21

Everardo: "We HAVE to write something."

The cheese packet from the boxed macaroni falls from the counter and Everardo catches it right before it hits the floor, the kids and us yell "OOOOOOOOOOOO!" One of the kids asks, "Is the incus a real thing? A real bone?"

Everardo: "I don't think they'll let us publish this."

Shannalia: "No, most definitely not!"

Everardo: "It has been fun though, such a good idea."

Shannalia: (urgently): "We should type it out. Maybe, this could be our introduction. Oh, write this down."

Everardo types,

> **Shannalia: "I don't think they are going to let us publish this, but we are going to try anyway. I wonder, what is the best that can happen?"**

Everardo: "I like that a lot."

Shannalia: "That's 'Our Chapter.'"

Everardo: "For 'Your Chapter,' we have to tell the reader/artist that the pages are unfilled not empty, to highlight the possibilities for them to add themselves to the book[2]." [Everardo looks at you, the reader/artist]

We finish dinner and the kids chant, "pizza, pizza, pizza" in chorus, apparently still hungry. There is food on the floor (Figure 18.1). Our oldest leaves to the living room to work on a "special project." We look up incus on the internet—it is a real thing.

Everardo: "Happy Anniversary."

FIGURE 18.1 *Computer, food, remote, with family.*
Photograph by Shannalia Reyes, 2023.

Your Chapter

Notes

1 This is not Arts-Based Research, it is a representation of arts-based research (Magritte, 1929).
2 Everardo: "Like that John Cage performance 4'33. If there is no such thing as silence, then there is no such thing as a blank page" (Cage, 1952/1953).

References

Cage, J. (1952/1953). *(4'33" [In Proportional Notation])* [Ink on paper]. New York, NY: Museum of Modern Art. https://www.moma.org/collection/works/163616

Magritte, R. (1929). *(La trahison des images [Ceci n'est pas une pipe])* [Painting]. Los Angeles, CA: Los Angeles County Museum of Art. https://collections.lacma.org/node/239578

PART 3

Translations/Relations

Experiments in Writing to Each Other

PART 3

Translations/Relations

Experiments in Writing to Each Other

19

LINEAGE OF AFFECTION

A Letter

Natalia Espinel

Late November—2021
Urbana-Champaign
To: Cesar Peña

Querido amigo,

This letter is my response to one of the final assignments for Sarah Travis' class *Curriculum Development in Art*. Sarah invited us to write our curriculum philosophy integrating our teaching experience and our learning process during the semester. I wanted to extend her invitation to connect with you, intersecting the courses of our lives.

I wanted to write to you some time ago, but, as you know, the first semester as a PhD student is challenging at many different levels. This letter is, however, an attempt to meet with you through some of my experiences. It is also a tribute to your affection for this program and its people. How you talked to me about your time as a PhD student at the University of Illinois Urbana-Champaign (UIUC) was a powerful impulse for me to specifically come here. I will always be grateful to you for inspiring me with your love and trust for this community.

When I arrived, I found exactly that: love and trust. Both things connected me with the core of my practice as an artist and teacher. I felt welcomed, safe, and ready to be vulnerable; to be myself with joy and openness. We arrived at the Armory and Jorge Lucero came to pick us up. It was the first time that I saw him in person, but I felt familiarity; strong bonds of mutual care and interest. Perhaps, I arrived a long time ago through other people. I arrived with Catalina Hernández-Cabal, and, without knowing, I arrived with you.

DOI: 10.4324/9781003430971-23

As José Saramago (2008/2017) writes in the opening of his book *The Elephant's Journey*, "In the end, we always arrive at the place where we are expected." This journey started years before.

I've been feeling a strong net of relations between past and new students and professors. All of you have created a powerful connective tissue that holds us together. There is a lineage of affection that is supporting my growth—grounding me and, at the same time, extending my ideas. I'm grateful for what you all have set in motion with your inquiries and curiosity. Each of you created space for something new to emerge, so the ones coming later have more possibilities to develop our practices and inquiries, opening spaces for life to grow stronger. If we create a little more space grounded in this lineage of affection, generosity will continue to be the only way we come together.

There is history in any curriculum made by traces that influence what is about to happen. They give the ones here and now the strength to push the edges a little further. I read your traces, and, from that careful reading, I create new marks that will prepare the surface—of the academy, the class, the curriculum—for someone else. I propose a curriculum practice where we first recognize the marks left by others. We can offer something new to join a stream already in motion from that intentional exercise.

Cesar, Jorge, Sarah, Catalina, Paulina, Jennifer, Laura, Samantha, Azlan, Tim, Rachel, Jean Carlos, Natalie, Kaleb, Shivani, Paria, Gail, and more!

My community is my practice. My community is my curriculum.

William Pinar (1975/1994, 2011) talks about the curriculum as *currere*, as the course of our lives. He proposes an autobiographical examination of how the past and the future generate one's present and how multiple courses, currents, and *curreres* intersect in a particular time and space. The intersection of those *curreres* is what creates the curriculum. This juncture will never happen again. We decided to share this moment—we sensed in our bodies the resonance of our coming together. We knew that, here, we would learn whatever we needed to learn. When you were telling me about your experience as a student, I also attended to the brightness in your eyes, the expansiveness of your breathing, your open-heartedness, and your curiosity. All those elements created an impulse in me to come.

Since I arrived, I have felt that the closest thing to happiness was feeling gratitude. I was just at the beginning of my first semester when Sebastian's father called us to notify us that Yamile (his beloved wife) suddenly passed away, working at her house, surrounded by the traces of her life and the memory of her son, Antonio. When Yamile died, we surprisingly felt an immense sense of gratitude. We left everything in Colombia, our house, family, and friends. It was hard. However, what kept us strong was the feeling of gratitude and the tenderness that this feeling awakened. Gratitude is a practice, an intentional effort, and an action I must remember daily. The curriculum unfolds from this practice because gratitude creates space to learn new things.

We also lost Margarita, the best friend of Sebastian's mother, Norma. One of the things that I admired the most about Margarita was her genuine interest in people. Also, her way of expressing joy even in the most challenging moments of her illness when she almost couldn't move her body. Every time we went to visit Norma, we also saw Margarita. She was always very curious about my projects. The last time that I saw her, we talked about the idea of "moving towards the other." It was before coming here. I explained to her that I was thinking of four stages for this project (that I wanted to develop in my PhD studies).

The first movement, or stage, is the initial impulse that makes us move towards other beings. This impulse can be our curiosity, genuine interest, or motivation to move closer. It can also be an ethical urge that literally makes our bodies move out of place to meet the other. Imagine that someone is falling; your impulse is to jump and help. This caring and ethical urge happens at different levels, but it always carries a strong pull that moves our bodies out of place towards others. The second stage is the movement of the body in space. The way my movement unfolds in the space and how it leaves a trace, creating a drawing. The third stage is the actual encounter. The moment of encountering the other is complex and beautiful. It is, probably, the richest stage of all. The last moment is the separation, moving away from the other. I've been thinking a lot lately about this stage and its relation to death. It is the moment in which we understand how our encounters with others have transformed us. There are multiple connections between "moving towards the other" and my curriculum philosophy. The four stages that I mentioned before are the core of my curriculum practice.

For my curriculum unit (another class project), I developed a series of collaborations with my classmates. Instead of being a unit, the curriculum became a multiplicity of emerging encounters. It began with the idea of a collaborative tool kit that evolved into the logistics and efforts of finding time and space to be with each other. From that time together, we left traces that prepared the surface of the class for future collaborations. The curriculum is the process of coming together. It is the encounter and the multiple unfoldings of that encounter.

I want to share a photograph of a *box* as a curriculum unit and syllabus that I created with a series of materials to engage in collaboration (Figure 19.1). The box is created to be assembled and disassembled in multiple ways; it has clear and opaque sides and circular openings. Among the things the box contains, there is a set of cards to "play the course of life," a series of wooden cards with symbols and words that invite participants to revisit critical moments of their personal history (Figure 19.2). The idea is to relate to personal history playfully and more simply, retelling stories and combining moments in collaboration with others. It also contains the app *Somatic Agitations*, that invites embodied ways of relational experimentation.

FIGURE 19.1 Curriculum box.

Artwork by Natalia Espinel, 2021.

As the invitation at the beginning of the app explains: "Agitation refers to the action of being active, of setting in motion, shaking and, perhaps, transforming. *Somatic Agitations* touch on embodied dynamics that unsettle a disembodied and normative relationship with our bodies, others, and surroundings." These materials, among others, offer new ways of approaching the curriculum and the syllabus based on collaboration and embodied forms of relationality.

A curriculum is a breathing organism; it expands and contracts, wrapping and unwrapping. We wrap what we think is important for our teaching—like an embrace. We hold tight to those things together. By unwrapping, the curriculum opens to include further possibilities, ideas, and desires. As a teacher, I'm very sensitive to the breathing of the class—when to wrap, contain, or hold and when to unwrap and release, giving space for new things to become part of the curriculum. I've trained my somatic perception to sense this wrapping and unwrapping process, creating a practice of embodied receptivity—a quality of being attentive to others and my surroundings. Years of training in somatics, dance, and other embodiment practices have given me an acute perception of the needs of others and the needs of the class. I taught and trained myself in that expanded receptivity.

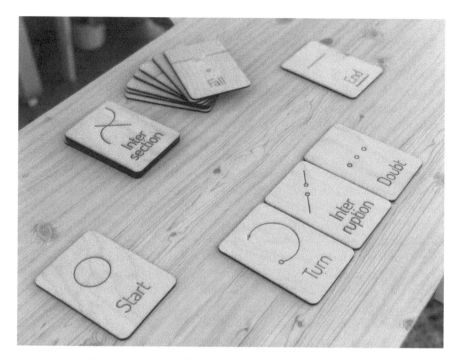

FIGURE 19.2 Currere Game: Cards to play the course of life.

Artwork by Natalia Espinel, 2021.

Learning and teaching are not solely cognitive acts, but embodied senso-rial and deeply relational processes. However, we lack the tools for embodied engagement in the classroom. Moreover, teachers haven't often had the opportunity or the willingness to create for themselves a practice of embodied awareness. Our bodies are, many times, disengaged from what we are trying to communicate. How do we cultivate an expanded understanding of our embodied presence in the classroom? Antonia Darder (2009) calls for special attention to this; she writes: "The sensuality of the body is discouraged in schools through the prominent practice of immobilizing students' bodies within hard chairs and desks that contain and restrict their contact with one another and the environment around them" (p. 21). If we create classes for inactive bodies that are constrained to chairs and desks, we won't see the richness of our living experiences unfolding. We need movement, sensory expansiveness, a haptic communication that connects us with the flesh of the world.

Almost all the readings we discuss in our curriculum development class situate the embodied experience at the center of the conversation. However, I can sense how they are entrenched in notions that don't necessarily trans-verse the experience of the person who writes. In classes, most of the time, we

discuss readings and ideas in very disembodied ways. I always lack specific examples or somatic descriptions that express how those concepts are felt in the skin and are negotiated through weight and tension, time, space, and proximity. We talk about our bodies as if they were somewhere else. We talk about other people's bodies as if they weren't intertwined with ours.

It takes time to trust our bodies' know-how—the flesh of our intuition, the epistemologies of our feelings and sensations. As bell hooks (1994) states, we need "knowledge about how to live in the world" (p. 15), and for that, we need "the will to know and the will to become" (p. 19), letting the things we learn have an impact on the ways we live and relate to others. Ultimately, the curriculum-as-lived and -embodied experiences become an attitude, a form of being-with-others in the world. As Erich Fromm (1956) writes, "Love is not primarily a relationship to a specific person; it is an attitude, an orientation of character which determines the relatedness of a person to the world as a whole, not toward one 'object' of love" (p. 46). When I was teaching in Colombia, I noticed over and over that my classes were opportunities to invite students to relate to each other in different ways, always through art. More than teaching a specific subject matter, I was cultivating that extended receptivity to be with and for others.

Thank you for reading this letter. I hope we can continue finding ways to intertwine the courses of our lives.

Un abrazo inmenso,

Natalia

References

Darder, A. (2009). Decolonizing the flesh: The body, pedagogy, and inequality. *Counterpoints, 369*, 217–232.

Fromm, E. (1956). *The art of loving*. Harper & Row.

hooks, b. (1994). *Teaching to transgress: Education as the practice of freedom*. Routledge.

Saramago, J. (2017). *The elephant's journey* (M. J. Costa, Trans.). Vintage. (Original work published 2008).

Pinar, W. F. (1994). The method of *currere*. In W. F. Pinar (Ed.), *Autobiography, politics and sexuality: Essays in curriculum theory, 1972–1992*. Peter Lang. (Original work published 1975)

Pinar, W. F. (2011). *What is curriculum theory?* (3rd ed.). Routledge.

20

A SINGLE CONNECTION*

Urbana-Bogotá

Cesar Peña

English Version

Dear Nata, thank you for making me part of what you called your "lineage of affection"—which I loved, by the way, and I am really honored to be part of. It is gratifying to know that my body, my voice, my eyes, and lastly, my voice, successfully communicated the several and varied layers of affection linked to my time and experience at the art education program at the University of Illinois Urbana-Champaign (UIUC). This letter was never written. ... Well, it was not written until now, because back then, I decided to try and let my body speak through my throat and my voice. Now, I am going to add some more layers because this was originally written in Spanish, and you will read the final version in English.

Your letter took me to different moments and feelings about my life in Urbana-Champaign, particularly, regarding the web of affection that—along with my wife and children—I metaphorically left behind, but which we are still carrying deep within us. When you asked me about my experience at UIUC, it was a great opportunity to rethink my narrative from your perspective and realize that I was part of a puzzle; part of something larger than my own body, ego, and family. I understood that I am still part of a body and a fabric that goes beyond our own bodies and territory. To know that you finally got there and that you found love, affection, well-being, and proximity, is as satisfying as if it were me and my family finding the same. The image of Jorge Lucero picking you up at Armory was very touching and it brought back my own memories when Michael and Marilyn Parsons picked us up to get some

* A Companion Piece to "Lineage of Affection: A Letter" by Natalia Espinel.

DOI: 10.4324/9781003430971-24

furniture for our new place at the event called "dump and run." A few days ago, I was attending a parent-teacher conference at my kids' school about adolescence, and someone dropped the sentence "it takes a village to raise a kid." I extrapolated and adopted this idea—that makes sense to describe the experience of having and raising teenagers—to understand how probably we all need a village to help raise ourselves. An essential part of my village is the art education program at UIUC. While I am writing this, I notice that my understanding of "village" in this case also stands for humanism; this is something I found not only in the program but in different scenarios at the University. "Moving towards the other," is an expression you use that allows me to understand that the world is not so unpleasant as sometimes the news try to convince us that it is: that there is room for caring about each other, for kindness, and selflessness. I have not realized, but I think that many of the curricular changes and updates to my syllabi have been, one way or the other, informed by this principle. Coincidentally, last semester I taught a course on image analysis and critical theory where I invited Susan Livingston, a friend from my PhD program, and after her presentation, my students and I discussed about curriculum. In that discussion, I had a glimpse into some of the ideas you posited in your letter: the curriculum can be understood as a living organism that moves around, breathes, skips, and sometimes trips, but overall, decidedly moves forward. The idea of embodying communication with your students was both intriguing and provocative. Especially because it breaks apart the contractual nature of the syllabi and turns it into a living organism that fosters connection. Likewise, the concept of "sensuality of the body in the classroom" dismantles the comprehension of the student exclusively as a thinking unit separated from their body. Within the context of the courses that I teach—theoretical seminars that unfolded also in the pandemic—sensuality in the classroom requires me to root my ideas in my body, to be able to teach such ideas with it. I was recently reading and discussing Juhani Pallasmaa's "The Thinking Hand," particularly on the general idea about how we must embody our thoughts to be able to really own them. I learned a lot from Jorge's conception of teaching as a performative act. From our friendship, I was moved by the way he argued and strongly believed that performing was embodying, caring, trusting, and believing, all at the same time. Many of those performances were supported by delicious Mexican American food and the love and care of his family. Keeping in mind Jorge's approach to teaching, I cannot help but examine my own teaching practices here, in Bogotá.

Through your letter, dear Nata, I embodied and re-lived the experience of adventure, which was also of dislocation. Past and future come together in a single experience, but for once they do not invoke depression or anxiety, but the vertigo of leaving all behind and the expectation of finding everything to come.

I asked my wife (Clau) to read your letter again to help me get into the right mindset and connect again with our time there so I could write this text. Clau was moved to tears. Afterwards, I could not stop writing. We both embodied the connection with you, with Jorge, with our dearest friend Jen and, overall, with the Urbana-Champaign community. Love is not a relationship with another person but with the whole, with the universe—like Fromm's quote says in your letter. We are part of the whole. We are the whole and the parts. A great synecdoche of intertwined stories. A single connection.

Spanish Version

Querida Nata, primero que todo, muchísimas gracias por incluirme dentro de tu "linaje de afectos", una expresión que me encantó y de la cual me siento muy honrado de haber sido incluido. Me da una gran satisfacción saber que mi cuerpo, mi voz, mis ojos y, por último, mis palabras, lograron transmitir las múltiples y profundas capas de afecto ligadas a mi paso por el programa de Art Education en UIUC. Esta carta nunca se escribió, o bueno, hasta ahora se escribió, porque decidí que fuera mi cuerpo a través de mi voz la que te siguiera interpelando y hablando.

Tu texto me conectó con diferentes partes y aspectos de mi vida en Urbana-Champaign. Particularmente me conecta con el programa y con la red de afectos que, junto con mi esposa y mis hijos, dejamos atrás metafóricamente, pero que seguimos llevando muy dentro en el corazón y que aún representa una fuerza vital a la distancia, aquí en Bogotá. Reencontrarme con mi relato sobre ese sitio a través de tu expectativa por ir a estudiar allá, me hizo entenderme como una pieza de un rompecabezas, como parte de un todo y de algo más grande que mi pequeño ego o que como una pequeña unidad familiar. Entendí que soy parte de un cuerpo y de un tejido que escapa a nuestras corporalidades y la pertenencia a un territorio. Saber que llegaste a UC y encontraste afecto, cuidado, bienestar y cercanía, fue tan satisfactorio para nosotros como si lo hubiéramos recibido directamente. La imagen de Jorge recogiéndote en Armory, movió las fibras más profundas y los recuerdos más cálidos de, en mi caso, Mike y Marilyn Parsons recogiéndonos para trastearnos por la ciudad a comprar muebles y atender eventos y bienvenidas. Hace poco en una reunión del colegio de mis hijos, en una conferencia sobre adolescencia, dijeron la frase "it takes a village to raise a kid." Esa noción, que inicialmente me pareció perfecta para describir la situación de criar a un hijo adolescente, rápidamente la extrapolé y la apliqué para entender cómo todos los necesitamos un village to raise ourselves. Definitivamente nuestro programa de Art Education en UC, es parte esencial de esa village. Al tiempo que escribo esto, me doy cuenta de que "Village stands for humanism," algo que encontré no solo en el programa sino en varios espacios académicos y no académicos de la Universidad. "Moving towards the other," es una

expresión que usas en tu texto y que permite entender que este mundo no es tan desapacible como a ratos las noticias y las redes sociales nos pretenden hacer creer, sino que hay espacio para la belleza, el humanismo y la generosidad. No lo había pensado, pero creo que todos los cambios curriculares que he venido implementando desde hace un tiempo, han estado informados de una u otra manera por esta noción. Casualmente, hace poco estuve discutiendo temas curriculares con un grupo de estudiantes que están tomando un curso electivo conmigo y, después de una charla a la que invité a mi compañera de doctorado Susie Livingstone, vía Zoom, entendí lo que planteas sobre el curriculum no como algo inerte sino como un organismo viviente que se mueve, respira y trastabilla de vez en cuando pero también marcha con firmeza. La idea de encarnar la comunicación con tus estudiantes, me pareció una idea inquietante y provocativa en la medida en que necesariamente conduce a romper la naturaleza contractual del syllabus y lo hace trascender al plano de la conexión. De la misma manera, el concepto de "sensuality of the body in the classroom" desmantela la concepción del estudiante como una unidad exclusivamente pensante. Esto, en el contexto de las clases que yo dicto (seminarios teóricos y en el contexto también de la pandemia), implica entender que mis ideas necesitan estar instaladas en mi cuerpo para ser enseñadas a través del mismo. Cuando tuvimos este intercambio justo estábamos discutiendo en una de mis clases el texto La Mano que Piensa de Juhani Pallasmaa y su planteamiento sobre la forma en que el pensamiento necesariamente se encarna; Si esto no sucede, entonces algo se está perdiendo. De Jorge aprendí muchísimo a través de su concepción de la docencia como una acción performativa. No tomé clases con él pero a través de nuestra amistad me conmovió su argumentación alrededor de su idea de la docencia y me confrontó mucho con la forma en que yo la concibo y ejerzo.

A través de tu carta, mi Nata, encarné de nuevo la experiencia de la aventura, pero también de la dislocación. El pasado y el futuro se juntan en una sola experiencia, pero por una vez no conjuran la depresión ni la ansiedad sino el vértigo de dejar todo atrás y la expectativa de encontrar todo adelante. Mi esposa y yo volvimos a leer la carta porque le pedí el favor para ayudarme a entrar en situación, tanto mental, como espiritual y corporalmente para poder escribir este texto. Clau terminó muy conmovida llorando y yo no pude parar de escribir. Ambos encarnamos la conexión contigo, con el territorio y la comunidad. El amor no es una relación con otra persona sino con el todo, con el universo, es lo que dice la cita de Fromm que incluyes en tu carta. Somos parte de un todo. Somos el todo y las partes. Una gran sinécdoque de historias que se entrelazan. Una sola conexión.

21

TO MEET IN GESTURE

A Place, a Dance, a Drawing, a Study

Catalina Hernández-Cabal

About 15 years ago, Natalia and Catalina met dancing at Universidad Javeriana in Bogotá, Colombia. They follow each other's vital inquiries as collaborators and comadres, support each other's creative and academic journeys, and share the most challenging and rich moments of their lives. Together they also develop MovEncounters (movencounters.com), an ongoing project about collaboration and closeness, scores, and generative ways of being in relational tension.

Come on in.

Sit down wherever you feel comfortable. Let your back rest against the wall if you want or just hold yourself up feeling the weight of your back held by your spine and your core muscles. As you sit there, take a couple of breaths, and be prepared to become involved in a practice of movement study, as a witness.

Pause, observe, shift your position …

Begin.

What gestures keep you in connection with bodies we love? Can these gestures teach you something? Or take you somewhere? What place are these gestures?

Where is that gesture coming from? What history, which stories?

Alternatively: Think of someone you love.

Revisit your experience of their movement. Inhabit it. Repeat it. What gestures do you find? What connections do you find between that person's gesture and their history? Between your gestures and your history?

DOI: 10.4324/9781003430971-25

Imagine that is the only information you have when meeting someone: their name, their gesture, their gesture's brief biography. Now you share your name, your gesture, your gesture's brief biography. You will study these gestures together, revisiting them over and over. Soon, you will begin noticing the stories and struggles that constitute the movement patterns and muscle tone needed to execute your gestures.

Now imagine you will move together to study each other's story, and maybe, craft forms to inhabit them together. This practice soothes the tensions accumulated in your bodies and histories. What would such a practice be?

To Practice Witnessing

In Authentic Movement,[1] a form of practice emerged from experimental dance, being a witness means holding space for people to move as they explore what is in their body here, now. Witnesses are also responsible for keeping movers safe upon limited visibility. In the feminist of color perspectives of María Lugones (2003) and Yomaira Figueroa-Vásquez (2020), witnesses are responsible for attending to what lies there beyond the evident fact and making connections to how the apparently mundane is connected to larger histories of power.

Each line you will read echoes our 16-month long gesture study with Ana Melissa Caballero. Thus, you are now a witness of movement and of history(ies). Ours, but also yours. You become a witness—as in Authentic Movement and as in feminisms of color. Witnessing, like movement, is a practice. This space may not be enough, but as you read try to hold space, to notice beyond the evident, to make connections (with larger histories, your own stories and movement), and let yourself be affected. Perhaps, this can be an opportunity to practice.

Meeting in Gestures

Between March 2021 and July 2022, the brilliant Colombian dancer Ana Melissa Caballero and I met at least once a week from two different countries and time zones. We met on Zoom, in movement, to study gestures that connected us to our stories and entangled us in shared histories. We found ways to inhabit each other's gestures while at a distance, to repeat them over and over. With each repetition, we witnessed each other's embodied and kinesthetic life trajectories. Like

Melissa wrote about the prompt I created about my gesture:

> *Nos detenemos, nos miramos, cambiamos …*
> *Volvemos a empezar*

>> We paused, we observed each other, shifted positions …
>> We began again.

In this brief text, which conveys some testimony of our 16-month-long movement study, you will experience gestures as a site of encounter and as a relational form of study.[2] That is, studying our physical positions and movements, we studied dimensions of our positionality. What do you find in those gestures and in that repetition, about us, about movement, about yourself, and about the possibilities of art research? As you sit there in the presence of Ana Melissa's and my movements, remember, you are a witness.

Pause, observe, shift your position, begin again.

Witnessing and Moving With Melissa

One person lives in a small house in the southeast of Bogotá-Colombia, a vibrant working-class part of the city. She dances for a living as a dance teacher and in professional companies—and for life; hers, and her mother's. I later learned that her name is Melissa. I asked her about the gestures that connect her to her genealogy. Instantly, she turned to her mother's gestures to navigate arthritis. Melissa bears witness to her mother's pain, becoming familiar with the gestures she has developed as tactics to keep moving. Bearing witness, she too, is in pain. Melissa studies her mother's gestures over and over again, until they become a movement study, or a dance.

Activa los dedos con mucha fuerza

Melissa continues, reminding me to feel my fingers activated and strong.

Siente la tensión que se toma todo el brazo. Pesa. Es difícil moverse.
Reconoce esa dificultad. Siente cómo afecta la muñeca, el codo, la escápula.
Cada milímetro de movimiento pesa, te hace sudar.

Melissa guides me now to pay attention to the strong tension that takes over my entire arm. It is heavy. Makes it difficult to move. She compels me to notice and acknowledge the difficulty and to perceive how those tense fingers affect my wrist, elbow, scapula.

I continue to follow Melissa's instructions, attending to the involuntary pulses she has witnessed in her mother, that in my body emerge from the tensed muscles.

Each inch of movement weighs, makes me sweat.

She closes this segment of the practice giving me an instruction to both explore movement and to consider as a sort of existential reflection:

> *Siente el peso de lo que sostienes con tus manos. ¿Qué acaricias, qué agarras, qué acercas, qué alejas? ¿Qué te guardas?*

> While I feel the weight of what I hold in my hands, Melissa asks me to consider: What do I tend to? What do I hold, bring closer or push away? What do I keep to myself?

A Pulse, a Mark, a Drawing, a Dance

With this body, heavy and tensed, we explored mark-making. Drawing helped us materialize and share somehow the reverberations of this practice. Remember, we had never met in person. Picture this:

> One continuous line that carves the paper and the surface underneath. The line is frantic and unpredictable almost. A series of short marks, interrupted, emerged from pulsations. Each of these short, interrupted marks has a different color, a different intensity. These intense pulsing marks take over almost the entire paper, becoming an overarching texture of a landscape. Then a thin, thin line, in which the mover-drawer was able to take a quick rest and breathe through the avalanche of pulsations, contorted fingers and arms. Next, several very thick angled lines which, despite all the effort put into drawing them, only made it halfway through the page.

Taking advantage of Zoom's features, we inhabit our drawings as our landscape—as shown in Figure 21.1.

> I dive through Melissa's frantic lines and shake in spirals through the thick entangled line she drew with tensed wrists. As I glide down the thick line that ripped the paper, it makes me stumble several times. Recovering from the ground, I meet the colorful interrupted marks, each of which makes my limbs move in a different direction.

> Pause. *Nos detenemos, nos miramos, cambiamos.*
> *Volvemos a empezar.*

> Melissa shudders and throws her limbs around as she navigates the short, interrupted, pulsating lines. She manages to pause when her body meets the long thin line, and rests on top of it. She is held by the line I created through my muscular rest.

As we continue to study what this tension entails in our body and movement, we realize that the difficulty and pain we explored is, however, not a

FIGURE 21.1 *Catalina and Melissa dancing in the landscape emerged from their gestures.*

Still of screendance by Catalina Hernández-Cabal and Melissa Caballero, 2022.

synonym of stillness. We continue to move. Melissa's mother continues to move, despite pain, or with it. We realize that we can feel each other's muscular tension, miles away, through our drawings. We can inhabit the landscapes emerged from our muscles' pulsations, spirals, and efforts to extend and grow from that which holds us in place.

[What I Hold to Myself]

Here, I intended to guide you through prompts I offered from my story for this study of gestures. However, it feels necessary not to distract you from Melissa's and Melissa's mother's resolution to continue to move. Yet, I will share some

of the key questions guiding my invitation and what Melissa wrote in a letter
to me about what she witnessed in the gestures that I offered.

Catalina:

- How to extend from what restrains you? Use the restraining force as a
 support to free another part of your body.
- What is the difference—in your body—between hugging and restraining?
 Can one become the other?
- What is heavy in your body? What is heavy in your story? Can you feel
 both?
- How can you rest from that place of ambiguous hugs-restraints, and
 acknowledging what feels heavier in one's embodied history?

> *Fui testigo de un cuerpo que se balancea. Un cuerpo que insiste y que
> persiste en la dificultad. Observé la lucha para encontrar estabilidad y
> equilibrio de los apoyos inexplorados del cuerpo. ¿Cómo se pende de
> un hilo? ¿De dónde emergen las tensiones? ¿Qué nos sostiene? ¿Qué
> nos hace querer cierta estabilidad? Empujas ese cuerpo para seguir,
> para estar en pie, para resistir.*

> Melissa witnessed my body balancing, insisting, and persisting within
> difficulty, struggling to find stability and balance with unexpected
> emerging supports. She asks: How do you hang from a thin thread?
> What holds us/you? What makes you/us desire some stability?

> *Nos detenemos, nos miramos, cambiamos.*
> *Volvemos a empezar.*

> We pause, we observe each other, shift positions …
> We begin again.

We begin again, we hold, we repeat, we reverberate.
We resonate. R E S O N A N T E

All these feelings—physical and affective—continue reverberating after
our meetings, throughout the 16 months of practice, up to this moment.
I remember my muscles and jaw tight for hours after our gesture study of
Melissa's witnessing of her mother's movement tactics, pain, and strength.
They're tense now, as I write about them. I became used to a lingering sense
of dizziness from intense efforts of simple movements. Melissa's strength
(muscular and vital) reverberates up to this moment, as I keep witnessing
her tenacity working and dancing in the number of jobs and projects nec-
essary to—like her mother, like mine, like me—continue moving despite
adversity.

We met online, because there was a global pandemic, but also, because I lived in Blacksburg, Virginia and Melissa in Bogotá, Colombia. Through many hours of practice, of drawing, of conversation, of recorded meetings, we decided to compose a video-dance with material from this process. We collaborated with Colombian video artists Paula Andrea Meza and Jonathan Vargas (Goz), with whom we gave this process another form, the three-minute video we called R E S O N A N T E.

R E S O N A N T E exists for now as a piece that gives testimony of the practice. It is similar to what Erin Manning and her group Senselab call an anarchive: not the actual artwork, "not documentation of a past activity. Rather, it is a *feed-forward mechanism* for lines of creative process, under continuing variation." (SenseLab, n.d. Para. 2). Ours is a curated and composed "repertoire of traces" (Manning, 2018. Para. 1) of a gesture study. This study crafted a friendship and helped us learn from our own stories and each other's, and about the possibilities of movement, proximity, drawing, and entanglements through space-time. Our gesture study is still active and may take new forms in the future. We never saw each other in person until we launched R E S O N A N T E in Bogotá in July of 2022, when we gave each other a long and sounding hug.

We paused, we observed each other, shifted positions …
We began again.

Notes

1 To learn more about Authentic Movement visit the website "Discipline of Authentic Movement" dedicated to the work and legacy of Janet Adler, who is known as the practice's founder (https://disciplineofauthenticmovement.com/) and The Authentic Movement Institute (https://www.authenticmovementinstitute.com).
2 I want to highlight the role of dancers-educators like Kirstie Simson, Jennifer Monson, Chris Aiken, and Lisa Nelson in my approach to movement as study, as well as the genealogies of practice where they dwell like Pauline Oliveros, Simone Forti, Nancy Stark-Smith and Steve Paxton.

References

Figueroa-Vásquez, Y. (2020). *Decolonizing diasporas: Radical mappings of Afro-Atlantic literature*. Northwestern University Press.

Lugones, M. (2003). *Pilgrimages/Peregrinajes: Theorizing coalition against multiple oppressions*. Rowman & Littlefield.

SenseLab. (n.d.). *Anarchive – Concise Definition. SenseLab – 3e*. https://senselab.ca/wp2/immediations/anarchiving/anarchive-concise-definition/

Manning, E. (2018). *The Colour of Time — Anarchive*. Erin Manning. http://erinmovement.com/the-colour-of-time-anarchi

22

BITÁCORA DE UN VIAJE[*]

Ana Melissa Caballero

> ***** Bitácora de un viaje.**
> **Parte 1 ….**
> **Por: Ana Melissa Caballero**
>
> ***

> *Dear reader. In case you do not read Spanish, I will offer a brief summary of Melissa's response to our process. I don't intend to translate her voice, but to help you follow her journey as much as possible.*

En el 2021, recibí la invitación de Cata para embarcarnos en un viaje en torno a los gestos y los movimientos que nos conectan con los seres queridos y que están presentes en nuestras historias de vida y de cuerpo. Lo interesante de viajar en compañía es la posibilidad de explorar caminos diferentes, y sorprenderse de lo inesperado que puedas encontrar en el medio…¡Ah!… Eso sí… Es importante la brújula por si se corre el riesgo de perderse. Para mí, esa brújula siempre fue Cata.

> *Melissa begins narrating our process as a trip with many stops, rooted in gestures. She kindly refers to me as her compass.*

[*] A Companion Piece to "To Meet in Gesture: A Place, a Dance, a Drawing, a Study" by Catalina Hernández-Cabal.

DOI: 10.4324/9781003430971-26

FIGURE 22.1 *Melissa inhabits Catalina as an architectural space.*

Still from video documentation of practice by Melissa Caballero and Catalina Hernández-Cabal, 2022.

Primer destino

El itinerario de viaje inició por reconocer mi relación con el dolor en sus diferentes dimensiones, explorando en principio el dolor en la historia de mi madre causada por la artritis y la displasia de cadera y cómo esta historia dialogaba con mi propia historia. Esto me permitió identificar un gesto relacional sobre el dolor de mi madre, recorrerlo y habitarlo en mi cuerpo. Ofrecí este viaje íntimo como una ruta compartida en el itinerario de viaje que, junto a Cata, decidimos abarcar.

Poco a poco esta ruta, se convirtió en fuerza y en potencia creadora, que permitió tejer una relación íntima entre dos historias corporales, que se unen y se identifican en su lucha con el dolor. A través de esta experiencia corpórea, emergieron ecos que reflejábamos constantemente en el cuerpo de la otra y que poco a poco se transformaron en las memorias físicas, espaciales, digitales y emocionales de nuestro viaje. Al bailar juntas, pudimos acceder a ellas una y otra vez para evocarlas, re-habitarlas y resignificadas en el propio cuerpo. Paralelamente, el viaje fue interno e introspectivo: ¿Qué nos hace frágiles? ¿Cuáles son los recuerdos que se archivan en el cuerpo y lo moviliza? ¿Cómo

responde el cuerpo cuando se le plantea una y otra vez la misma pregunta? ¿Cambia la mirada? ¿Se transforma la respuesta? ¿Surgen más preguntas? ¿Surgen más respuestas?

First destination: pain as a path of study of Melissa's history but also as creative source. She offered her personal exploration as a shared path of movement study. Key questions she remembers: What are the memories that are archived in the body and move it?

Segundo destino: las tensiones

Las tensiones fue el lugar donde encontramos espacios improbables y desconocidos en nuestros cuerpos, jugando con distintos puntos de apoyo, buscando la extensión máxima de la tensión que producía la estructura corporal que surgía a partir de estas provocaciones que nos sugería el esfuerzo, la resistencia, el peso, y la gravedad en cada punto de apoyo en el que nos encontrábamos. Durante el viaje ella me preguntó: ¿Cómo ese espacio improbable, incómodo, interactúa con tus posibilidades de activar el cuerpo? Reflexionando, encontré la tensión como una fuerza dinamizadora que contradice y configura el cuerpo en correspondencia con el estado de tensión del momento. Descubrí que al soltar la tensión de un sistema de apoyos, podía trasladarme a otro espacio improbable provocado por un nuevo estado de tensión que se daba al reconfigurar el cuerpo en otros apoyos distintos de los anteriores.

¿Qué nos sostiene?, ¿Qué pesa en el cuerpo? Compartir estas preguntas me hizo reflexionar que cada cuerpo carga sus pesos, no solo el físico, sino el peso de los pensamientos, de las emociones, de los dolores, de los miedos. Nos permitimos reconocernos vulnerables pero, al mismo tiempo, con la necesidad constante de sostenernos, empujarnos, permanecer y de resistir. Recuerdo, también, el lugar de las tensiones como mi parque de diversiones; no solo jugaba a permanecer sino también a contradecir la gravedad, buscando, por un lado, la tensión en una parte del cuerpo que me sostenía y por otro, buscar en otra parte de mi cuerpo en el que no ocurría la tensión, poder liberarla, articularla con esa sensación de ingravidez para permitirme flotar (Figure 22.1).

Second destination: tensions. Melissa remembers tension as a dynamizing force which contradicts but shapes the body. Through tensions she learned to inhabit unlikely places in the body. Each body carries its weights: not only physical, but the weight of thoughts, emotions, pains, and fears.

Tercer destino: los escenarios móviles

Los 'escenarios móviles' es un destino, o más bien, un camino de conexión que moduló y matizó las experiencias durante el viaje. Usamos Zoom para mantenernos en contacto y poder viajar juntas. Sin embargo, descubrimos la potencia de esta herramienta como 'dispositivo' de transformación de nuestros espacios físicos en territorios de relación y proximidad en los que se encontraron distintas formas de contacto y de soporte. En estos territorios emergentes, trascendimos la limitación de la ausencia del cuerpo tangible de la otra.

Third destination: Mobile landscapes. Melissa discovered Zoom's potential as a device to transform physical spaces into landscapes of relationality and proximity.

El souvenir del viaje: R E S O N A N T E

R E S O N A N T E es un pequeño video-danza como gesto creativo, de documentación y memoria de este viaje. Es nuestro principal recuerdo que compila esta travesía y plasma parte de los lugares, las preguntas, los paisajes de cuerpos, colores, dibujos y arquitecturas que propiciaron el encuentro. R E S O N A N T E, sin duda, nos alienta a continuar viajando juntas. Agradezco esta aventura que me permitió converger y conectar sensorial, corporal, experiencial e íntimamente con Cata.

The journey's souvenir: R E S O N A N T E. She remembers our screendance as a main resource to document and memorialize our shared journey.

23

OUR MONSTERS, OUR BREATH

Rachel Yan Gu and Azlan Guttenberg Smith

Catalina and Rachel know each other through little moments woven into a community of shared friends. Rachel remembers hanging Catalina's artworks outside Jorge Lucero's old office. Catalina recognized Rachel's name in the Zoom room of her dissertation defense, after hearing about Rachel's beautiful ceramics. In little ways they introduce each other to what art education could be.

Introduction

I (Rachel) have practiced drawing for a long time. When I was six, I would practice by doing three portraits every day, seven days a week. As I got older, I became very good at drawing: I would still do three portraits every day, but I would also draw other things, and I could draw faster and faster. I wanted to be accepted into China's Academy of Art, which is very difficult. I went to an art high school to draw, and in the afternoon, I stayed at school to keep drawing. Then I went home to draw more. And I've never really stopped drawing.

I am also someone who feels emotions very, very strongly. Drawing became both a kind of stress, a trigger, a cause for many of my hurt emotions (as I pushed myself, and was pushed by my environment and society, to be better and better), and a tool for stepping inside my emotions and experiencing them. A tool for trying to heal.[1]

Over the last few years, I've become increasingly engaged with abstract drawing as a way of entering into, moving through, living inside, and moving out from emotions. I've designed curriculum activities for people to start practicing emotional abstract drawing. I've used emotional abstract drawing to take notes in graduate school seminars, mixing a record of how I'm feeling with a visual record of the conversation. Part of my drawing might stand in for

DOI: 10.4324/9781003430971-27

the fear I'm feeling, and the boxes and containers of safety that I'm trying to arrange around my fear. Part of my drawing might also include the patterns from a colleague's shirt, the arrangement of our chairs in the room, and the arrangement of ideas in an academic article. In this way, each picture was a kind of meeting place where I could draw what I was hearing, what I was thinking about, what I was learning, what I was feeling, what I was hurt by, and what I didn't understand yet. My friend Azlan Smith started sitting next to me and drawing along with me. We didn't talk about it much, but we shared the practice.

The pictures in this chapter show some of my emotional abstract drawings and my abstract ceramics (Figures 23.1 and 23.2).

In February 2022, I talked with Azlan about writing practices, and they suggested that I might like weaving poetry into my other artistic mediums. We talked about what that could look like. We spent some time writing together. Over the next ten months, I wrote lots and lots of poems that played with images from my emotional abstract drawings, and my environment. For this collection I choose three of those poems, which you can read both in Mandarin and translated into English. In writing both the translations and the introduction, Azlan and I co-wrote together. We would sit together,

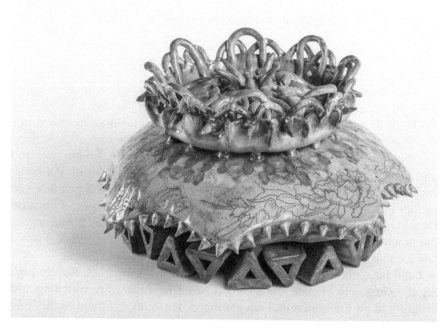

FIGURE 23.1 *Monster I*. Ceramic artwork by Rachel Yan Gu, 2022.

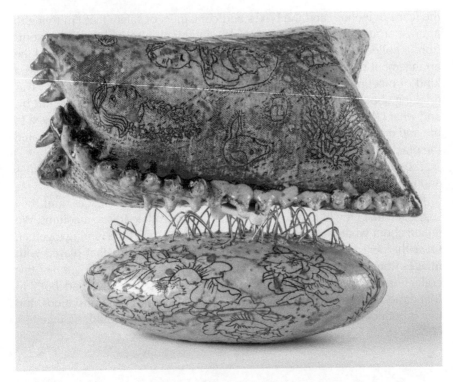

FIGURE 23.2 *Monster II*. Ceramic artwork by Rachel Yan Gu, 2022.

sometimes sharing candy or fruit, and talk about what the poems mean to me. Azlan is also a good friend, and we have worked a lot together.

Once, when Azlan was suggesting English words for the Chinese words I had written, I laughed and said, "You already know me so well." Working together, we put down the words you're reading. Both of us, on our own and together, want to say that writing together has been so wonderful. We know each other. We support each other. It is wonderful to have a practice that includes that. Azlan has said, "I love drawing, but I'm so scared of it because I feel like I don't know how." I have said, "I'm so scared of writing!" In sharing our practices, Azlan draws more, and I write more. Together we're less afraid and we talk and laugh more.

I still have not drawn — or described in words — my 思念. But through my drawings, my ceramics, my poems, my friendships, my watching and listening to my environment, I am getting closer to my 思念 and to the 呼吸 that is life.

Three Poems to My Monster

思念
Missing
我不明白我 我不明白我的怪物的机制 也不明白它的用途
它好像就一直在那里 观望 蓄意着什么 让我总是不确定 也有一丝丝的不安
它在做什么 它怎样生活 它何时睡觉何时休息 它需要睡觉休息么？
我也在观察着它 但是迷雾太重看不清 拨开了又被遮起来
好多好多层啊 难难难

"Missing"

> **I don't understand who it is, this** 怪物 *[Guàiwù]* inside me.
> **I don't understand myself because I don't understand how my** 怪物
>> eats, mouth in my mouth
>>> sleeps, head on my pillow
>>>> cooks, spatula in its claw
>
> **I have been trying to draw my** 怪物, **but I haven't figured out what it looks like**
>> and it changes all the time. I know it has many arms
>> legs like a bug's legs
>> a hard skin.
> What does it do, how does it live, why does it grow, and when does it
>>> need to rest?
> I'm not smart enough to understand myself.
> I'm not smart enough to understand why I can't understand myself.
> I want to see it, but the fog is too thick to see clearly.
> It's pushed away again
> covered again
> so many layers, hard, hard.

Translation note: 怪物 means something strange, something scary, not normal and unacceptable by "normal" people. The characters are literally 怪 ("strange") 物 ("thing"). It might be translated as "monster," though there are layers to the word. 怪 is also used in 怪异, which describes something not connected to daily life — an alien, or a ghost, or the sky suddenly turning bright green. 物 is also used in 物体, which means object—anything from a pen to an orange to a rock to a severed hand. So a 怪物 might literally be when a piece of the physical world 物体 becomes very strange 怪异.

象

它是什么
如象一般藏在里面

象存在于世间
它又或许不存在于世间
世间是什么
认知之下
个人之上

它是什么
暂且是个怪物吧

"象"

I can be a 象 [*xiang*] even in my body.
I feel inside me a core, a nucleus,
abstract but solid.
 Can we imagine
something that we have not
been shown?
 Maybe I think
my 怪物 is a 怪物 because of television
(creatures with tentacles) and movies
(beasts with teeth) and maybe
my 怪物 is actually a tree or a fairy
or a cliff.

I do not believe what we see,
what we learn, what we know
about the world. What is the world?
We created God with a human body.
I know there is something beyond the human body.

Sometimes the 象 core of me looks like
grass
or looks like
sand
but it only looks like
grass
and it only looks like
sand

so I cannot use these metaphors
to explain the 象 of what truly is.

Translation note: 象 means something like "projection," or "image"— if a projector puts a picture on a screen, 象 means that picture, that construction of light and form. 象征 can also mean "stand for" or "symbolize," like a flag for a country or the word "apple" for an actual physical apple. 象 can also mean "elephant." I don't know why. My language is a funny, tricky, playful 怪物.

呼唤
Calling
我一直在呼唤
呼唤雨雪
呼唤甜腻
呼唤红痕
呼唤沉静
它是怎样的存在?

它于此诞生 更加复杂与稳定
它融合了情绪 暗影于是作为外壳显现出来
然而 暗影下又潜藏了什么
随着它不断长大 我好像看到了一点迹象 却无法确认
差什么 一根针
针也不见得能刺穿它 于是流出了液状的迷雾 徒增疑惑

我在等 焦急的等着
我难过 我难受 我忍了太久太久
我期待 它的成熟 某一刻出现在我面前
我会拥抱它 义无反顾的亲吻它
我会对它说 亲爱的 你可曾知道我是多么的思念你啊

I keep calling—
calling for rain and snow
 difficulties, parables
calling for sweet
 a partner's warm eyes
calling for the red mark
 scratched on my body
calling for the silence
 of my attitude. So often I live in silence.

How does it exist, my 怪物 ?
It was born from my calling, my voice and lips and breath
but it is more stable and complex than my breath and lips and voice.
When I draw my emotions I draw purple, brown, black,
and when I draw my 怪物 my 怪物 grows a shell, purple, brown, black.
A shadow. I wonder what is inside.

Inside my 怪物 is changing and growing.
Sometimes I can see it growing, grassroots into earth
or tumor into bone.
If I want to see what is inside the shell
maybe I need a needle
but I'm not sure if a needle can go through the shell,
and even if it can, maybe the needle's hole will only let out
mist, flowing, swirling, covering up more doubts.

I'm waiting to see what my 怪物 is.
I don't know how long I'll have to wait. Sometimes
I'm very sad. Sometimes happiness
stops my breath. Maybe my 怪物 is a sweet fruit,
a plum, red, pink, purple, and one day when it's ripe and full
I'll say
 here is what you are
I'll see
 this is what you look like
I'll hug my 怪物 and kiss it without hesitation
and call
 you don't know how much I've wanted to see you
and call
 lovely do you ever know how much I miss you.

Translation note: 呼唤 [hū huàn] might be translated as "calling." One of my
friends, Natalia Espinel (who has also written something in this book), told me
once that when you want to relax you can exhale a soft sound from your body.

"Hooo."
**The character 呼 alone might be that relaxed sound, that "hoo," when
things are done or when you're letting things go. This character is also used
in 呼吸, which means breath, and in 呼吸器, which means a rebreather—like
what someone uses when scuba diving or what a medical team might use in
a hospital.**

The second character 唤 is also used in 召唤, which is a way of asking someone to pay attention. If young kids are out of the house playing, and parents want the kids to come in for dinner, 召唤 is that action of calling the kids back in.

So 呼唤—the kind of calling I mean—is something about breath, about the relaxation of letting your breath spill out from your lips, about the moment of connection and even tension when you call someone (or yourself) back in.

Note

1 In this way, my approach to drawing is related to an approach to theory that bell hooks describes in *Teaching to Transgress*: "I came to theory because I was hurting—the pain within me was so intense that I could not go on living. I came to theory desperate, wanting to comprehend—to grasp what was happening around and within me. Most importantly, I wanted to make the hurt go away. I saw in theory then a location for healing." I think this experience of hurt, this movement toward healing (for myself, for us), is inside lots of art and lots of teaching. Sometimes we cover up this personal motivation, this pain and healing. Sometimes—like hooks—we are open about it.

24

TRANSLATING TEA

Interpreting Relationality of Tea Ceremony in Collaborative Gatherings

samantha shoppell

> *Rachel and samantha met as members of the same graduate student cohort.*
> *They connected on the morning bus to class, discussing their experiences in*
> *Japan. Rachel later contributed to one of samantha's first collaborative tea*
> *gatherings in Illinois, sharing cups from her ceramic collection and the stories*
> *each held.*

How does one translate a cultural practice responsibly? I have been grappling with this in my work with 茶道 *chadō* (lit. "the Way of Tea"), more commonly known as Japanese tea ceremony.[1] As a thoroughly embodied practice, deep cultural roots underlie even subtle elements of the practice. I first came to tea in 2016, to remain connected with Japanese culture upon returning to the United States after several years in Japan. In my practice, I strive to be mindful how much I have to learn, particularly as someone without Japanese heritage. The idea to translate tea arose from reflecting upon my personal tea practice as well as my work with organizations that educate about tea ceremony in the United States. I've noticed that those invited into the tearoom for the first time may feel hesitant or alienated when engaging with this formalized cultural practice. Participants' worries about potential faux pas can obscure the core relational experience of receiving tea prepared with ritualized care. My experiments in translating tea aim to open up the form of tea ceremony, diverging from traditionally prescribed movements and phrases, to make the relational potential more accessible to those who may not necessarily have the experience required to fully interpret cultural elements of this practice. In this chapter, I discuss the first iteration of tea translation as collaborative gatherings developed with members of an arts-based research (ABR) course at University of Illinois Urbana-Champaign (UIUC).

DOI: 10.4324/9781003430971-28

As I consider relating within tea practice, I must also consider my own relation to the Way of Tea as a non-Japanese person. I strive to pursue my work with care and respect informed by ongoing tea practice in first the Omotesenke and now Urasenke lineages of tea, and as a researcher and teacher in the United States and Japan. As an educator, I often act as an informal cultural ambassador, interpreting language as well as cultural ideas and practices. In translating tea, I make intentional breaks from formalized tea tradition, including using the term "gathering." (I use "ceremony" to refer to the traditional practice of tea, to avoid conflating my experiments with tradition.) I hope that my translation mediates the core principles of tea practice with respect to both the traditional origin and to the people and location where I currently find myself in the United States.

Sen no Rikyū, the 16th-century tea master largely credited with formalizing tea practice as it remains practiced today, described the essence of tea thus:

Tea is nought but this;
 First you heat the water,
 Then you make the tea.
 Then you drink it properly.
 That is all you need to know.

(Sen, 1979, p. 44)

A new guest might doubt that this is truly "all [they] need to know" when observing the highly choreographed movements of the tearoom. The host enters, bringing in assorted tea utensils (tea bowl, scoop, and whisk, among others), ritually cleanses them with a precisely folded purification cloth, prepares and serves a bowl of frothy green matcha to each guest, then cleans and removes each item, returning the tearoom to its original empty state. Experienced guests know this choreography and respond on cue with bows and humble phrases. Yet, it can be overwhelming for a new guest. How best to accommodate those new to tea is often a consideration for hosts, particularly outside of Japan, as tea practitioners Marius Frøisland, Anthony Crasso, and Adam Wojciński (2022) discuss in a tea podcast episode "Tea for Non-Tea People." My current response to this question is one that strips away the choreography to the core of simply making and drinking tea as Rikyū taught, while emphasizing the collaborative nature of tea by explicitly inviting guests to contribute to the gathering.

This work is grounded in the relational potential of shared experience. Understanding tea as a communal sensory experience, I see Stephanie Springgay's (2008) concept of "inter-embodiment" (p. 18) as a way to illustrate how participants "make sense of something and simultaneously make sense of themselves" (p. 22) in an emergent process of understanding self and

other. In these collaborative tea gatherings with peers from my graduate course, I recognized this when we drew upon previous experiences to both give meaning to our shared experience and to understand each other.

In structuring these gatherings, I reflected on practices of art educators, such as the communal walking and storytelling in Kimberly Powell's *StoryWalks* (2017) and the role of invitations facilitating Alberto Aguilar's dinner parties (described in Lucero, 2013) as well as understanding Jorge Lucero's (2013) concept of "permissions" itself as a form of invitation. Lucero's conception of permissions as the Duchampian "everyday-gesture-as-art" (p. 24) is also deeply connected with the intentional everydayness of tea tradition. In recognizing commonalities between tea practice and these art educators' collaborative and embodied work, I borrowed elements of walking and invitations in my process. Walking in my gatherings echoes both Powell's walking and the symbolic cleansing of tea guests strolling through the garden prior to a ceremony. Aguilar's process of inviting and hosting guests for dinner parties re-envisioned as participatory conceptual art mirrors the impact I hope these tea gatherings have.

Conceived as part of an ABR course, my professor and classmates were integral in developing these tea gatherings as experiments in translation. I first hosted a class workshop at UIUC Japan House, where I teach as a graduate assistant, performing a traditional tea ceremony and teaching participants how to whisk and serve matcha to each other. Later, I initiated individual gatherings with a handwritten invitation asking the invitee to decide the time and location for our gathering and to walk together before tea. Importantly, the invitation asked that guests bring something to the gathering (e.g., tea, wares/cups, sweets, etc.). At present, I've held seven tea gatherings, during which I asked a series of six loosely structured interview questions.

Originally, I focused on the collaborative element that I hoped would make the gatherings relatable for my participants. I was not explicitly thinking of Rikyū's Seven Rules for tea gatherings (this chapter's epigraph), though I came to realize it was precisely these concerns I was attending to in my preparations and considerations for gatherings. In the following, I use three of the seven rules to illustrate my attempts to translate tea.

"Make a delicious bowl of tea"

Presumably, good tea is the entire point of a tea gathering. However, this rule (as with the others) goes beyond the literal, considering that tea tastes better when the effort and care that went into it is fully appreciated. Hosts consider guests' preferences to select and prepare satisfying tea. Traditionally, only matcha (抹茶 powdered green tea) is served at a tea ceremony, though I open my gatherings to a variety of teas to suit a broad range of tastes.

In nearly half of my gatherings, invitees supplied the tea, and I did my best to brew it well. In one gathering, I prepared puerh tea a classmate from a

tea-producing region in China had gifted me. Though my brew was techni-cally poor, the experience of sharing the tea with her was meaningful and was made all the better when complemented by her contribution of sweets from her hometown.

One of my collaborators did not drink tea, yet I wanted him to feel wel-come to participate. Speaking with him beforehand, he suggested herbal tea could work. The peppermint tea he brought evoked memories of enjoying this tea in our individual pasts, which sparked a more personal connection when shared. Though we hadn't talked much previously, tea facilitated a rich con-versation full of insights applying the host-guest dialectic of tea to pedagogi-cal relationships and practices.

"In summer suggest coolness, in winter, warmth"

Although temperature of the tearoom is an important consideration for guests' comfort, this, too, is not merely literal, but reminds us to cultivate seasonal awareness. Seasonal references are expressed throughout the tearoom, often conveyed through materials and motifs of tea utensils. In my efforts to harmo-nize the tea and items that I brought together with my invitees' contributions, I also kept this sense of seasons in mind (Figure 24.1).

I met one participant in the Japan House gardens just before the cherry blos-soms were about to bloom. She brought a small set of watercolors and watercolor paper, and I brought everything else. In anticipation of the blossoms, I selected a Japanese green tea with notes of cherry blossom, teacups

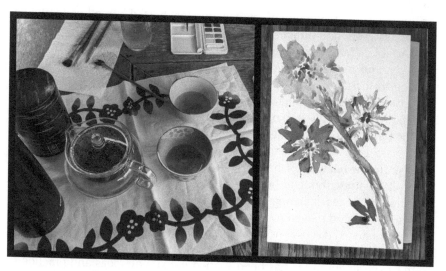

FIGURE 24.1 *Shared tea and watercolors express anticipation for cherry blossoms in the Japanese gardens.*

Photographic collage by samantha shoppell, 2022.

decorated with cherry blossom motifs, and a tea caddy made of cherry tree bark. Without quite thinking of it, a cluster of blossoms came forth as we painted collaboratively while discussing our excitement for the coming marker of spring.

"Give Those With Whom You Find Yourself Every Consideration"

This final rule has been the most important in planning and executing these gatherings, which were grounded from the start in consideration. Several collaborators reflected on the tea ceremony workshop, noting that the later gathering's comparatively less formal/ized atmosphere and the ability to concretely contribute made them feel more comfortable.

Inviting participants to bring something of their own was a key element to interrogate the host-guest dichotomy, giving the guest some hosting responsibilities and vice versa. While this might seem contrary to the aims of formal tea ceremony, where the host preemptively attends to guests' needs/ desires, both the traditional and adapted strategies can serve as two paths leading to the same goal. The 15th-generation tea master Sen Sōshitsu (1979) explains, "there is neither audience nor performer, but a true interaction of human beings. Through sympathetic coordination, host and guest become one" (p. 40). My invitation to contribute to the gathering helps create the same effect albeit with a different flavor. This is described as 無賓主 *muhinshu* (lit. "no guest or host"), "when host and guest are in harmony at a tea gathering, they merge into a single entity that transcends their respective roles" (Sen, 1979, p. 40).

This struck me when one of my collaborators hosted me in her apartment, provided sweets, and prepared Persian-style tea. Accustomed to a more host-forward role, I found myself in a flipped dynamic, waiting for cues on how to properly drink tea in an unfamiliar tea culture. Was I host or guest? It was often difficult for participants to say who precisely was the host or guest. Several also commented on the interdependent nature of the roles requiring openness from both host and guest to make the gathering successful (Figure 24.2).

This series of tea gatherings has given me a greater understanding of how sharing tea is a way of sharing understanding between people. I have been surprised by the many ways these gatherings created noticeable effects in myself and collaborators. Though I began this work with some hopeful skepticism of how much these tea gatherings could demonstrate relational capabilities, I have been surprised and moved by what arose in collaboration. I'm grateful for the time and nuanced discussions of deep topics surrounding culture, history, relationships, and education that collaborators shared with me.

This experiment in tea has been shaped initially by ideas and practice in art education, particularly by Lucero's (2013) permissions that allowed me to conceive of this as a site for artistic research and allowed me to make further

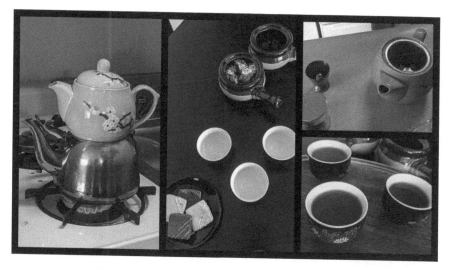

FIGURE 24.2 *Collaborative Persian-style tea gathering with a flipped host-guest dynamic.*

Photographic collage by samantha shoppell, 2022.

connections between tea and artistic practices. In future work, I plan to meet with tea practitioners to check whether my translations remain legible as a faithful adaptation of tea tradition. Already, my colleague at Japan House, Lindsey Stirek, whose writing accompanies mine in this volume, has pointed out important considerations of space that I have overlooked. I look forward to continuing to refine my translation while also learning about others and myself over shared tea.

Note

1 Many English-speaking tea practitioners express dissatisfaction with the approximation of "ceremony," but I use it here due to its wide familiarity.

References

Frøisland, M., Crasso, A., & Wojciński, A. (Hosts). (2022, October 1). Tea for non-tea people (No. 143) [Audio podcast episode]. In *TeaLife Audio*. https://tealife.audio/tealifea-audio-ep-143-tea-for-non-tea-people/

Lucero, J. (2013). Instructional resources as permission. *Art Education, 66*(1), 24–32.

Powell, K. (2017). *Storywalks: History, place, and identity on the move in San Jose Japantown*. https://walkinglab.org/walking-san-jose-japantown/

Sen, S. (1979). *Tea life, tea mind*. (Foreign Affairs Section, Urasenke Foundation, Trans. & Ed.). Tankosha. (Original work published 1979).

Springgay, S. (2008). Corporeal pedagogy and contemporary video art. *Art Education, 61*(2), 18–24.

25

LAND-ART RELATIONSHIPS IN CHANOYU PRACTICE*

Repair with Foraged Materials

Lindsey Stirek

As a traditional Japanese art, *chanoyu* (tea ceremony), also known as *chadō* (the way of tea), naturally takes Japanese aesthetics and wares as its base. Even practitioners outside Japan tend to use Japanese-made implements and order new implements from Japan when needed. The intention is, at least in part, to preserve the art as much as possible in what is perceived as its original form, a Japanese art using Japanese objects. However, in preserving the "Japaneseness" of *chanoyu* in this way, foreign practitioners end up deviating from some of the core teachings of *chadō*.

> Observe the rules and procedure standards to the limit, and though you may break them or depart from them, never forget the principles.
> —*Rikyū Hyakushu verse #102 (Iguchi 23)*

The above is the final verse in a collection of 102 verses attributed to the founder of *chadō*, Sen no Rikyū (1522–1591). This collection of verses imparts the rules and spirit of tea and is so integral to *chadō* that students at the Urasenke Gakuen Professional College of Chadō, where I attended as a student in the international division, are required to memorize and recite a number of them each day before class. In *chanoyu* classes, we are primarily taught the rules and procedures, but this final verse reminds us that as long as the principles underpin our practice, we are still practicing *chadō*.

* A Companion Piece to "Translating Tea: Interpreting Relationality of Tea Ceremony in Collaborative Gatherings" by samantha shoppell.

DOI: 10.4324/9781003430971-29

There is another verse that is particularly applicable to *chanoyu* outside of Japan:

> Keep the tea rustic and, through your heart, give warm hospitality; for the implements, always use items which you have at hand.
> –*Rikyū Hyakushu verse #96 (Iguchi, 2020, p. 22)*

The central tenets of tea are harmony, respect, purity, and tranquility, and this verse particularly connects with the former two. While we must remember the principles and origins of *chanoyu*, respect is also due to the lands upon which we practice, and we must harmonize with the spaces we occupy. I consider this to be critically important in North America where we have a history of harming the land and its original peoples and disregarding or being hostile toward their teachings.

Recently, in an attempt to honor and implement indigenous wisdom in my artistic practice, I have been searching for ways in which *chanoyu* can be adapted to this land, and how native materials can be used for *chanoyu*. Yucca fibers have become a particular favorite of mine for their strength and ease of cord-making and weaving. I have also been harvesting from invasive species; white mulberry (*Morus alba*) is a particularly invasive plant from Asia, and I have been collecting its bark and stems in order to honor the mulberry, which is here through no fault of its own, while I protect the native ecosystem by removing the plant. Its bark and branches have become valuable weaving materials in my tapestries and baskets.

However, to solely take from the land for the purpose of my art is hardly in line with indigenous wisdom. In her book *Braiding Sweetgrass* (2013/2020), Robin Wall Kimmerer of the Citizen Potawatomi Nation writes about an indigenous way of thinking she calls the Honorable Harvest, which emphasizes taking only what you need, showing respect and thanks to the plants from which you seek to harvest, and reciprocity. In taking from the land which gives so generously, I must also consider how to honor and give back to it. While I do this via many different means, in terms of my artistic practice I have decided to do this via the act of repair. Thanks to many factors including the difference in climate, age, and wear, there is a surplus of Japanese implements in the United States that are cracked or broken. Bamboo objects are particularly susceptible to cracks, but they are cheap and easy to find online, often prompting tea practitioners to discard the broken items and import new ones. Yet, if we consider the principles set forth by Rikyū's verse 96 and the Honorable Harvest, it is better to repair these damaged objects with foraged materials. The broken object, if treated with respect and care, can become a beautiful, rustic implement, and in keeping and repairing it using ethically foraged materials, we avoid waste, show gratitude, and take a step toward achieving more harmony with the land.

A cracked bamboo lid rest woven together with yucca cord, a damaged tea box revitalized with birch bark veneer, a worn woven basket restored with mulberry cordage. Though these implements may depart from the standards, it is precisely through this departure that I seek to preserve the principles of chadō.

References

Iguchi, K. (2020). *Rikyū's hundred verses in Japanese and English*. (Urasenke International Affairs Department, Trans.). Tankosha.

Kimmerer, R. W. (2020). *Braiding sweetgrass: Indigenous wisdom, scientific knowledge, and the teachings of plants*. Milkweed Editions. (Original work published 2013)

26

LETTER TO THE QUEEN OF ART EDUCATION

Albert Stabler

Samantha and Albert met (virtually) at a "Cripping the Curriculum" Zoom panel—although they didn't quite know it at the time. This project has given them an opportunity to properly meet and find common ground through sharing their experiences with the University of Illinois Urbana-Champaign's Japan House and discussing anxieties and trauma that can come with being in academia.

Your most royal Highness,

I hesitate to address a personage such as yourself, seen by acolytes as a beacon and muse of the most anxious art, education. I regret that I inadvertently incited your displeasure by failing to honor a pact I did not see and so did not know that I was expected to have signed. Indeed, I suffer from degenerate vision and social disorientation, and my squinting, stumbling, and stammering may inadvertently appear seditious. In keeping with Edgar Allan Poe's (1844/1988) story of "The Purloined Letter," we can assume that nobody of consequence will see my epistle either, courtesy of obviousness that eludes the oblivious. So, although I failed to see the contract you meant me to sign, as recompense let me offer an attempt to negotiate terms.

The creative cognition of children! Legions of data oracles have advanced scores of causal conjectures, regressions, and predictions of trends over time, meta-analyses of meta-analyses. Some speculations spur justification for the humanistic edifying of future supply-chain managers and network administrators. Other findings extol the benefits of behavior modification and paraprofessional assimilation of populations deemed to be feeble-minded and inexplicably violent. The oracles reach for answers, imagining themselves researchers assessing vaccine efficacy. The oracles use batteries and measurements, but,

DOI: 10.4324/9781003430971-30

unlike with the researchers, there is no tangible target nor objective effect. There is simply education, a pursuit Theodor Adorno et al. (1950/1964) identified as one of permanent impotence, an institutional archipelago that won't recognize its edifices of enclosure. There is no individual, narrowly defined "achievement gap," but a leaky, drafty atrium of architectural hierarchy that relies on gaps to sustain a myth of transferable mastery.

Such impotent mastery might be epitomized in the police engaged by the queen in Poe's story. The officers meticulously sought the purloined letter in every hollow book spine and table leg, as proudly described by the prefect. Of course, the letter was sitting in plain view all along, where it could be easily monitored, and later appropriated by the crafty detective Dupin, the story's narrator and protagonist. A virtuoso performance of futile rigor is outdone by a bold and blunt gesture, that of disguising a letter as simply a letter. This is the outcome of a flaw which art is amply equipped to demonstrate, an affliction effecting the ineffectuality of the art teacher and the police officer: that of reliance upon technique, means as ends.

If schooling isn't founded on the logic of forensics, what coherence can it have? The logic of progress, perhaps? The narrative arc of history that droops flaccidly toward justice? Recalling Poe's metaphorically blind king, I emphatically do not ascribe blindness or impotence to Martin Luther King, but rather index his tactical interest in indulging the white philanthropic fantasy wherein a nation is educated out of racism just in time to exonerate the last lynching victim. This narrative arc is the thematic coherence of the unit plan, the visionary giddiness of the scope and sequence, the curricular vector toward endless skill building that steadily advances up from slavery but is constantly dampened by diminishing returns. This educational surface is weakened at innumerable points by disavowed race and sex trauma. The multicultural sunset can be hypnotic, but be out of town by sundown, lest ye tempt the cuckold wrath of sovereign citizens.

In their interviews of people with authoritarian impulses, Adorno and his colleagues encountered individuals unable to find an internal or abstract source for prescribed action. In *The Authoritarian Personality*, the scholars find that those who insist upon the scrupulous observation of table manners are often those who believe in public whippings for those convicted of sex crimes, as well as believing in vast depraved orgiastic conspiracies that must be stopped at all costs, long before the Satanic panic of the 1980s. The personality the authors describe is one that sees strangers as stereotypes and is guided by a faith in normalcy and the standardization of humankind. Adorno and his colleagues identify standardization as an outcome of the expansion of literacy accompanying the European Enlightenment, and so it is appropriate that professionalized education is the realm wherein standardization has become foundational, forging implements of regulation and control, generating authoritarian energy. Authoritarians rely on rules laid down by others,

gleefully enforcing them whenever the slightest transgression is perceived—particularly when the transgressor belongs to a group of intruders, bent on sowing disorder.

Jacques Lacan (1955/1988) said that the unconscious is structured like a language, and so perhaps our experience is structured like a conspiracy. But in his discussion of Poe's "Purloined Letter," Lacan uses character types in an allegorical way. He identifies a cycle by which the roles in the story remain stable over time, but the characters in the story rotate through those roles. There is a "blind" role, first played by the king and then the police. The one who acts is the "thief," first embodied by the minister who steals the letter, then later the detective, Dupin, who steals the letter back for the queen—or more precisely, for the reward. In between the blind role and the thief role is the "passive viewer," played first by the queen and then the minister, when Dupin assists the police by reclaiming the stolen letter.

This impotent, anxious figure, caught between ignorant force and enlightened escape, seems a perfect location to place an educator who uplifts neither experiment nor expression, but technique, an uneasy compromise between twin fears of transgressing virtue and displeasing authority. This impotence is far from neutral, however, as it results in capricious acts of abuse, directed against any seen as both less powerful and less virtuous. By this act the passive queen becomes the blind policeman, harmonizing arcane technique and blunt trauma. Continuing the rotation of roles, Lacan asserts that the detective Dupin takes on the role of blind ignorance when he leaves a spiteful note supplanting the minister's blackmail. Betraying his own gesture of transcendent autonomy to revel in sanctioned criminality, the artful Dupin becomes both instrument and mirror of the police.

How can teachers not be an extension of police? How can students not be criminals in need of reform? If an insurgent curriculum is not a contradiction in terms, who would find it and employ it? Certainly not a queen playing policeman, who claims that rules can be flaunted only if they are memorized, feigning to forget that rules are known only through being obeyed. The actual police, on the other hand, deliberately forget to obey the laws they ostensibly enforce.

But what if teachers were disabled by their anxiety? Not impaired, which is already the case, but, borrowing from King, brought into a "beloved community" of stammering, stumbling, and squinting? There is no place to go beyond the psychic symptom that bends the narrative arc of our experience, the axis of our drive around which people rotate through their roles like the hands of a clock. Like Copernican spheres, the clock must move. To hope to prevent it is hopeless, to pretend to deny it is perverse, to act to break it is divine. Impotence as anxiety disavows castration as fact. We can learn about student learning through shared transference, mutually filtering our experiences, but we cannot master even one child's cognition any more than we

can master our own. An apparatus that demands this will never be appeased but will constantly produce gaps.

We all play the roles of blind policemen. Blindness is involuntary, but we have the choice to stop playing policemen.

In humble service,

Ibid.

References

Adorno, T. W., Frenkel-Brunswik, E., Levinson, D., & Sanford, N. (1964). *The authoritarian personality*. Wiley. (Original work published 1950).

Lacan, J. (1988). Seminar on the purloined letter (J. Mehlman, Trans.). In J. P. Muller & W. J. Richardson (Eds.), *The purloined Poe: Lacan, Derrida & psychoanalytic reading* (pp. 28–54). Johns Hopkins University Press. (Original work published 1955).

Poe, E. A. (1988). The purloined letter. In J. P. Muller & W. J. Richardson (Eds.), *The purloined Poe: Lacan, Derrida & psychoanalytic reading* (pp. 3–27). Johns Hopkins University Press. (Original work published 1844)

27

LETTER TO PAULINA AS A LETTER TO YOU

Angela Inez Baldus

> *Both Angela and Albert's pieces are meta-letters, writing a letter about books about letters, to go into a book. Angela's is to someone she cares about, whom she expects to read and benefit from her annotated bibliography; Albert's is a cathartic exercise in the genre of "what I'd like to say to my bully." They met in this volume.*

Dear Paulina,

Books on correspondence, about correspondence artists, and of letters have been stacked near me for the past several years. I know you, Paulina, also accumulate stacks and in recent years our stacks share some things in common (Figure 27.1). Books that stay in proximity to our bodies find ways of moving our thoughts. We think about books in terms of condition and position—whether they are creased, closed, open, or tagged. We wonder how their marks tell stories. Something I appreciate about books of letters is how they situate us through descriptions of experiences. Through address books of letters fold experience into the now and call us to be present.

I think this presence, the one that is felt when reading a letter, is what I was trying to describe to you in the letter I wrote to you just over a year ago. In that letter I wrote of Jane Gurkin Altman's (1982) description of *future presence*, an idea that has followed me but admittedly I might guess has grown away from what Altman intended. Altman's book is the first I list below, and I do this because it has helped me conceptualize future presence. This list of texts to follow is almost a genealogy or literature review but might more accurately be understood as a collection that I have compiled for study. Like many personal collections it is constrained by limitations of time, accessibility, rarity,

DOI: 10.4324/9781003430971-31

The handwritten and typeset overlapping text reads:

change & what happens &
and what might happen
I thought I would do all these things
& now making note &
committing thoughts to touch
I plan to do all of the what I had
thought. I hope and trust that the
arrangement will make some thing
appear. Something we might be
interested in thinking about together
And so in this letter and those to follow
I will begin doing what I was thinking we do together...

FIGURE 27.1 Page 7 of 7 from A Letter to Paulina October 10th, the day before, and days after, 6 ¾ in. × 8 ¾ in.

Page of notebook scanned and altered to be a digital collage by Angela Inez Baldus.

and proximity. Like most collections I hope and intend to grow it beyond what it is now. I ask you (Paulina), and you (future readers), to understand what it is now as something that exists in response to my reach and through it invite you to consider how stories surround us and how they wind us into specific paths (Figure 27.2).

The Stack—Numbered, Named, and Briefly Explained

1. *Epistolarity: Approaches to a Form* (1982) by Jane Gurkin Altman

 I do not remember the search in the library's online database that led me to this book, but I have been renewing it for years now. If judged by academic expectations to stay relevant this book might be called old. Some of this book was difficult for me to read because Altman quotes French authors and texts without providing translations. My French has not progressed past late-night Duolingo curiosities. In every read of the text, I linger longest in a singular quote wherein Altman introduces a letter

FIGURE 27.2 The Books of the List (Stacked).

Digital drawing by Angela Inez Baldus, 2022.

writer's preoccupation with future presence. When I read about future presence as a preoccupation, I believe Altman too is intrigued by correspondence for reasons I am. When writing a letter, it is understood that what is written will not be read until later, sometime in the future. Anticipating what will be received is not unique to correspondence, but in particular I believe this imagining is something we also do as teachers. Imagining where the reader (or student) will be and how they might receive a letter (or things we teach) is emphasized by the letter writer's (and teacher's) preoccupation with the address. In doing their work teachers and letter writers may not ever fully know but must continually imagine what will happen.

2. *Letters to a Young Poet* (1986) by Rainer Maria Rilke

The first letter that appears in this text is dated 1903 and begins with a thank you. It is a response. It reads quickly as if each letter is personally addressed to the reader. The ease of the exchange is something I often desire to achieve. Of course, I never intend to write exactly like Rilke.

Instead, I recognize how Rilke gives thanks and shows gratitude and appreciation. I wish to do the same. Sometimes Rilke's thank you comes at the beginning of a letter and other times it shows up somewhere else, but no matter where, it always feels very important. Rilke recognizes the value of the exchange for both the young and the old poet. The thanks point to mutual benefits and reasons to correspond. It must be addressed that Rilke also emphasises solitary work, inner searching, and childlike presence in a way that might mistakenly celebrate individualistic understandings of the world. However, when Rilke states, "you should not let yourself be confused in your solitude by the fact that there is something in you that wants to move out of it" (Rilke, 1986/1903, p. 67) I find a glimpse of hope and a recognition of our interdependence. Rilke might continue to remind the young poet of what is gained through the difficulty of solitude, but the acknowledgement of what is beyond solitude invites us to consider the ways in which we are never alone.

3. *Ray Johnson: Selective Inheritance* (2018) by Kate Dempsey Martineau

This book was published recently and includes a lot of interesting tidbits about Ray Johnson, his love of Marcel Duchamp, and his playful way of navigating through relationships. When I read this text, I often find myself imagining what Ray Johnson would do with digital media. Would there be a school of email? The tracing of Johnson's practices to his time at Black Mountain College and the influence of John Cage and Merce Cunningham makes it particularly easy to understand Johnson's work as pedagogically poised and consistently in response. Schools, no matter their distance to and from compulsory education, find ways of putting persons in lineage, exchange, rooms, and (in)boxes. I selectively inherit the relationality of this text.

4. *Care Of: Letters, Connections, and Cures* (2021) by Ivan Coyote

I know that you (Paulina) have read this book. And you (the unknown reader) might consider adding this book to your list. Coyote's book came into my hands in nothing short of a serendipitous moment. I believe they work as a teacher and a healer. Perhaps being both enables their artistic practice to linger in pedagogical presence. The palpable sincerity in this text grounds each letter in love, care, and response.

5. *Affect[1] | Marcel: The Selected Correspondence of Marcel Duchamp* (2000) edited by Francis N. Naumann and Hector Obalk, translated by Jill Taylor

I flip through this book casually. I appreciate how it includes both the original French and an English translation of Duchamp's letters. I also find joy in the red ribbon bookmark that is pasted in the book's binding. It stands in stark contrast to the rest of the book's neutral blacks, greys, and creams. A letter addressed to "numerous acquaintances" (Naumann and Obalk, 2000, p. 365) seeks to enlist more people into the American Chess

Foundation. My initial thought is to wonder how playing correspondence chess is art.

6. *Envelope Poems* (2017) by Emily Dickinson

 I often look through these poems when I begin to feel unsure about what I am doing. I do not plan to, but I have noticed the pattern. I find Dickinson's poems pleasantly reminiscent of the way conceptual artists have made words both romantic and utilitarian. I think that each word asks for time, and if given, something else unexpected happens. I think it helps that they often are made of something or on something that is considered every day—an envelope, a chair, a comb.

7. *Image Bank* (2019) edited by curators Krist Gruijthuijsen, Maxine Kopsa, and Scott Watson, an exhibition catalogue with essays by Scott Watson, Zanna Gilbert, Felicity Tayler, AA Bronson, Hadrien Laroche, and Angie Keefer as well as interviews with Michael Morris, Vincent Trasov, and Gary Lee-Nova

 I believe some of the most interesting resistances to assumptions and judgements about systems and structures are born from the generative seeds of artists' sociability. This happens when artists respond to each other and open themselves up to exchanging and sharing ideas. The New York Correspondence School and the New York Corres Sponge Dance School of Vancouver have a lovely history of being in conversation. The exhibition *Image Bank* and its respective catalogue recognize the value of artistic exchange, collaboration, and networking that allows for playful response that includes but does not limit itself to complex matters including social and political struggles. *Image Bank* artists sought to recognize how play, language, and performance can and do yield astute observations and critiques. I think this exhibition catalogue is particularly useful for considering the possibilities of correspondence art in relation to the different ways correspondence art and collective thinking has happened, especially through correspondence schools, networks, and exhibitions like the 1971 *Image Bank Postcard Show*.

8. *Correspondence Art: Source Book for the Network of International Postal Art Activity* (1984) edited by Michael Crane and Mary Stofflet with contributions from Ken Friedman, Dick Higgins, Ulises Carrión, Judith A. Hoffberg, Michael Crane, Marilyn Ekdahl Ravicz, Jean-Marc Poinsot, Thomas Cassidy (Musicmaster), Milan Knizak, Klaus Groh, Kenneth Coutts-Smith, Richard Craven, A.M. Fine, Tomas Schmit, Thomas Albright, Anna Banana, Stephan Kukowski, Robert Rehfeldt, Steve Hitchcock, Edgardo-Antonio Vigo, Geoffrey Cook, Gaglione 1940–2040, Ce.E. Loeffler, James Warren Felter, and Peter Frank

 Reading through the extensive list of known and unknown names provides an introduction akin to the variety of experience that this book offers. I placed green, orange, pink, yellow, and blue tags on at least 30

of this book's pages. At one point, while reading this text with an analytical desire, I was aiming to follow a system of codes. The system no longer feels relevant, but the book has not stopped short of piquing my interest. From early in the text when Ken Friedman calls the binding and bridging of correspondence art phenomenological instead of conceptual (Friedman, 1984, p. x), to the relationship between correspondence art and calls to action that take the form of an open letter, or a public letter, this book presents fertile ground for long and twisting rabbit holes in correspondence. What it highlights for me is how correspondence art has always been a means for questioning the visibility of artists, collective meaning making, play, and ephemerality. Epistolary moves might counter the exclusivity, individuality, and commercialization that guides the political interests of the social art world and its economic counterparts (p. x). This is not to say that all correspondence art works this way. Instead, acknowledging how correspondence art has existed in and outside art world hierarchies shows how it might be possible for correspondence art to continue to challenge and grow in relation to what has happened and what could happen. What allows us to wade in what might be the case is often a product of the unknowable future, a missed connection, or a return to sender.

9. *Radical Hope: Letters of Love and Dissent in Dangerous Times* (2017) edited by Carolina de Robertis, with contributions by Junot Diaz, Alicia Garza, Roxana Robinson, Lisa See, Jewelle Gomez, Hari Kunzru, Faith Adiele, Parnaz Foroutan, Chip Livingston, Mohja Kahf, Achy Obejas, Viet Thanh Nguyen, Cherrie Moraga, Kate Schatz, Boris Fishman, Karen Joy Fowler, Elmaz Abinader, Aya de León, Jane Smiley, Luis Alberto Urrea, Mona Eltahawy, Jeff Chang, Claire Messud, Meredith Russo, Reyna Grande, Katie Kitamura, iO Tillett Wright, Francisco Goldman, Celete Ng, Peter Orner, and Cristina García

I distinctly remember this book being relevant to our conversations before many of the other books on this list made it to my shelves. I was walking alongside Queen E. Park in Vancouver, British Columbia while talking to you on the phone. It was two years ago, almost exactly. This book was nearly three years old, but the four years that this book anticipates and responds to had not passed and the pandemic was finding us in new rhythms. As I walked you asked if you could read me a letter from the book. I love listening to you read. I love it when you stumble through a pronunciation and when you dictate each word with poise. That day you made the letter you read absorbent. You found a way to reach beyond our physical limitations and touch the cheeks of those listening, and we were both listening. Our cheeks both glistening. This is the thing about correspondence that I have not heard explained. The thing about reading someone else's letter and listening to someone read a letter to you that is

difficult to describe. You read, "Dear Mama Harriet," which was written by Alicia Garza in 2017. I heard you read what Garza wrote as if we were being invited to witness the truths that the present with the past and future demand we know. Perhaps Garza does correspondence with all its artistic, pedagogical, and conceptual possibilities intact. And in reading and in listening we might undergo an experience that calls us to live in response.

Indebted to us,
Yours,
Angela

References

Altman, J. G. (1982). *Epistolarity: Approaches to a form*. Ohio State University Press.

Coyote, I. (2021). *Care of: Letters, connections, and cures*. McClelland & Stewart.

Crane, M., & Stofflet, M. (Eds.). (1984). *Correspondence art: Source book for the network of International Postal Art Activity*. Contemporary Arts Press.

Dickinson, E., Bervin, J., & Werner, M. (2017). *Envelope poems*. New Directions.

Friedman, K. (1984). Introductions. In M. Crane & M. Stofflet (Eds.), *Correspondence art: Source book for the network of international postal art activity* (p. x–xi). Contemporary Arts Press.

Gruijthuijsen, K., Kopsa, M., Watson, S. (Eds.). (2019). *Image bank*. Hatje Cantz.

Martineau, K. D. (2018). *Ray Johnson: Selective inheritance*. University of California Press.

Naumann, F. M., & Obalk, H. (2000). *Affectt Marcel: The selected correspondence of Marcel Duchamp*. J. Taylor (Trans.). Thames & Hudson.

Rilke, R. M. (1986). *Letters to a young poet*. Vintage Books.

Robertis, D. C. (Ed.). (2017). *Radical hope: Letters of love and dissent in dangerous times*. Vintage Books.

28

COMPANION, PEACE*

Richard Finlay Fletcher

Dear Angela,

Got it! On a quick skim, I was reminded of this old Minus Plato post:

http://minusplato.com/2021/10/everything-is-signed-by-ruth-wolf-rehfeldt.
 html

(You may need to refresh the page a couple of times to get the images to come through; old Minus is getting creaky with age!).

I'll try to make some sense of why I was reminded of this post in my more considered reply (by Dec. 1st & you can take me at my word that I will keep my reply to exactly 300 words!).

I tend to overuse exclamation points (marks?) & to write out of that line by Charles Olson – that hulking maximalist of a man – echoing in my head ("words, words, words/all over everything"). But in my reply, I'll try to channel some corner where Your Emily Dickinson could be found lurking. I can't tell you with any precision why Ruth Wolf-Rehfeldt jumped out to me from reading your letter, although maybe it was her role in the International Postal Art scene (& marked absence from the list of authors from the book you cite). I wish I could tell you about the time I stole a Ray Johnson work from an author's university archive at the author's request, but instead I'll play the pedant & point out that you missed the accent on Ulises Carrión's name. Writing to you from here in Ohio (Other Books & OH!), I will most likely include a line or two from an open letter Minus once wrote to the Shawnee

* A Companion Piece to *Letter to Paulina as a Letter to You* by Angela Inez Baldus.

DOI: 10.4324/9781003430971-32

poet Laura Da'. In a poem called "Nationhood" she writes "Our new bodies obliterate old frontiers," to which came the reply:

Whenever the Shawnee are named in institutional Land Acknowledgments, I think of your poetry; whenever Indigenous people are referred to in the past tense, I think of your poetry; whenever we park the car in front of Seip Mound – the name of which always sticks in my throat –, I think of your poetry.

More soon!
All my best wishes & in gratitude,
Richard

29

A PROMISE TO RETURN

Sustained Correspondence as an Act of Love and Relational Study

Paulina Camacho Valencia

When Angela drove Paulina across campus at the University of Illinois Urbana-Champaign for the first time, she was nervous about what music would encourage Paulina to join the art education program. Angela thought she blew it. Apparently, she didn't, and post-punk, gothic rock, and new wave have a funny way of bringing us near. From playlists to postcards, Paulina and Angela have been connecting ever since.

Querida Angela,

Thank you so much for your letter. Reading your thoughts, observations, and recollections made my eyes swell with tears and, despite my anticipation of the content, the tears resurfaced each time I revisited it. I think my reaction was in response to the momentary closeness your letter enabled. We currently reside approximately 2,225 miles, or 3,580 kilometers, away from one another. Oddly enough, this is approximately the same distance between us before I relocated to a different region of the United States this past summer. Even though I moved further west in your direction, I also moved further south and away from you. The breadth of the space and land that exists between us usually feels abstract and incomprehensible, until I long for a hug from you or a swivel chair race in our old office—then the 2,225 miles are understood differently. Your letter helped to suspend the vastness of this distance and made your presence deeply felt for a little while. Granted, it's not the same as sitting side by side reading over a shared pot of coffee, but the effect and resonance of your ideas make you more present in my mind, body, and spirit.

I am learning to extend permission to myself to publicly display unexpected surges of feeling and affect. This is new to me, as I grew up in an environment that taught me to hold and suppress emotion, especially vulnerability. This is

DOI: 10.4324/9781003430971-33

why it's still hard for me to fully cry. Outside of a few tears, I don't believe I've had a good cathartic cry since probably 2008, and those tears were prompted by ██

██. Recently, on a flight to visit family in Mexico, I tested the contours of my emerging comfort with vulnerability. To help ease the discomfort of the middle seat, I decided to revisit one of the texts you mentioned in your letter: *Care Of* by Ivan Coyote.[1] Almost immediately, the deeply beautiful, vulnerable, and intimate letters Coyote published in response to readers made my breath shallow and my sight blurry with swelling tears. A couple of tears escaped the pools around my eye and slid down my face. I did not rush to hide them, although I think the people seated next to me didn't notice. I allowed them to linger on my cheek, trapped under my N95 mask. Maybe I was able to cry in public because I knew that the mask helped to conceal this fact, but maybe I'm also slowly learning not to hide and run from my emotive responses. In any case, I appreciate the way Coyote's letters allowed me to sit in a space of connection and vulnerability.

Correspondence, to co-respond, is one of many ways in which you and I engage in reciprocal relationality. Our relationship shapes and informs our continual becoming—I am because you are. Relationality is an ancient principle practiced around the world that persists in spite of oppressive attempts to minimize the importance of reciprocal development that is integral to human experience. I don't know that the word necessarily conveys the depth of connection and power involved in relational exchanges, but that is partly because words are slippery and constantly changing. Indigenous beliefs and practices remind us that relational development is not confined to human relationships, and they position our more-than-human relations as central to the process of coming to know and understand ourselves relative to all things. The letters we send one another in both digital and analog form are some of the many iterations of reciprocity between us. Through these exchanges we share details of our lives, we recount interactions and experiences with our many human and more-than-human relations, we share insights and epiphanies, and we pose questions. Regardless of the specificities of the content, we continue to reciprocate through our responses and our mutual promise to return to this shared practice; in this way, we tend to our relationship and the love, care, and respect we have for one another. Relationality requires a certain degree of vulnerability and can create openings through which we may allow ourselves to be aware of how we are shaped and possibly changed through various relationships. I will never fully know what it is to be you but, in entering reciprocal relational dynamics, I allow myself to enter a space of vulnerable connection that allows me to come within closer proximity to the contours of your ideas predicated on your experiences.

Indigenous scholars, such as Leanne Betasamosake Simpson,[2] Shawn Wilson,[3] Laura Harjo,[4] and Ionah Scully,[5] remind us to be aware of and responsible for the power involved through relational exchanges. Wilson refers to this practice as relational accountability.[6] In maintaining an awareness of our responsibility for ourselves and for how our words and actions impact others, we are prompted to engage in deep self-reflection. This is an ongoing process that requires us to understand our varied positionalities in context and that our roles and responsibilities are ever changing. I appreciate that these letters allow me to share my reflections with you. The sharing is not meant to be an act of unloading where I expect you to be my emotional container, or where I'm absolved of responsibility for my actions. Relational accountability is also not intended to be wielded through disciplinary imposition or meant to cause anxiety. Rather, if we remain cognizant of the potential impact of our actions and words, we may orient our movement through the world with deliberate intention. We will inevitably stumble, but I got you. We have one another, and we also have many other trusted relations, to help us reframe what feel like failures into opportunities to learn and grow, and to lovingly point to the areas where we might still require a bit of work. The trust we have built over time allows me to engage in open and honest dialogue that enables reflective practices, and this helps me better understand my responsibility in relational accountability.

I admit that it has been a bit difficult starting this response. I hesitated because I was struck by the realization that my response and our correspondence is intended for public display and consumption. The awareness that this exchange is not private created a conceptual block that took me a few weeks to try and understand. I still do not fully know the source and contours of my initial hesitation, but I suspect that it's tied to my learning to embrace and publicly display vulnerability, as well as my respect for relational accountability. It may also have a lot to do with ████████████████████████ ███ ███████████████████████. But that's beside the point.

Even though I was struck by momentary hesitancy, I appreciate the letter form because writing is more enjoyable for me when I write with another person in mind and can address my ideas to the receiver of my correspondence. This helps ease the tension and anxiety of the writing process and builds excitement to share the ideas, observations, and points of illumination that surface while being in relation to others. As you know, I wrote my dissertation as a series of letters to the members of the Chicago ACT Collective. They became my support network as I worked through my ideas and overcame the fear of making them publicly accessible. I imagined each member of the group sitting around a table like we've done countless times. I pictured them cracking jokes, pouring a drink, strumming a guitar. Their smiling and

encouraging faces and their both subtle and animated gestures were present as I wrote. Now, as I write to you, I can picture your face smiling back at me, head slightly tilted to the left, your hair parted down the middle framing your face. In my mind, you are wearing your glasses and seated in front of me, your right foot propped up on your chair, your right arm hooked around on your knee, a mug in hand. I imagine you—as well the collective, my family, ancestors, and others—when I write. This helps me gather courage and reminds me of the importance of relational exchanges that enable emergent and generative study.

A few weeks ago, I watched a documentary about Kurt Vonnegut,[7] and there was a moment when the directors were contextualizing the significance of Vonnegut's relationship with his older sister, according to the narration Vonnegut wrote with her in mind after she transitioned to the ancestral realm. Vonnegut wrote with and through the memory of his sister. I felt a moment of pause. While you and I have chosen to publicly share our correspondence, I wonder if, before he passed, Vonnegut gave his consent for his letters to be included in the documentary. I imagine someone gave consent on his behalf, but I began to wonder what it means to have our personal exchanges made available to an audience beyond who was intended to receive them. The content of the letter was sweet but knowing that the sentiment was not intended for me made me feel as though I was prying. When I was a high school teacher, I would often find misplaced notes in my classroom, in the hallway, tucked in pages of textbooks. I remember having the same conflicting sensations of guilt and curiosity when I would read them. Admittedly, I enjoyed finding these lost treasures, just as I enjoy reading published letters in varying forms.

Many of the texts you referenced in your letter are collections of correspondence not initially intended for publication, and here we are sharing our own letters with unknown readers. Ultimately, we decide what is made public. I have begun to use redactions for the content of my letters that feels more private; while I am testing the waters of public vulnerability, I'm not quite ready to dive into the deep end. You should see me try to get into Lake Michigan, it's usually an improvised dance between me and the cold, undulating, small waves of our beautiful lake. For some reason, this metaphor feels like a good representation of my process.

Even though we may share some of our letters, they still only offer a partial glimpse into our relational dynamics. They build on and respond to the previous address and other exchanges that exist in the space and time between this iteration of our continued correspondence. These letters share aspects of ourselves, but they also create opportunities to wander aimlessly, following our curiosities and attunements. This often becomes the space of ideas. While it can be difficult to trace the many intersecting points of relational exchange and collaborative study, I wonder what the commitment to the practice of

letter writing can teach us when we look back at our letters in the future. For now, we think alongside each other, and this allows ideas to take shape, to wander down unexpected paths, and to unfold in unexpected ways. I know and understand that our ideas are not siloed or in a vacuum. Your questions and curiosities often linger and join my own thoughts to form their own presence. They take up space in my mind and body. Sometimes they surface without anticipation.

I look forward to continuing to collect these exchanges over the course of our hopefully long lives and friendship. They are a reminder that we are not alone.

Con mucho cariño,
Pau

Notes

1 Coyote, I. (2021). *Care of: Letters, connections, and cures*. McClelland & Stewart.
2 Simpson, L. B. (2017). *As we have always done: Indigenous freedom through radical resistance*. University of Minnesota Press.
3 Wilson, S. (2008). *Research is ceremony: Indigenous research methods*. Fernwood Publishing.
4 Harjo, L. (2019). *Spiral to the stars: Mvskoke tools of futurity*. The University of Arizona Press.
5 Scully, I. M. E. (2021) Shapeshifting power: Indigenous teachings of trickster consciousness and relational accountability for building communities of care. *Seneca Falls Dialogue Journal, 4*(6), 50–67.
6 Wilson, S. (2008). *Research is ceremony: Indigenous research methods*. Fernwood Publishing.
7 Weide, R. B. & Argott, D. (Directors). (2021). *Kurt Vonnegut: Unstuck in time* [Film]. Whyaduck Productions.

30

LEARNING TO LOVE[*]

A Letter of Becoming via Citational Politics

Tiffany Octavia Harris

Heeey or Osiyo Pau(lina),

What's good? Wado or thanks for the letter. Grateful thought partner alongside you. Our paths crossed before thru the arts and collective imagining.[1] We are students of the creative process and yet several forces against us. Regarding being fully human.[2] While writing, I am intentionally making time to do so, despite it all; cuz *I know why the caged bird sings*.[3] Logics designed to beholden *this bridge called my back*.[4] Deceptive distortion rendering ahistorical assumptions.[5] Marked, but not everyone knows our names.[6] We are still here.[7]

Your compelling letter absolutely touched me. Timely. I desperately desire to revisit artifacts which haunt[8] me. Familial gifts, permanenting, all around.[9] A divinely orchestrated journey.[10] Multidimensional ancestral maps.[11] Infinite homeland, bloodlines immeasurable.[12] Keepsake genealogies,[13] nevertheless, complicated, entangled material realities.[14] Land has memory.[15] You mentioned a good cathartic cry. Whew, dats[16] where I be, cuz it is praxis.[17] A survival litany.[18] Dirty laundry: tears wash, rinse, and twist. A contorting shapeshifter.[19]

Eagle vision: soaring altitude and radiating magnificence.[20] Like her prophetic words:

I am learning to fly, to levitate myself. No one is teaching me. I'm just learning on my own, little by little, dream lesson by dream lesson … I'm better at flying than I used to be. I trust my ability more now, but I'm still afraid.[21]

[*] A Companion Piece to "A Promise to Return: Sustained Correspondence as an Act of Love and Relational Study" by Paulina Camacho Valencia.

DOI: 10.4324/9781003430971-34

Perhaps, so clear, cuz I am her and she is me.[22] Visited the garden one day.[23] Piercing, soul-searching stare. Wings spread, long reaching width for great distance and speed. Cardinal directions, but not a linear trajectory.[24] Wholly sovereign.[25] Abundant lessons, now and forever.[26] Ceremonial conjuring, otherworldly crossings.[27] There is more, and this is it!

Let's take care of our energies,
Tiffany Octavia aka Avanti Quietstorm

Notes

1 SOLHOT. (n.d.) *Saving Our Lives, Hear Our Truths*. https://www.solhot.com/.
2 McKittrick, K. (Ed.). (2014). *Sylvia Wynter: On being human as praxis*. Duke University Press.
3 Angelou, M. (1983). *Caged bird*. Poetry Foundation. https://www.poetry foundation.org/poems/48989/caged-bird.
4 Moraga, C., & Anzaldúa, G. (2021). *This bridge called my back, fortieth anniversary edition: Writings by radical women of color*. State University of New York Press.
5 Hartman, S. V. (1997). *Scenes of subjection: Terror, slavery, and self-making in nineteenth-century America*. Oxford University Press.
6 Spillers, H. (1987). Mama's baby, papa's maybe: An American grammar book. *Diacritics, 17*(2), 64–81.
7 Jordan, J. (2002). *Some of us did not die: New and selected essays of June Jordan*. Basic/Civitas Books.
8 Gordon, A.F. (1997). *Ghostly matters: Haunting and the sociological imagination*. University of Minnesota Press.
9 Pensoneau, M. (Writer), & Harjo, S. (Director). (September 21, 2022). Offerings (Season 2, Episode 9) [Tv series episode]. In S. Harjo & T. Waititi (Executive Producers), *Reservation Dogs*. FX Productions.
10 Harris, T.O. (2022, Dec.). Ancestral plane: Buried in plain sight. *Surge: The low-country climate magazine*. Issue 3. Page 11.
11 Alexander, M.J. & Mohanty, C.T. (1997). Cartographies of knowledge and power: Transnational feminism as radical praxis. In M. J. Alexander & C.T. Mohanty (Eds.), *Feminist Genealogies, Colonial Legacies, Democratic Futures* (pp. 23–45). Routledge.
12 Tuck, E. & Yang, K.W. (2012). Decolonization is not a metaphor. *Decolonization: Indigeneity, Education & Society, 1*(1), 1-40.
13 Maparyan, L. (2012). *The womanist idea*. Routledge.
14 Coogler, R (Director). (2022). *Black panther: Wakanda forever* [Film]. Marvel Studios.
15 Baca, J. (1978). *The Great Wall of Los Angeles* [paint on concrete or mural]. http://www.judybaca.com/artist/portfolio/the-great-wall/.
16 Smitherman, G. (1986). *Talkin and testifyin: The language of Black America*. Wayne State University Press.
17 Maparyan, L. (2012). *The womanist idea*. Routledge.
18 Lorde, A. (1978). *A litany for survival*. Poetry Foundation. https://www.poetry foundation.org/poems/147275/a-litany-for-survival.
19 Cox, A. (2015). *Shapeshifters: Black girls and the choreography of citizenship*. Duke University Press.

20 Harris, T.O. (Director and Producer). (2021). *Becoming* [Film]. https://www.youtube.com/watch?v=8XOTRACT02s.
21 Butler, O. (1993). *Parable of the sower.* Grand Central Publishing.
22 Walker, A. (1982). *The color purple.* Pocket Books.
23 Harris, T.O. (Director and Producer). (2021). *Becoming* [Film]. https://www.youtube.com/watch?v=8XOTRACT02s.
24 Tedx Talks. (2022, April 22). *TEDxEmory – Chenae Bullock – Indigenous medicines of the land and water* [Video]. YouTube. https://youtu.be/VDEnQ1eko6l.
25 Tuck, E. & Yang, K.W. (2012). Decolonization is not a metaphor. *Decolonization: Indigeneity, Education & Society, 1*(1), 1–40.
26 Brown, R. N. (2013). *Hear our truths. The creative potential of Black girlhood.* University of Illinois Press.
27 Alexander, M. J. (2005). *Pedagogies of crossing: Meditations on feminism, sexual politics, memory, and the sacred.* Duke University Press.

31

FRIENDSHIP AS SCHOLARSHIP

A Path for Living Inquiry Together

Sarah Travis

> *When Sarah's daughter was a very young child, every time she saw Paulina, she was excited to share the drawings of cats that she had made. Paulina always engaged deeply with these drawings, as they allowed for intergenerational conversations about artistic practice. These informal moments of connection created opportunities to support and recognize each other as artists and are an important reminder that it is wonderful to be present, not just as ourselves but as parts of our larger families and communities.*

December 27, 2022

Dear Emily,

I hope you are enjoying the holiday season with your family! It has been a long time since we have exchanged handwritten letters, but I am once again driven to write to you as a way to reflect on how our friendship and our scholarship are intertwined. With the writing of this letter to you as the method for this reflection, I wonder if we can consider our friendship as scholarship, a path for living inquiry together. I am currently developing an edited book with a collection of "experiments in art research," asking: "how do we live questions through art?" This is a project with some of my students and colleagues, situated in our community of art researchers that branches out from the University of Illinois. Each of the central contributors is writing something about their own experiments in art research as a chapter in the book—and some of us have also invited a collaborator to write a related companion piece. At first, I hesitated to create a chapter of my own, feeling that I did not have anything grand to contribute. However, I thought of our ongoing inquiry together through letter writing and I realized that this was the way.

DOI: 10.4324/9781003430971-35

A little over a week ago, I asked you if you would like to participate. I'm so glad that you agreed. Still, it took me some time to build up the motivation to start writing my letter. Somehow, though, this morning I felt compelled to write to you and to begin again our correspondence.

In writing this, I feel how our friendship is a space to ask questions together, to live questions together, to live and do inquiry together. Here's a question: how does friendship enable inquiry? In the being together and the doing together with you, I feel motivated and propelled to do the work I must do as a scholar. When we collaborate, which is often/always, I feel supported and cared for by you, my friend, knowing that you will help me to move forward in my work, that I can take risks with you, and that in so doing, my reflection upon myself as an art educator moves towards a relevance beyond me, towards others.

We have practiced creative and critical inquiry together over the past decade—most recently through a series of handwritten letters to each other. When we first started writing these letters, it was the spring of 2020, the early days of the COVID-19 pandemic. Remember our interrupted plans for a social science research study on critical reflective practice with preservice art teachers? When COVID-19 put our research plans indefinitely on hold, you suggested we begin writing letters to each other as a path for continuing our line of inquiry. Through these letters, amidst the difficulty of those days, you opened a new door for us in our scholarship and our friendship.

We are certainly not first to consider friendship as a path of inquiry, nor the first to recognize the intellectual and creative power of correspondence through letters. There are extensive scholarly and literary epistolary traditions as well as a longstanding practices of educators turning to letter writing to engage in critical discourse about teaching (e.g., Anzaldúa, 1981/2015a; Hofsess, 2019; Newton, 2017; Pithouse-Morgan et al., 2012; Rocha, 2021; Shalaby, 2017). For us, the letters have become a place for creative and critical inquiry, a form of research that is not separate from our everyday lives. This research becomes an art form through our interactions with each other, a socially engaged art research where the medium of the scholarship is our friendship. I'm reminded of Lisa Tillman-Healey (2003) who writes of "friendship as method"—"inquiry that is open, multivoiced, and emotionally rich, friendship as method involves the practices, the pace, the contexts, and the ethics of friendship" (p. 734). I feel we have lived this through our work together.

Our own friendship as scholarship manifested through our letters is evidence of how we have embedded our shared inquiry within the flow of our everyday lives as women and as mothers. As Tillman-Healey (2003) states: "With friendship as method, a project's issues emerge organically, in the ebb and flow of everyday life: leisurely walks, household projects, activist campaigns, separations, reconciliations, losses, recoveries. The unfolding path of

the relationships becomes the path of the project" (p. 735). This is a path also taken by other feminist scholars like Gloria Anzaldúa (2015a, 2015b), bell hooks (1994), Madeleine Grumet (1988), Sandra Harding (1991), Patti Lather (1991), Patricia Hill Collins (1991), and Carolyn Ellis (2001), whose work paved the way for a greater acceptance of acknowledging situated and relational experience within scholarship.

Now, I am writing to you to reflect not only on letter writing as scholarship, but on friendship as scholarship. I think that our friendship is a form of scholarship: a path of inquiry, a site of inquiry, a catalyst for inquiry. We have often discussed how relationality encompasses all that we are doing as scholars and educators and that we feel it is important for us to engage in critical reflection upon ourselves as we work towards liberatory pedagogical practices with our students. We have developed a framework for critical reflective practice in art education (Hood & Travis, 2023) and we recently wrote an article about how writing letters by hand became a way for us to engage in critical pedagogical inquiry together in the midst of the COVID-19 pandemic (Travis & Hood, 2023). This work of critical reflective practice that we do together necessitates a commitment to honesty and that often makes us feel vulnerable.

A critical reflective practice requires what our shared teacher AnaLouise Keating (2000) describes as "risking the personal" (p. 2) in the life and scholarship of her mentor and friend, Gloria Anzaldúa, and as Keating (2022) writes: "risking the personal is not about self-elevation, solipsistic navel-gazing, or confessional self-expression. It is, rather, a vehicle for intimate engagement with readers" (p. 7). Inspired by the risks that Anzaldúa took within her writing, with you by my side, my friend, my fear of vulnerability is not so overwhelming, and I feel that I can take risks, make mistakes, and be honest. Even with an awareness that the personal becomes public as soon as we mark it as research, I have found that I feel a sense of exhilaration in facing this fear of "risking the personal" (Keating, 2000, p. 2) in scholarship that is made easier with you beside me. In writing, Anzaldúa (2015b) herself often worked closely with friends, stating: "You rely on your comrades to tell you what works and what doesn't, to help you say what you're trying to express, and to keep you on track. Writing is a shared act of creation, an act of the imagination for both writer and reader" (p. 113). I sense a resonance between these writings from Anzaldúa and Keating and our own scholarly friendship. You help me to feel comfortable enough to openly critique myself and that I can accept your critique of me, knowing it comes from a place of love and trust.

What I love about our friendship as scholarship is how we critically make sense of the world together, how we theorize together, and work to create things together. I often fret that in my work as a scholar I don't have time to do creative work. I feel guilty that I haven't started sewing as I had wished to,

that I don't make paintings or drawings as I used to. However, I have started to feel that this work with you helps to carry me so that I am living a creative life. There is a creative energy that I feel when we are working through something together in dialogue, and it is in this space of experimentation together that our most exciting work resides. The letters allow for our inquiry to flow as creative work where we do not feel the same pressure to polish our thoughts before presenting them to others as we do with most of our academic writing. The act of writing a letter by hand is a reminder that the thoughts and feelings that we have in any given moment are fleeting and precious. In writing to you now, admittedly after already writing a few previous drafts, I feel a sense of exhilaration, a feeling of being joyfully alive, knowing that even though we will likely make further edits to our writing in preparation for scholarly publication, the handwritten scrawls remain as traces that document this moment within our process of intermittent (written) dialogue and continuous (creative) dialogue. Experimenting with you through these letters is a living inquiry that connects us to our ongoing search for understanding within ourselves and with one another.

In our previous letters, we have primarily focused on writing, but for this project, I wanted to create a visual other than that of words on a page. Thinking of you, in the midst of writing this letter, I looked around my messy kitchen, recalling your recent article about "co-creating" with your "messy kitchen floor" (Hood, 2022, p. 60), inspired by Gloria Anzaldúa's (2015b) *autohistoria-teoría*, a form of creative scholarship from everyday lived experience that you describe as "simultaneously a reflection, healing, and reimagining of the self, situated within a relational or social context" (Hood, 2022, p. 62). In this moment, I felt a burst of inspiration to make a still life painting of something that was sitting on my messy kitchen countertop in my home in Illinois. Looking around the room, I noticed a blue tea kettle and I remembered you gave me this tea kettle one day when I visited your house when we were both living in Texas. You received two of these blue tea kettles as wedding gifts. Since you had an extra one, you offered it to me, and I accepted. Seeing this tea kettle prompted a realization in me of how we are always surrounded by artifacts of ourselves and our relationships with others, and I considered that you, too, might still have one of these tea kettles in your own kitchen where you now live in Arkansas. To mark this moment, I made you a small postcard with a simple watercolor painting of this blue tea kettle. It is enclosed in this letter (Figure 31.1). I am also sending you a blank postcard: will you make a painting for me?

In writing letters by hand, we are leaving human traces of the lived experience of our path of inquiry together, evidence of our friendship as scholarship. We have been intentional about retaining the natural flow of our writing by hand and not overly editing ourselves as we document our experience, leaving some things undone. I sometimes worry about the imperfections and

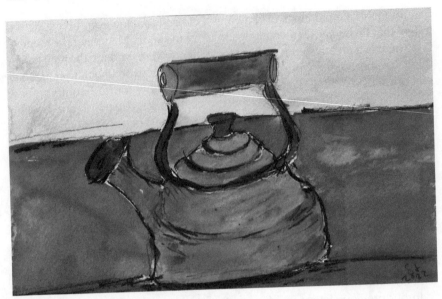

FIGURE 31.1 My Blue Tea Kettle from Emily.

Artwork by Sarah Travis, 2022.

the incompleteness of it all. This is complicated by the fact that I am also writing this with the intention to publish it in a book and, in fact, this time, I have made a few drafts of this letter before sending it to you. But maybe it's supposed to feel unfinished, to best reflect the ongoing conversation between you and me. In that spirit, I am resisting my urge to polish up this letter too much, to bring it to a tidy, un-messy conclusion. That tidiness stifles the living quality of these scrawls on the paper—moving from my hand towards you as I write them on the page, anticipating that I will mail this letter to you, and you will read it, and, I hope, you will respond. As your response shapes our path forward in a friendship greater than scholarship, all I can say now is that I am grateful to you, dear friend. Thank you.

Love,
Sarah

References

Anzaldúa, G. (2015a). Speaking in tongues: A letter to third world women writers. In C. Moraga & G. Anzaldúa (Eds.), *The bridge called my back: Writings by radical women of color* (4th ed.) (pp. 163–172). State University of New York Press. (Original work published 1981).

Anzaldúa, G. E. (2015b). *Light in the dark/Luz en lo oscuro: Rewriting identity, spirituality, reality*. (A. Keating, Ed.). Duke University Press.

Collins, P. H. (1991). *Black feminist thought: Knowledge, consciousness, and the politics of empowerment.* Routledge.

Grumet, M. (1988). *Bitter milk: Women and teaching.* University of Massachusetts Press.

Ellis, C. (2001). With mother/with child: A true story. *Qualitative Inquiry, 7,* 598–616.

Harding, S. (1991). *Whose science? Whose knowledge? Thinking from women's lives.* Cornell University Press.

Hofsess, B. (2019). *Unfolding afterglow: Letters and conversations on teacher renewal.* Brill.

Hood, E. J. (2022). Co-creating with a messy kitchen floor. *Journal of Cultural Research in Art Education, 39*(1), 60–75.

Hood, E. J., & Travis, S. (2023). Critical reflective practice for art educators. *Art Education, 76*(1), 28–31.

hooks, b. (1994). *Teaching to transgress: Education as the practice of freedom.* Routledge.

Keating, A. (2000). Risking the personal: An introduction. In A. Keating (Ed.), *Interviews/entrevistas: Gloria E. Anzaldúa* (pp. 1–16). Routledge.

Keating, A. (2022). *The Anzaldúan theory handbook.* Duke University Press.

Lather, P. (1991). *Getting smart: Feminist research and pedagogy with/in the postmodern.* Routledge.

Newton, M. (2017). Philosophical letter writing: A look at Sor Juana Inés de la Cruz's "Reply" and Gloria Anzaldúa's "Speaking in Tongues." *Pluralist, 12*(1), 101–109.

Pithouse-Morgan, K., Khau, M., Masinga, L., & van de Ruit, C. (2012). Letters to those who dare feel: Using reflective letter-writing to explore the emotionality of research. *International Journal of Qualitative Methods, 11*(1), 40–56.

Rocha, S. D. (2021). *The syllabus as curriculum: A reconceptualist approach.* Routledge.

Shalaby, C. (2017). *Troublemakers: Lessons in freedom from young children at school.* The New Press.

Tillman-Healey, L. M. (2003). Friendship as method. *Qualitative Inquiry, 9*(5), 729–749.

Travis, S., & Hood, E. J. (2023). Writing letters by hand: Critical pedagogical inquiry through inner and outer worlds. *Journal of Curriculum and Pedagogy,* 1–32.

32

TRACES OF FRIENDSHIP AS INQUIRY*

Emily Jean Hood

April 27, 2023

Dear Sarah,

I am writing as a response to the letter you wrote to me on December 27, 2022. It has taken me exactly four months to respond which is hilarious and, also, normal in the chaos of family and academic life. This creative inquiry was born from a time of crisis and this letter follows in that tradition because I am currently displaced and living in a hotel with my family for almost a month now. Our home was destroyed (as you know) on March 31, 2023, by a tornado.

We've often talked about the parallels in our lives—white women who grew up in locations where most of the citizens were people of color, mother-scholars, and now both survivors of wind-based natural disasters (as you experienced Hurricane Katrina in 2005). You talked about the mess of your kitchen (and I have written about mine!), but the truth is—my kitchen is far messier than it has ever been in the past. I'm laugh-crying as I write this.

I know I am privileged to be alive, to have shelter. And partaking in this creative practice is also a huge privilege that I am very grateful for.

The artwork, the watercolor painting, that you sent me in the mail pressed up against the blank watercolor paper that you included for me to use, and it left traces of your painting on my paper. I was surprised by this accident and also very inspired to work with the ghost of your painting. It's an obvious

* A Companion Piece to *Friendship as Scholarship: A Path for Living Inquiry Together* by Sarah Travis.

DOI: 10.4324/9781003430971-36

metaphor for what friendship as research is like—we bump into each other—the things we say and do leave traces, impressions.

Our pasts somehow reach into the present and build new layers about what we know of each other and the things we encounter in our daily lives.

I have to say a quick word about our dependence on our friendship for furthering our scholarship. I do think we have both been led to believe that we do not hold places of authority in our little academic worlds. We lean toward timidity because it is safe, we won't rock the boat. And sometimes—I know for me—(I should not speak for you, I'm sorry). I don't believe that I have something to offer on my own. I'm not smart enough or I don't work hard enough for solo publications. None of this is true—I believe that our friendship as research is resistance work. We are resisting the lie of "solo authorship." In fact, we are resisting the lie that you and I are somehow separate—not connected. But I think we are the unique iterations of consciousness that are actually interconnected in ways we cannot perceive—and that this is not unique to you and I, but rather we are this shared consciousness with all things.

Now my perfectionist self is struggling to decide what to do with the watercolor paper you sent me. I took my FAVORITE pencil and drew light wispy outlines to further accentuate the ghost of your watercolor painting. I've been thinking about handwritten poetry as drawing practice (you know—similar to

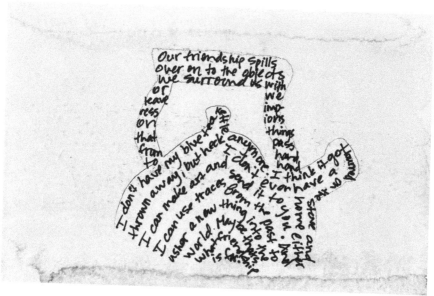

FIGURE 32.1 Traces of Sarah's Blue Tea Kettle.

Artwork by Emily Jean Hood, 2023.

my National Art Education Association (NAEA) presentation—that you actually presented for me because the conference happened just after the tornado!!!). So I think I'll engage with that kind of drawing—and maybe watercolor too because I've done a bit of that lately with my students and I am enamored by the texture and impression of water that is left even when the paint is dry—further evidence that water was once there (Figure 32.1).

I don't even care if this is published—doing this shit gives me life. Peace, my friend.

<3 Emily

EPILOGUE

An Aggregate of Bursting Suns

Jorge Lucero

I was born, raised and educated in Illinois, and I remember wanting to be an artist from as early as four years old. After finishing my undergraduate painting degree, when confronted with invitations to become a teacher, I resisted. I've detailed this story in other places, so I'll skip ahead. I became a high school art teacher and every year in that position I secretly told myself that if I treated my teaching job like an artwork, eventually I would get fired. My wished-for dismissal would free me to be a true artist. I never got fired. I had a principal who was way ahead of me, understanding teaching—in fact, life— as a creative practice. I had colleagues who were truer artists than I could ever imagine in my conservative artworld mind. This high school was brimming with bright, daring, eager, and sometimes wild young people who wanted nothing more than to test the pliability of the institutions they lived in. So, it turned out that what I thought was subversive behavior—treating school like art—was a manifestation of a shared desire for an emergent, dynamic educational time together as full-blown creative practitioners. We gave each other permissions. After seven years of being in that community, I couldn't dream of leaving it.

The experiments of those years in that school are also told in other essays and lectures I've given, archived on YouTube and my website. Jumping ahead again, Drs. Charles Garoian and Stephanie Springgay heard about my shenanigans as a teacher, and I found myself—with our family of six—at Penn State University, through a fellowship completing my graduate degrees over three years. It was the only time anyone in our family had lived away from Chicago, so, when a job popped up at the University of Illinois, I applied to be a one-year visiting professor in Urbana-Champaign. I figured, I'll work at U of I for one year, finish my dissertation and then go back to the city and

DOI: 10.4324/9781003430971-37

work at a Chicago Public School again. Heading into that one year, I told myself, "The stakes are so low, make this whole year art." I figured, at the very least, I would leave with a little bag of failed experiments that I would remember fondly as that one time I got away with treating something so revered as mere material.

Not unlike my attempts to sabotage my high school teaching career, trying to get kicked out of the academy proved equally elusive. Again, foiled by colleagues, students, and administrators who saw the value in a way of thinking about the intersection of art and education—which I had convinced myself was incompatible with the juggernaut amalgam of bureaucracy, capital, and "best practices" known as college—I was hired as a tenure-track faculty member. When that happened, I took an index card out of my desk and wrote "publish only art" on it; taping it to my computer monitor where I could see it every day. This little command was my reminder that my time on the tenure-track was a temporary gift—in my mind, a three- to six-year artist's residency—that would end with my foretold perishing in a sea of noncompliance and institutional tension. It would be okay because I would then return to being a high school teacher, where a few years back I was just beginning to familiarize myself with its materiality and potential for a true art practice, the thing I'd wanted since before I spoke English.

Fifteen years later, the marker has faded, but I still have that "publish only art" postcard.

I can't stress enough how powerful it is for me that this book exists. It is a published artwork, and one I had a minimal direct hand in. It traces networks of experiment and friendship, creativity, playfulness, and hope. I recognize what my role is in fostering this community of creative practitioners—I'm not trying to humblebrag here. I think what I keep doing—the thing I keep coming back to in all these scenarios dating back to being a high school teacher—is helping to set up the parameters, and maybe even insist that we test how soft they can become. That process is fundamentally communal, and together we get to the point of expanding our imaginations, and then to carrying out attempts that start resembling genuine education/art gestures. This is where every single one of the contributors in this book shines and frankly, we bask in each other's glow. We've aspired to be permission-offerers, life-engenderers, carrying out the singular criteria of being excited about the potential to be an aggregate of bursting suns, hurling through the universe, chasing each other's energy. We have a good time together. We test the pliability of the institution. We open ample pathways for each other, and we're constantly holding hands as we egg each other on.

You're now invited.

INDEX